Lewis
GINTER

Lewis
GINTER

Richmond's Gilded Age Icon

BRIAN BURNS

THE
History
PRESS

Published by The History Press
Charleston, SC 29403
www.historypress.net

Copyright © 2011 by Brian Burns
Front cover: Lewis Ginter by John P. Walker. *The United Daughters of the Confederacy; on deposit at the Virginia Historical Society (1946.101).*
Back cover: Allen & Ginter advertisement for Richmond Straight Cut No. 1 and Virginia Brights cigarettes, featuring the World's Champions, second series. *Library of Congress.*

First published 2011
Manufactured in the United States

ISBN 978.1.60949.380.6

Burns, Brian, 1959-
Lewis Ginter : Richmond's Gilded Age icon / Brian Burns.
p. cm.
Includes bibliographical references and index.
ISBN 978-1-60949-380-6
1. Ginter, Lewis, 1824-1897. 2. Businessmen--Virginia--Richmond--Biography. 3. Philanthropists--Virginia--Richmond--Biography. 4. Richmond (Va.)--Biography. 5. Richmond (Va.)--History--19th century. I. Title.
F234.R553G563 2011
975.5'45103092--dc23
[B]
2011021480

For Judd

Contents

CONTENTS

Contents

Acknowledgements

So many wonderful and generous people have helped bring Lewis Ginter's story to life.

First, I'd like to thank John Stewart Bryan III and Liz Humes, who gave me the courage to take on the project in the first place.

I'd also like to thank all the staff at the Virginia Historical Society, the Library of Virginia, the Richmond Public Library and the Valentine Richmond History Center who assisted me with research. Autumn Reinhardt Simpson made some remarkable finds and lent her cheerful encouragement and sharp wit. Ray Bonis pointed me to the incredible research tool "Chronicling America" and volunteered many rare graphics. And Patty Parks connected me in a touching way to Grace Arents's *Travel Journal*.

Thanks go also to writer Ed Slipek for showing me just how vital Ginter was to Richmond's past and present.

Very special thanks go to writer Pete Humes for his keen eye with my manuscript. He taught me some valuable lessons in storytelling and served as a profound source of inspiration.

Just as important are the people who share my passion for the remarkable Lewis Ginter, including Fran Purdum and Carroll Hill.

And lastly, I thank the one-in-a-million Judd Proctor, whose unwavering support and encouragement have sustained me. Not to mention all the hot meals he happily brought me for two years at my computer. He's been my cheerleader, my ambassador, my sounding board, my confidant and my closest friend.

Introduction

More than a century after Lewis Ginter's death, his name is still revered in his adopted city of Richmond, Virginia. An entrepreneurial powerhouse and zealous philanthropist, his life was filled with heroic acts of devotion to Richmond. He risked everything to protect her and moved mountains to nurture her. His enterprises were chosen in service to her.

One lasting tribute is the exquisite horticultural showplace on the city's north side, Lewis Ginter Botanical Garden. Yet as important as Ginter was—even on the world stage—a definitive account of his life has never been published. Many details of his life have been scattered to the wind, while others have been whitewashed, exaggerated or twisted beyond truth. Any information readily available is sketchy, at best. His life comes off as a series of unrelated bullet points—however impressive those bullet points may be.

Besides separating fact from fiction, this book was researched and written in an effort to see Lewis Ginter's life through his own nineteenth-century eyes. An exceptional Richmonder during his time, his choices are viewed in a somewhat different light today. Dramatic changes have taken place, affecting traditions and values, the area of medicine and the political and economic environments.

Not that these facts diminish his legacy in the least. When his adopted city was threatened by war, he made every sacrifice to rush to her aid. Equally inspiring, Ginter—throughout his long life—pursued the grandest of forward-thinking enterprises with fervor, precision and creativity. He

revolutionized the tobacco industry worldwide, making him the wealthiest man in the South. He showed us there are few things on Earth more potent than a genius with ambition.

Then there was his philanthropy, which went far beyond helping the poor and disadvantaged in Richmond. He enthusiastically embraced nearly every movement that reached his city and backed it with his wealth.

One of the makers of post-Reconstruction Richmond—with an ever-present pioneering spirit—Ginter forever changed its landscape, architecture and social life. Richmond would be a much different place today if it weren't for his foresight and tireless efforts. His impact on the city's stature in the world is incalculable.

Lewis Ginter's homes were exquisite, his lifestyle refined. Yet he faced extraordinary adversity with extraordinary fortitude.

One of his architectural treasures in Richmond is the magnificent Jefferson Hotel, a monument to his idol, Thomas Jefferson. Ginter was one of the best-read men on Jeffersonian literature and believed strongly in Jefferson's democratic ideals. He could repeat, verbatim, many of Jefferson's most famous speeches. But Jefferson was more than a statesman; he was an architect and inventor—all of which inspired Ginter beyond measure throughout his life. Interestingly, Richmond's *Style Weekly* ranked Lewis Ginter as one of the most influential men in shaping the Richmond of today, second only to Thomas Jefferson himself.[1]

Even in retirement, it seemed that Ginter could conquer the world—that is, until the premature death of his close companion, John Pope. For many reasons, the brilliant and dutiful John Pope has practically been erased from history, yet he was equally passionate about serving Richmond and critical to Ginter's success. This book was written in part to correct this injustice.

But the greater injustice, of course, is that Ginter's life story—in all its epic glory—has never been saved for posterity. And if there's anyone in Richmond's long history who deserves that honor, it's that gallant soldier, that brilliant and influential entrepreneur and philanthropist, the forward-looking, highly principled and ever-fascinating Major Lewis Ginter.

Chapter 1

Ascent

A pale, lonely looking young man stood in the doorway of his little toyshop on cobblestoned Main Street in antebellum Richmond, hoping that someone—anyone—would venture in. Above the door was a sign painted with his name: Lewis Ginter.

It was autumn in the mid-1840s. Although the quaint, one-of-a-kind shop was in the heart of the capital's business district, business was slow. It had been slow for weeks, ever since he hung his shingle on the door. All the elements of supply and demand appeared to be in place. He'd created a most beautiful display of special toys in his window, and there was an abundance of playful children in this small city on seven hills. The trouble, he'd discovered, was the competition. The grown-ups were buying toys for the children at the dry goods stores, and the little boys and girls were getting some themselves at the confectionaries, where the smell of cakes and candy drew them inside as if under a spell.

Slim yet attractive, Lewis Ginter had a kind, oval face that bespoke his Dutch ancestry. His nose was very nearly straight. About twenty-one years old—the age of majority in the South—he stood just five feet, five inches tall. There in his doorway, with his brown hair neatly combed, his hazel eyes stared off into space. This was more than a tad frightening. He didn't know how to get things moving.

Just then, Lewis saw a group of little children sauntering by his shop and glancing toward his window. Shepherding them was their mammy, in a plain dress. The children started jumping up and down while tugging at their

caregiver. Lewis's heart pounded. A few moments later, the ebony-skinned woman guided the group of little ones toward his door.

Courteously clearing a path, Lewis cheerfully welcomed them all in. The children's eyes widened with wonder as they scanned the shelves of toys. This was fantasyland. Everywhere there were toys, each one pure and simple but of every kind that a childish heart could desire.

Lewis directed the smiling children's attention to the low counter, where he was piling a big collection of toys on top. Each was in its own pasteboard box with a glass window in front. Among the adorable characters were a fairy-like dancer, a bear and a monkey. As the children watched intently, Lewis appeared to make a magical wave of the hands and a quick jostle of the toy boxes, setting the characters into motion. In a split second, the whole counter came alive with a miniature circus. The children giggled in amazement.

More children came into the shop with their mammies and stepped up to the counter to see the show. Without missing a beat, Lewis piled more toys on the counter. There were seesaws, teetering and tottering. Miniature band organs that would make sweet melodies as long as their crank was turned. Whole troops of tin soldiers. Wooden-jointed dolls that could sit down, lie down or stand up. Dolls tucked snugly in their cradles that would cry if they were rocked.

Later, one of the little girls was captivated beyond her wildest dreams when Lewis placed a beautiful, waxen doll in her arms. He gently pointed out that it had blue eyes and golden curls, just like her own. But this doll was unlike any Richmond had ever seen: its eyes could open and shut.

Lewis Ginter had worked his magic, indeed—the whole crowd left his shop that day with their arms full of toys. It's been said that he even sacrificed his profits just to make the children happy. Little did young Ginter know that he would one day become one of the South's business titans and, through his generosity, the most beloved man in his adopted city.

<div style="text-align:center">⚬⚬⚬</div>

It was the spring of 1842 when the precocious, seventeen-year-old Lewis Ginter arrived from New York City seeking his fortune. Orphaned since the

age of ten, he had been talked into coming to the small city of Richmond by a close friend, John C. Shafer. A meek and mild sort with dark hair, Shafer was about four years older than Ginter.

Once Ginter and Shafer arrived—whether by stagecoach, train or steamer—they knew at once that they were in the South. The air was delightfully soft—quite a difference from the raw and fickle weather of New York. The leaves of spring gave a vibrant green cast to the landscape. Magnolia blossoms perfumed the air.

After collecting their luggage, the two were free to explore. More important than anything Ginter may have brought with him, whether he knew it or not, were his intellect, artistic eye and burning desire for success.

The pair were met with a simpler, more tranquil scene than that of today. On Richmond's grid of streets were the occasional horse and carriage,

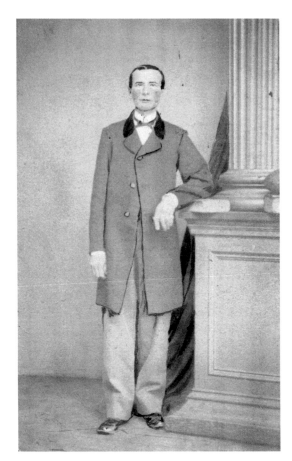

John C. Shafer, the man who brought Lewis Ginter to Richmond. *Photo by E.J. Rees & Co., Richmond. Valentine Richmond History Center.*

and most of the streets had no paving. A languid town of only twenty-two thousand people, Richmond was a refreshing change from the mad, hectic Northern metropolis that Ginter and Shafer left behind.

But this one-hundred-year-old city had a liveliness all its own. It was centered on the gleaming Capitol Building, which stood in stately grandeur on the brow of Shockoe Hill. On the Capitol's southern side was a handsome portico with towering Roman columns overlooking the river and the city. It was undeniably the pride of Richmond.

Thomas Jefferson designed the edifice in 1785, based on an ancient Roman temple in Nimes, France, the Maison Carree. So moved by the classic, columned building at first sight, he had positively "fallen in love." Using it as inspiration for the Capitol Building was part of his campaign "to improve the taste of my countrymen, to increase their reputation, to reconcile to them the respect to the world, and procure them its praise."

Soon, Lewis Ginter would positively idolize this architect, philosopher and statesman named Thomas Jefferson—that is, if he didn't already.

By the time Ginter and his friend arrived in Richmond, Jefferson's influence was already spreading throughout the city. Greek Revival houses

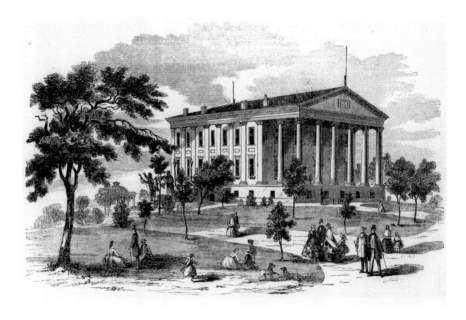

The Capitol, designed by Thomas Jefferson. Ginter would come to idolize the statesman and arts lover. *Library of Virginia.*

built in the early 1800s were simple but dignified, frequently occupying a quarter of a square. Predominantly brick or stucco, they featured classic details like columned porticos or porches and cornices with heavy brackets or dentil molding. Scattered throughout the city were numerous churches in Greek Temple style with their steeples towering above the cityscape.

Ginter and Shafer couldn't help but be enchanted by the city, situated as it was along the curving bank of the James River. It was as pretty as a picture. With the river flowing over granite ledges amid waving hills and valleys, it was as if Mother Nature had said, *There shall be a city there.*

Richmond also had a rich history, and history can have a beauty all its own for men like Lewis Ginter. In the early eighteenth century, the land was owned by Colonel William Byrd II. He first conceived the plan of laying out his lands for a town, which he did in 1733, and Richmond was established as a town by the General Assembly of Virginia in May 1742.

Richmond held the distinction of being center stage in laying the foundation for American democracy. It was in Richmond that Patrick Henry delivered his eloquent "Give me liberty or give me death" speech at St. John's Church in 1775. Richmond was where the U.S. Constitution was ratified, and it was also where Thomas Jefferson wrote the Virginia Statute for Religious Freedom in 1779. Ginter's generation revered their Revolutionary forebears.

The city's business quarter was on Main Street, with a hodgepodge of shops, banks, residences, hotels, carriage factories and sawmills. On the north side of Main, between Sixth and Seventh Streets, stood a large and hospitable-looking boardinghouse called the Edgemont. Ginter and Shafer couldn't afford such luxury, however, and found a room to share in the residence of a nice gentleman named John F. Alvey.

Soon after Ginter and his friend arrived in Richmond, they knew deep down inside—this was home. Like many businessmen and capitalists who came before them, they could see the city's economic advantages. In the way of manufacturing, the James River and Kanawha Canal connected the city to the outlying countryside rich in mineral resources, as well as farmland producing immense quantities of tobacco, wheat and corn, all ripe for trade. And the river's unlimited waterpower made the city well suited for milling, as seen by Richmond's flour, cotton and paper mills.

When Ginter first settled in the quaint city, he took a job as a clerk in a hardware store. But with a keen intelligence and unbridled ambition, he was looking onward and upward.

AN APPETITE FOR SUCCESS

Each night at closing time, the table was empty.[2]

Shortly after that special day when young Lewis Ginter dazzled the crowd at his toy store with his miniature circus, things began looking up for him through the kindness of a fellow Richmonder. Known simply as Mrs. Clopton, she was the wife of prominent Judge John Bacon Clopton. In those days, Richmond's churches each held a fancy fair during the winter in the courtroom of the city hall at Broad and Eleventh Streets, and Mrs. Clopton was the keeper of the "post office" at the fairs. She'd heard about the poor, friendless, young shopkeeper, so—with that renowned Richmond hospitality—she offered to add a toy table to the fair.

Every day, young Ginter would bring his toys and arrange them artistically on the beautifully decorated table, all ready for the fair attendants. Each toy was ticketed at a price that would give the fair, as well as himself, a fair profit. Each night at closing time, the table was empty.

The fair organizers also fashioned an exhibit of mechanical toys, with the tiny booth staffed by a group of little girls. The exhibition money went to the fair, and the toy was raffled off at closing time for the benefit of young Ginter. It was here at these festive fairs that Richmonders became acquainted with Ginter's shop. Before winter's end, business was brisk and prosperous in the little toyshop on Main Street with "Lewis Ginter" over the door.[3]

A scrupulous entrepreneur from the start, Ginter was focused on building up his business. With a "retiring" personality, he "cared little for gaiety, nothing for what was known as society life,"[4] so most Richmonders knew very little about him. To widen the appeal of his store, Ginter decided to add "notions" to his shelves—an assortment of small products like needles, buttons and thread.

With good instincts in business and an eye for beauty, Ginter fine-tuned his approach again, offering the very things sought after by Richmond's cultivated society.

By 1845, about three years after young Lewis Ginter first arrived in Richmond, he had accumulated enough capital to branch out into the house furnishing business. His shop was on the south side of Main Street, near Fifteenth. It was called the Variety Store.

The neat and pretty shop dealt in fancy goods, jewelry, clocks, woodenware, fanciful combs and brushes and the like. With a knack for attractive merchandising, Ginter "displayed in an imminent degree that exquisite taste and love of the beautiful in the number, variety, and arrangement of the pretty things he collected and exhibited for sale," said a newspaper of his day.[5]

He had more experience in this game than his young, innocent face suggested. While growing up in New York, he had sought work at a young age, and his artistic sensibilities led him to stores where fancy articles and art fabrics were for sale. At the tender age of nineteen, he'd taken his first trip to Europe from Richmond to purchase clocks and other fine merchandise. This was at a time when steamships like the RMS *Britannia*, with their paddle wheels, took a full three weeks to make the crossing.

Another one of Ginter's priceless qualities was his off-the-charts energy level, both physically and mentally. The most focused of workers, he seemed to be "restless and dissatisfied unless engaged in some active work."[6] Just in his early twenties, it was clear: this man was going somewhere.

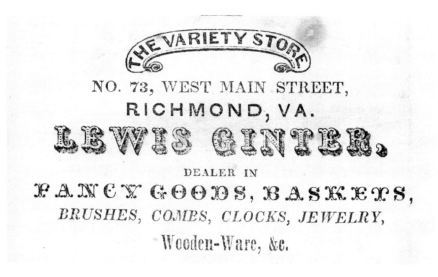

Ad for Ginter's store in the 1845–46 city directory. *Valentine Richmond History Center.*

Entering Richmond Society

*Little excuse was needed to bring people together where every one was
social, and where the great honor was to be the host.*[7]

By the mid-1840s, Lewis Ginter finally began diverting some of his energy
to Richmond social life. Reportedly, "his rare good taste and fine eye for the
artistic were much admired by all with whom he associated after his settling
here, and men of literary taste courted his companionship."[8]

One such man was the witty, cultured gentleman and native Richmonder
John R. Thompson. Small in stature and with a "delicate appearance," one
of his friends said he was "extremely nice in his dress and careful of his
personal appearance." With wavy, chestnut hair and expressive blue eyes, he
sometimes quipped idioms in Latin. A pleasant conversationalist with a low,
brisk voice and a delightful manner, he was "essentially a gentleman with the
most refined tastes." The classic dandy.[9]

Thompson had begun his career as a lawyer. But with a true calling for
literature, he became editor of the *Southern Literary Messenger* in 1847. The
magazine had started up thirteen years earlier, featuring poetry, fiction,
nonfiction, reviews and Virginia historical notes. The now-famous Edgar
Allan Poe served as editor from December 1835 to January 1837, and his
brilliance gave it a national reputation.

Predating the *Atlantic Monthly* and *Harper's Magazine*, the *Messenger* went
a long way in awakening a literary culture in the South—and turning it
into a tradition. During the 1840s, the offices of the *Messenger* were located
at the southeast corner of Main and Fifteenth, just seven doors up from
Ginter's new shop. Thompson and Ginter were intimate friends, perhaps
giving Ginter one of his earliest introductions to the ways of cultured society.

Traveling in the same circles was the highly intelligent Moses Hoge (like
vogue, beginning with an H). He was a tall, thin man with a dark brow.
Coming from a long line of preachers, he arrived in Richmond in 1844 and
went to work as assistant pastor at First Presbyterian Church. Even before
leaving divinity school, he had become a brilliant and powerful orator.

Just a year after coming to Richmond, Moses Hoge already had his own
congregation, meeting in a "lecture room" on Fifth Street near Main. Before
long, he built a church next door, Second Presbyterian. Despite Richmond's
growing appetite for Greek Revival architecture, he was "tired of Grecian

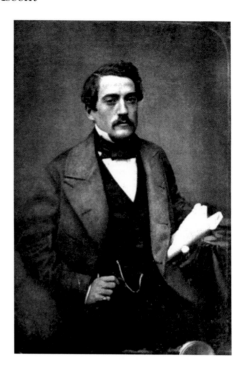

John R. Thompson, circa 1847, the year he became editor of the *Southern Literary Messenger. From* Poems of John R. Thompson.

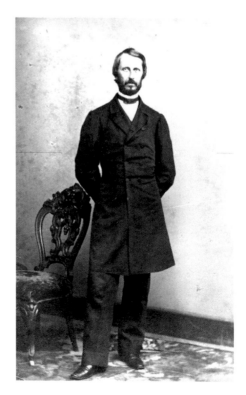

Reverend Moses D. Hoge, circa 1848. He would rise to supreme eminence. *Virginia Historical Society.*

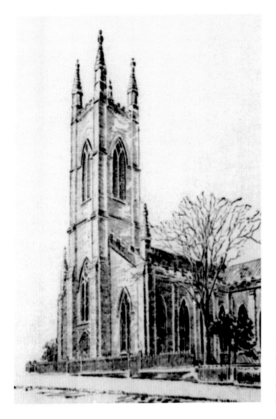

Reverend Hoge was "tired of Grecian temples with spires on them," so he built Richmond's first Gothic church.
From Richmond Dispatch.

temples with spires on them," so he created the first Gothic church in the city. It boasted tall Gothic doors, diamond-paned windows and a square bell tower adorned with four stone spires. Reverend Hoge's tower rose 120 feet above Fifth Street—fitting for the man who would become the most prominent divine in the city.

Inside the church and out, Reverend Hoge was intense, with a fire burning just below the surface. From the pulpit, his voice ranged from "aeolian to thunder" and could shake the church's rafters.[10] He was also well versed in literature, which provided fodder for his sermons.

Lewis Ginter had found his niche. Among learned men like Thompson and Hoge, as well as the Richmond physician and lover of literature Dr. William P. Palmer, Ginter was regarded as a man of "strong intellectuality."[11] With his in-born sociability now in full bloom, he was "genial" and modest but never stuffy or pompous—easily making his way into the circle of Richmond's most prominent, cultured gentlemen.

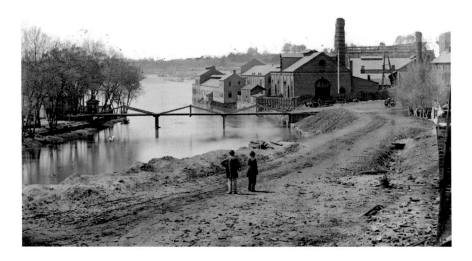

The Tredegar Iron Works, along the canal. *Library of Congress.*

Among them was the handsome and ambitious Joseph Anderson, a dark-haired graduate of West Point. Compared to Ginter, he was ten years older and about six inches taller. Having grown up poor, Anderson hungered for material success and became commercial agent for the Tredegar Iron Company in 1841. Harnessing canal and river power, the Tredegar was an iron foundry located along the banks of the James. As Anderson came aboard, the company was in dire financial straits. But soon thereafter, hoping to get contracts to build iron steamers for the government, his business prowess was already showing. He went straight to the White House, made his case to President Tyler and then lobbied other iron men to campaign on his behalf. He was soon awarded the contract for the revenue cutter *Polk*.

Anderson quickly turned the struggling company around by obtaining contracts with the federal government to manufacture cannon and other supplies for the army and navy, proving him as tough as the iron he forged. By day, the Tredegar's furnaces blackened the Richmond sky. In 1848, Anderson purchased the Tredegar and assumed control over all phases of the work. The company was headed for high renown under his shrewd leadership and firm hand.

While Joseph Anderson, Reverend Hoge and John C. Shafer were married, the literary John R. Thompson was often found with "ladies and

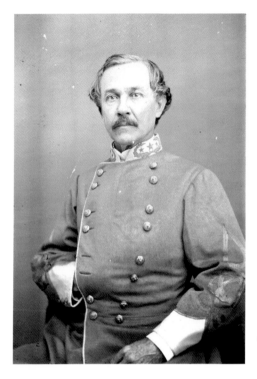

Joseph Anderson, 1865. His life was interwoven with that of Lewis Ginter. *Library of Congress.*

cultivated persons generally."[12] Lewis Ginter, in this male-dominated society, preferred the company of other gentlemen.

It didn't matter that Ginter and his friends all had different backgrounds and careers. They were all ambitious, intelligent and passionate about doing the right thing. Besides, Richmond society was interwoven, sticking together through thick and thin.

While the city was fast becoming the cultural heart of the South, Ginter and his cohorts basked in its art, architecture, music and literature. That didn't pose a threat to their masculinity, even for iron man Joseph Anderson. Refined gentlemen were the ideal of antebellum Richmond society—an ideal largely defined by Thomas Jefferson.

In fact, with the possible exception of Shafer, Lewis Ginter and his friends would become central to Richmond and its defining moments.

By the late 1840s, Ginter's fancy goods store near Fifteenth Street was flourishing. Things were falling into place. By 1851, he had moved to a larger store at the handsome Eagle Square, between Twelfth and Thirteenth Streets. Eagle Square took its name from the Eagle Tavern, built on the site in 1787. Around 1808, Thomas Jefferson was fêted there with a dinner and ball. The Eagle burned in 1839, but the corner would still be called Eagle Square for decades.

There, where his idol once stood, Ginter built up a lively trade. Dignified and businesslike, he was a familiar figure in that part of the business quarter. "From early in the morning until after sunset, and sometimes until late at night, the ambitious and thrifty youth could be seen at his place of business, looking over his accounts, or helping to arrange articles on the shelves of the store," said a Richmond paper.[13]

Meanwhile, tobacco dominated the city's commerce and was an inescapable element of its culture. In his antebellum book *Richmond in By-Gone Days*, Samuel Mordecai quipped, "Tobacco is in the mouth of every man and boy, either for mastication, fumigation, inhalation or discussion."[14] When tobacco manufacturing was at peak season in Richmond, the pungent, sweet aroma of the leaf filled the city.

Back then, tobacco had a much different aura. Mordecai called it a "universal medium of introduction" among smokers. It was an icebreaker—a means of forging new friendships. During this same period, the English politician, poet and novelist Edward Bulwer-Lytton even wrote, "The man who smokes, thinks like a sage, and acts like a Samaritan." Gentlemen chose between chewing tobacco, snuff, pipes or cigars. As Ginter "blew a cloud" with his own cigar, he had no clue that a different form of tobacco consumption would someday arrive—and with his name on it.

Like most of the antebellum South, Richmond was bursting with formal festivity—large parties, teas, dinners, dances, foxhunts and weddings. Lewis Ginter was at the center of it all. This liveliness was set against the gracious, Neoclassical architecture that became ever popular in Richmond throughout the 1840s. Thomas Jefferson's influence had become more evident than ever in the city, a fact certainly not lost on Ginter.

In April 1847, a public dinner was tendered in honor of "the great statesman" Daniel Webster. The gala took place at the classically styled Exchange Hotel at Fourteenth and Franklin Streets, the lobby of which had a marble floor with black and white diamonds and brass gas lamps hanging

from the ceiling. As part of the evening's pomp and circumstance, Reverend Hoge invoked the blessing, and John R. Thompson—the poet laureate of Richmond—read a song. This was just the sort of event found on Lewis Ginter's busy social agenda.

As for Richmond theater, it provided the makings of a gay evening on the town for Ginter and his fellow arts lovers. The ringleader was probably Thompson, since he knew Richmond intimately and because the atmosphere of society was his oxygen.

Beginning in the early 1840s, the city's theaters presented stars of the European and American stage, and Virginians came in droves by train or carriage to see dramas, tragedies, comedies, pantomimes, operas and minstrel shows. Richmond had three performance halls, but the finest by far was the Marshall Theater at Broad and Seventh Streets. Remodeled in 1838 with a "pure classical character," it was decorated with burnished gold, crimson and damask and was said to rival the celebrated New Orleans Caldwell.[15]

One of the first-rate actors to come to the Marshall was the lovable Joe Jefferson. In 1857, he played Rip Van Winkle and other roles. Two years later, a sensational comedic play called *Our American Cousin* came to the city. One of the actors was a man named John Wilkes Booth.

Around the same time, Odd Fellows Hall staged an unforgettable act: *Singing Sisters in Bloomer Costume*. Richmond's musical productions were in their heyday. Jenny Lind—or the "Swedish Nightingale," as she was dubbed by show business master P.T. Barnum—created an absolute sensation when she performed in Richmond in the winter of 1850. A critic in the audience that night described her voice as "exquisitely soft, like the music of pearls in a golden basin." (Her performance even inspired a flowery poem by John R. Thompson.) Several years later, the Italian opera diva Adelina Patti—considered the greatest vocalist ever—performed at the Marshall.

Yet with all of these many grand social virtues permeating Richmond life, the South was blighted by slavery. Southern society was grounded in it. Richmond's main slave-trading area was in the commercial district on Main Street. In fact, many slave auctions took place at the St. Charles Hotel, mere feet from Ginter's store. Slaves were just about everywhere one looked.

Having come from the North, where slavery had been abolished for half a century, we can only imagine how Ginter was struck by the Southern institution. But in the South's political atmosphere of the 1850s, you

couldn't publicly voice your distaste for slavery even if you wanted to. You could be censured.[16] Slavery caused deep divisions between the North and South—but life went on.

In 1848, Edgar Allan Poe, the former editor of the *Southern Literary Messenger*, came to the city for a brief time. Having spent much of his childhood in the city, he reunited with many old friends. Then, the following summer, he returned—with newfound fame—for an auspicious event at the venerable Exchange Hotel. On August 17, 1849, after being welcomed with uproarious applause, he read from "The Raven." Poe left Richmond on September 27, 1849, and within two weeks he was dead. This news was unsettling to Ginter, to say the least—Poe was one of his favorite authors, and Ginter had known him personally.[17]

Even more disconcerting in the 1840s were the bitter politics between the Whig Party and the Democrats. During this time, the Democratic Party defined itself according to Thomas Jefferson's ideals. Jefferson was a strong defender of states' rights and believed in the limitation of federal powers. He believed that individuals have "certain inalienable rights"—liberties that government can't take away. He even advocated restraining government with rebellion and violence, if necessary, to protect individual freedoms. Those ideals would soon be put to the test.

Lewis Ginter adopted Jefferson's political views to the letter. He was "an uncompromising Democrat, and asserted his Democracy when it meant almost social ostracism," said one newspaper, since the party was composed, for the most part, of "men in the lower walks of life." The vast majority of Richmonders were Whigs at the time. Among Ginter's fellow Democrats were Reverend Hoge and Thomas Ritchie, the editor of the *Richmond Enquirer.*[18]

In the early 1850s, Ginter moved into the prestigious and fashionable five-story American Hotel at the southwest corner of Main and Eleventh Streets in the commercial district. It was praised for its "excellent table, attentive servants, pleasant, richly-furnished rooms, and obliging assistants."[19] This conjures up a picture of Ginter and his gentlemen friends being served in the hotel's stylish dining room—replete with shining silver and porcelain—and discussing the politics and literature of the day.

While Lewis Ginter's place at the hotel was handsomely furnished, he couldn't bear untidiness. This perfectionism and attention to detail—perhaps to the point of obsessive-compulsiveness—served him well in business.

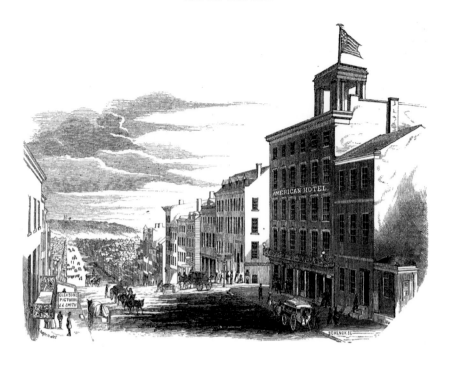

Engraving of Main Street, 1853, about the time Ginter took up residence at the stylish American Hotel. *VCU Libraries.*

With a sheer joy for entertaining, Ginter indulged in it liberally. He "gathered his intimate friends about him and spent his evenings in a quiet and charmingly social way," said one Richmond paper.[20] In the relaxed company of his close friends, Ginter was at his best. Dignified but sincere, he had a gentlemanly spark of wit and a "bright, cheerful spirit."[21] He exemplified Old South gentility by virtue of his social graces, intelligence, appreciation of art and hospitality.

But hospitality wasn't just a Ginter tradition, it was a Virginia tradition. Ever since colonial times, Virginians had "entertained with a lavishness and cordiality which established the custom of hospitality with the authority of a law."[22] It was one's duty. Richmond's fashionable society was one big circle, so "a fashionable party was a full house."[23]

Following suit, Ginter opened his home to his intimate friends like John R. Thompson, Reverend Hoge and Joseph Anderson, as well as countless friends and acquaintances throughout the city. The gentlemen exchanged pleasantries, smoked their cigars and engaged in stimulating conversation.

The 1850s were eventful for Thompson. The offices of the *Messenger* moved to the Athenaeum building at Tenth and Marshall Streets. In 1853, one of his guests was William Makepeace Thackeray, who spoke at the Athenaeum as part of an American lecture tour. In July 1854, Thompson went to Europe on hiatus. Delighting in travel, he kept company with Thackeray and other leading men of letters in England and Europe, including Thomas Carlyle and Alfred Lord Tennyson. In January 1855, Thompson returned to his beloved hometown and the *Messenger*, drawing around him the best literary talent of the South.

While his magazine had become a medium for Southern sentiment, he chose to prevent it from becoming partisan in a way that would further divide the Union. At least that was his intention. Thompson wrote prose and poetry as well, and his poetical writings were "finished with care, and displaying a delicate sentiment."[24] He also gave lectures, such as "The Life and Genius of Edgar A. Poe," in many Southern cities. Unfortunately for Thompson, editors such as he were poorly paid at the time.

During the 1850s, while Virginia's industrial development was catching the nation's eye, Joseph Anderson's Tredegar Iron Company was manufacturing all kinds of iron and steel implements and machinery, including railroad locomotives. In fact, many of the locomotives rumbling along the state's rails had been manufactured at his plant.

By 1852, with newfound wealth, Anderson and his large family purchased a Greek Revival residence at 113 East Franklin Street. It was one of the few Richmond mansions built in the style of the Greek temple, with a two-story columned portico on the front. Called "a happy combination of dignity and homelike intimacy,"[25] it became a social center of Richmond. While Ginter was being graciously entertained in its Victorian-style parlors, he had no idea that the home held a big secret for his later years.

Joseph Anderson was civic-minded and even had a political career. He was on the Richmond City Council for many years and was elected to a vacant seat in the Virginia House of Delegates in 1852. He was reelected the following year.

Anderson was a powerful figure in Richmond and, like Ginter, was a brilliant, ambitious and tireless entrepreneur. But while Ginter had found prosperity on his own merits, Anderson had innovated the use of slaves for skilled industrial labor at the Tredegar. In the early 1850s, he employed as many as one hundred slaves, providing them with food, housing and medical

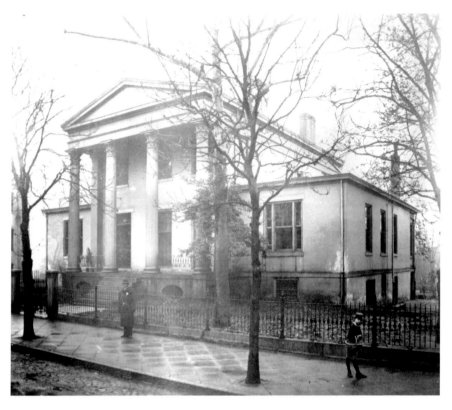

The home of Joseph R. Anderson, which would play an auspicious role in Ginter's future. *Cook Collection, Valentine Richmond History Center.*

care. It was his way of improving his bottom line. Tragically, since slaves were considered property in the South, it didn't raise eyebrows among Richmond's white folk when Anderson publicly argued that any threats to his slaveholdings were "pregnant with [abolition] evils."[26]

Another one of Ginter's acquaintances, Philip Whitlock, happened to stumble upon a slave auction in Richmond one day. It deeply offended his sense of humanity, and he never went back.[27]

By the early 1850s, Reverend Hoge had a solid following at Second Presbyterian. Typical of the times, the pastor and his large family had domestic slaves at their home at Fifth and Franklin. Apparently, they were inherited.

John C. Shafer, the man with whom Ginter had come to Richmond, was "a man of quiet and domestic habits"[28] and sewed for a living. His upscale

merchant tailor business, located under the Exchange Hotel and manned by a team of male seamsters, was quite successful. With clothing not yet mass-produced by assembly-line machinery, Shafer's shop made "gentlemen's fashionable garments" like formal jackets, shirts and pantaloons. It also offered "Paris and European Fashions."

Ginter would have patronized Shafer's establishment out of loyalty, if not for his fine handiwork. It's not difficult to picture Ginter standing in front of a full-length mirror being measured for a suit that would reflect his "unobtrusive" taste.

By this time, Ginter could have afforded the best suits from Paris, but he insisted on spending his money in his adopted city. He had actually been in Paris in 1848 on the night of the revolution, when Louis Philippe was dethroned and France declared free. Ginter said things were quite stormy that night.[29]

On that particular trip to Paris, Ginter borrowed a scene directly from Thomas Jefferson's life. While serving as U.S. minister to France, Jefferson was in Paris in July 1789, when the French people rose up against their rulers and the first blood was shed in *that* French revolution.

The uprising aside, Jefferson relished exploring the city's architectural sites and its bounty of fine arts; he was one of America's first connoisseurs of the arts. Ginter had cultivated very similar interests, such as touring the Château de Maisons along the Seine perhaps—a stately and awe-inspiring sight.

In the 1850s, a long economic recession had recently ended, and Lewis Ginter was prospering. Country merchants were now getting their goods from urban Virginia merchants such as he rather than making the arduous and costly trip to a Northern city. Richmond's dry goods establishments were able to reduce their prices because of improved transportation networks—with help from Joseph Anderson's rails and locomotives—which facilitated the transport of goods from Richmond to those merchants.

In April 1851, placing a classified ad in the *Richmond Whig and Public Advertiser*, Ginter addressed country merchants. (Classified ads were a primary medium of advertising those days.) He invited them to come into his larger establishment, since he had "now in store the most complete stock of Fancy Goods in the State, and purchasers are assured of buying at Northern prices."[30] The ad was a wise investment. At Ginter's store in Eagle Square, he did a very large retail business until about 1854, when he sold out to take on his newest challenge.

And as Richmond society sang the praises of success, wealth and entrepreneurial spirit, Ginter's move had the potential to elevate him into the ranks of Richmond's wealthy elite.

OFFERING A RICH DISPLAY OF FANCY GOODS

*By that Herculean labor which brings the golden apples from the garden
of Herperides, he brought himself steadily up to the front lines of
eminence as a merchant.*[31]

In 1854 or 1855, as the city of Richmond kept notching upward as a manufacturing center, Lewis Ginter started up a wholesale notions and fancy goods business. He partnered with John F. Alvey, the same man with whom he had boarded when first coming to Richmond.

The pair opened a store called Ginter & Alvey at 16 Pearl Street (now South Fourteenth) between Main and Cary. Their neatly arranged shelves displayed fine hosiery, gloves, handkerchiefs, cravats, embroideries, sewing silk and a whole assortment of ornamental goods. Antebellum Richmond society had a propensity to devour such delicacies, and the firm "came to be looked upon in mercantile circles as a reliable and solid wholesale concern."[32]

LEWIS GINTER. **JOHN F. ALVEY.**

FANCY DRY GOODS.

GINTER & ALVEY,

NO. 16 PEARL STREET,

RICHMOND,

Importers and Dealers in

HOSIERY, GLOVES, HANDKERCHIEFS, CRAVATS, EMBROIDERIES,

Trimmings, Sewing Silk, Buttons, Combs, Thread and Fancy Goods.

An 1855 ad for Ginter's fancy goods store on Pearl Street, now Fourteenth. *From* Statistical Gazetteer of the State of Virginia.

Although Ginter & Alvey dealt with a number of well-known retail houses in Richmond, most of its trade was conducted with village and country merchants. Many of these merchants came from the backwoods and purchased their goods to cater to a rural people. They sometimes spent several days looking over the store and selecting their spring or fall stocks. "Frequently a stream of buyers could be seen in and out of the well-known wholesale establishment of Ginter & Alvey," said a Richmond newspaper, "and the firm had one of the most extensive trades of any similar concern in the South."[33]

Pearl was a bustling, vibrant commercial street by mid-nineteenth-century standards. Very near Ginter & Alvey were a stationer, a saddle maker, a wholesale grocer, a hardware dealer and a fancy goods store featuring china and glassware. Just a block and a half north was the classic Exchange Hotel, in which Shafer was running his merchant tailor business. A public clock struck the hours at the intersection of Pearl and Main Streets.

Lewis Ginter's life took a turn in January 1855, when his beloved sister Jane was met with tragedy in New York. Her husband, cedar barrel maker Stephen Arents, died. Suddenly, Jane was a widow with five children—George, Frederick, Joanna, Minnie and the youngest, Grace Arents. (An eerie coincidence: Thomas Jefferson's eldest sister was also named Jane.) Because Jane had selflessly raised Lewis, he graciously took her and her children under his wing in Richmond. They all moved close by—perhaps right into his building at the American Hotel. As if Lewis had created a complete family overnight, he treated his sister's children as his own from then forward.

But that didn't get in the way of the roaring success of Ginter & Alvey. Just a short time after forming, it already needed larger quarters. Fortunately, the perfect place became available at the southeast corner of Thirteenth and Main Streets in the heart of the commercial district, so Ginter moved his store there around 1856. Within a block on Main were the offices of the *Richmond Dispatch* and the *Richmond Enquirer*, two banks, a bookbinder, a retail clothier and an apothecary.

Then, in the fall of 1857, came a great financial panic in the States. Lewis Ginter was so alert to factors affecting the markets that he predicted the panic sometime earlier to one of his closest friends. His friend didn't agree, but Ginter acted on his convictions nonetheless. He purchased seven horses and buggies and sent out collectors over a period of several months to collect what they could among the village and country merchants near Richmond.

The men collected a great many of the accounts, and Ginter set the money aside, just in case.

The crash came as predicted, but Ginter's business weathered it with ease. A Richmond newspaper even said that he "had plenty of money on hand to conduct his business upon a liberal basis, in addition to snug sums which he loaned to many of his friends and customers" during the ensuing depression.

Lewis Ginter had an eagle eye for the markets as well as the bottom line and—fortunately for him—was developing rare talents in the marketplace.

A MARKETING VIRTUOSO FINDS WEALTH

He was probably the first man in the South to raise the cry
against the middleman.[34]

In 1857 or 1858, with the population of Richmond having doubled since Ginter first arrived in the city, his firm ushered in a new partner: Mr. James Kent, formerly of the dry goods firm of Kent, Paine & Kent. Ginter and his partners changed the name of their firm to Ginter, Kent & Alvey and added linens and Saxony woolens to their stock. Ginter decided to buy this refined medley directly from factories in Ireland and the Saxony region of Germany, making him the pioneer in Richmond of the direct importation of European goods.[35] This meant that he was personally selecting the finest goods possible, his ideal of all ideals. "The firm built up a reputation far and wide for its reliability," reported the *Times*.[36]

These buying trips gave Ginter the opportunity of travel throughout Great Britain and Europe. With every sailing across the Atlantic, he broadened his appreciation for the arts, and his tastes became ever more cultivated and refined. His artistic taste, combined with his fine judgment, was certainly critical to the steady prosperity of Ginter, Kent & Alvey. When purchasing goods, his selections were carefully made after a diligent study of the public needs and the prevailing fashions.

A major reason Ginter's store attracted attention was because he was providing an extra flourish. He repackaged his European linens in lovely boxes and wrappings of his own design. It worked like a charm.

While in business with Kent and Alvey, Ginter hired his nephew George Arents to help in the store. An energetic, ambitious and diligent young man,

Lewis Ginter.
From Richmond Dispatch.

he often worked into the evening hours. When Mr. Kent retired from the firm around 1859, George Arents was admitted to partnership in the firm of Ginter, Alvey & Arents. Before long, Ginter, Alvey & Arents became "the largest dry-goods and notions-house south of Philadelphia, and the business was one of the largest in the city."[37]

Now, Ginter was importing practically his entire stock. Like the majority of Richmond merchants, he had stopped buying from the North whenever possible—even though that was his native land. Among the goods carried by Ginter, Alvey & Arents were clocks, jewelry and silverware and fancy goods like cigar cases, ladies' fans and perfumery. There were other niceties like cloaks, corsets, men's and women's hosiery and linen cambric handkerchiefs, as well as the finest silk and linen fabrics. Another item Ginter sold was the omnipresent article of the day: the hoop skirt. Ladies throughout antebellum Richmond and the surrounding villages were strolling the avenues and attending formal events dressed in his fashion-forward finery.

One such event took place in Richmond on February 22, 1858, the day the equestrian statue of George Washington was dedicated on Capitol Square. The celebration began with an elaborate, exuberant parade starting on Main Street—as all of them did those days—and marched right past

Ginter's store to the Capitol. At the unveiling ceremony, Governor Wise spoke, and he then introduced John R. Thompson, who read his original poem "The Opening Ode." In his last line of rhyme, he called Washington "the foremost man of time."[38]

Next came the orator of the event, United States senator from Virginia R.M.T. Hunter, whose powerful dedication to the father of our country sparked near-deafening applause. As the statue was unveiled, a cannon boomed in salute.

The monument was designed not just to honor Washington but to glorify Virginia's contributions to independence as well. In fact, one of the statues surrounding Washington was that of Thomas Jefferson—so Lewis Ginter wouldn't have missed this celebration for the world.

TENSIONS BETWEEN NORTH AND SOUTH

Politics took the place of honor among the gentlemen.[39]

At the very time that Ginter's career was in full blush, relations between the industrial North and the agrarian South got nastier than ever. The bitterness was keenly felt in the capital city of Richmond, with much of it revolving around the slavery question. While the South was on the wrong side of history on that issue, the bitterness was largely due to the exchange of highly inflammatory rhetoric on both sides.

A huge war of words erupted in 1852, when Harriet Beecher Stowe published the antislavery book *Uncle Tom's Cabin*. Many whites in the South asserted that it was an inaccurate portrayal of plantation life and an insult to Southern honor.

By now, John R. Thompson promised to use the *Messenger* to "repel assaults upon the South," so he composed an epigram that reflected the high-society South's reaction to the book:

When latin I studied, my Ainsworth in hand,
I answered my teacher that sto meant to stand.
But if asked I should now give another reply,
For Stowe means, beyond any cavil, a lie.[40]

Because of the magazine's large Southern audience, Thompson's words only added fuel to the fire.

Lewis Ginter, at the very least, saw *Uncle Tom's Cabin* as an unjust assault on two of his gentlemen friends, John A. Selden of Westover Plantation and Hill Carter of Shirley Plantation. Ginter had been a guest at Selden's Westover, situated along the banks of the James River twenty-eight miles east of Richmond, where wheat was grown with slave labor. His English manor–style mansion, considered one of the most beautiful homes in America, had been built around 1730 by the colonial elite, William Byrd II, on the twenty-six-thousand-acre tobacco plantation he'd inherited from his father. Ginter celebrated at least one Christmas holiday during the 1850s at Westover, providing him a window into the life of Richmond's famous forefather.[41]

Undoubtedly, Ginter had visited Hill Carter's Shirley Plantation as well. It was Robert E. Lee's ancestral home, and Lee was Hill Carter's first cousin. Ginter knew Lee, an officer in the U.S. Army, probably through his connection to Hill Carter.

But it wasn't just plantation owners who were facing a barrage of verbal attacks from the North. Angering Southern gentlemen like Ginter and his contemporaries, they developed a burning desire to defend their honor. Honor and duty were very important to men of the Old South. If there was anything Ginter had striven for—and earned—it was honor and respect. Duty had been a dominant theme in Thomas Jefferson's life, and the word is emblazoned throughout his writings.

By the time *Uncle Tom's Cabin* made its debut in the bookstores, the Northern-born Ginter had undergone a profound transformation. He had entered manhood in the South and been immersed in its culture for more than ten years, during which he forged a successful career and hundreds of personal ties. He was now completely, undeniably and unshakably Southern.

In 1854 came yet another trigger in the sectional divide, when Congress passed the Kansas-Nebraska Act. It was intended as a compromise on the slavery issue, but it ended up sparking violence and bloodshed in Kansas. Things even got violent on the floor of the U.S. Senate in May 1856 over a fiery speech about slavery.

Richmond's ministers got together to address the escalating crisis. They called on Christians to renounce lawlessness and violence, designating the Sunday before July Fourth as a day of prayer. Appealing for justice, harmony

and peace, their petition was signed by twenty-one ministers, including Reverend Hoge. Unfortunately, few took heed of it.

As the sectional bitterness heated up more and more throughout the 1850s, many Southerners intensified their calls for Southern independence—a movement long in the making. The Richmond press heralded the Tredegar Iron Works as a beacon in Southern independence, since Joseph Anderson was marketing his iron mainly in the South.

On March 7, 1857, the Supreme Court handed down its momentous ruling in the Dred Scott case—Congress could not prohibit slavery in U.S. territories. While the decision appeased the South, it infuriated the North.

Then, on October 16, 1859—as if the fates were trying to even the score—an event shook the entire South to its very roots: John Brown's raid at Harpers Ferry. John Brown was an extreme abolitionist who led a group of twenty-one men in a raid on the arsenal at Harpers Ferry in Virginia (now in West Virginia). He hoped to use the weapons to lead a slave uprising across the entire South.

Local citizens and militia responded quickly, gave chase to Brown and the others and forced them to take refuge in the engine house next to the armory. Then, U.S. Army lieutenant colonel Robert E. Lee led a counteroffensive and captured the men. Lee had just stepped into the spotlight. Brown was convicted of treason against the Commonwealth of Virginia and sentenced to hanging.

While Richmond's newspaper articles about the raid at Harpers Ferry dramatically escalated tensions and fears, the editors also made direct appeals to consumers. On November 29, 1859, the *Richmond Dispatch* implored that Virginians "not send another dollar's worth to the North for anything they can make themselves, or obtain anywhere else...This is the way, and now is the time, to strike a blow for the real independence and security of Virginia—NOW OR NEVER!"[42]

1860: PEAK PROSPERITY, CLIFF'S EDGE

We were prosperous beyond measure.[43]

Shortly after the raid at Harpers Ferry, Richmond merchants took matters into their own hands. They organized to address the challenges they faced from "hostile movements" in the North. Then, in January, scores

of merchants—including Lewis Ginter and Joseph Anderson—formally petitioned the General Assembly of Virginia to assist in making "commerce and manufactures of Virginia independent."

They insisted that Virginia, among other Southern states, was being subjected to "the despotism of a sectional majority, thus substituting the first principles of constitutional liberty by mere license, degrading these states from the position of equals to the condition of dependents." Among their requests was help with their long-held aspiration—establishing a commercial shipping line devoted solely to Virginia trade.[44]

Gaining support from the Virginia legislature, the Richmond and Liverpool Packet Line was established, and in 1860, the concern had a beautiful ship built in Baltimore. Christened *Virginia Dare*, the 160-foot-long steamship arrived at the port of Richmond on December 2. There was much fanfare the next day, as Richmond citizens gathered at the port to marvel at it. With a hold twenty-two feet deep, the ship was estimated to carry 1,100 hogsheads of tobacco. (A hogshead is a wooden cask that, when filled with tobacco, weighs about 1,000 pounds.)

In that day's edition of the *Richmond Dispatch*, the editor wrote, "The secession movement continues to be the great theme of discussion and comment throughout the country."[45]

Despite the heaviness in the air, the comedian Joe Jefferson was in town that week. Richmond's elite got dressed up in their finest duds and headed to the Marshall Theatre to catch him in the amusing show *The Lady of the Lions*, in which he was playing the role of "Clod Meddlenot." Richmonders weren't about to let the impending doom get in the way of their merrymaking.

By this point, because of Lewis Ginter's business success—not to mention his social and civic life—he was well established as one of Richmond's elite. Joseph Anderson had risen to the top of that list as one of the leading industrialists in the entire South. The Tredegar Iron Works was one of the largest in the entire country.

But John R. Thompson was barely scraping out a living. In May 1860, with other family members relying on his support, he resigned his editorship of the *Messenger* and accepted a higher-paying position in Augusta, Georgia, with the *Field and Fireside*. By the time Ginter bade the literateur bon voyage, he'd moved to the Arlington House, an imposing and well-kept hotel on a high spot at the corner of Sixth and Main Streets. Whether or not his sister and her children moved along with him, he kept a close eye on them.

About this same time, Reverend Hoge and his family moved to a large house beside his church at the corner of Fifth and Main. It was formerly the hospitable home of Major Gibbon, the collector of the Port of Richmond, and he had entertained Thomas Jefferson at the home. It had a three-story porch on the garden side, with a good view of the winding James River. One can easily imagine Ginter visiting Reverend Hoge some evening at sunset and the two of them having a heated political discussion while gazing at their peaceful, picturesque river town.

The year 1860 was a famously prosperous one for Ginter. By year's end, his firm was the largest wholesale notion house and the largest handler of white goods and Irish linen in the entire South. It was well known from Baltimore to New Orleans.

Richmond had become a city unrivalled throughout the country for wealth, refinement and culture. An important center of manufacturing, it was doing more business, per capita of population, than any other American city. Its flour and grain trade was "the highest in the world," Ginter pointed out, "and it resulted in our having a great coffee business, as the result of our South American exports."

He saw coffee offered on Richmond's docks by auction, with buyers from New York, Philadelphia, Boston and other large Northern cities. "It was the same with molasses," he added, "for grocers came from *everywhere* to buy our goods." Richmond boasted more than fifty tobacco factories, producing cigars, loose tobacco for pipe smoking and their staple: chewing tobacco. The city was positively "in her prime," as Ginter put it, and "prosperous beyond measure."[46]

But although he had ascended to prominence and wealth right along with his beloved Richmond, he was fully aware of the gathering storm. And it was a storm that was about to consume him, his city and indeed the entire South.

War

By late 1860, Lewis Ginter was just months from joining the Confederate cause. Not to defend slavery. It wasn't that simple. It wasn't even remotely that simple. By the time Abraham Lincoln was elected president that November, animosities between North and South verged on an explosive, earth-shaking conflict.

Under its new editor, George W. Bagby, the *Southern Literary Messenger* traded tender odes for nasty bile. Trying to incite support for secession, Bagby wrote, "Not a breeze blows from the Northern hills but bears upon its wings taints of crime and vice, to reek and stink, and stink and reek upon our Southern plains."[47] Such vicious attacks infuriated Ginter's Northern counterparts and painted them as public enemy number one.

By this time, many Southern states were considering secession from the Union, incensed that the Federal government was infringing on states' rights. Thomas Jefferson considered states' rights the heart of the Constitution. So in the eyes of Jeffersonian Democrats such as Lewis Ginter, the Federal government was grossly overstepping its bounds. The situation was a constitutional crisis—making Ginter a devout secessionist.

Then, on December 20, 1860, after years of threats, South Carolina finally seceded. The Union was broken.

Richmond's prosperity came to a screeching halt, and a financial panic swept the entire South. By February 1861, six more states had seceded: Mississippi, Alabama, Florida, Georgia, Louisiana and Texas.

On February 4, 1861, Lewis Ginter watched anxiously as all seven states formed the Confederate States of America. Montgomery, Alabama, was selected as the capital of the new nation, and Jefferson Davis was named its president. Then, with "Northern aggression" on the rise, the Confederates seized most of the Federal forts in the South to take them out of the equation.

Virginia was still heavily Unionist, seeking to avert the oncoming catastrophe. And Richmond was still a Union town.

As Ginter pondered the current crisis, it pulled him in two opposing directions. He was deeply inspired by Virginia's renowned Patriots who had fought for independence from tyrannical rule. He was also a vigorous advocate of peace.[48] There was an event just beyond view, however, that would dispense entirely of his doubts.

THE RESOUNDING FIRST SHOT

Attention, Volunteers![49]

In mid-April 1861, newsboys on the streets of Richmond were shouting out the big news—Confederate forces had taken action at a Union-held fort in South Carolina. "THE WAR COMMENCED! BOMBARDMENT OF FORT SUMTER!"[50] It was fate. Used in the assault were shot and shell manufactured by Joseph Anderson of the Tredegar.

On Saturday, April 13, came the surprise ending: "FORT SUMTER HAS FALLEN!" Newly elected President Lincoln promptly called for seventy-five thousand volunteers, including eight thousand from Virginia, to put down the rebellion in the Deep South and preserve the Union.

That pleasant spring afternoon—with a heady mix of anger, elation and resolve—at least ten thousand Richmonders poured onto Main Street between Eighth and Fourteenth Streets, congealing into a mob. Seeing Lincoln's act as simple tyranny and coercion, they had never felt so charged in their lives. Men delivered "grandiloquent" speeches at several spots among the massive, sprawling crowd—one within close view from Ginter's storefront window in front of the *Richmond Dispatch* building.

Joseph Anderson, just itching for Virginia to secede, had planned a rally of his own. He'd hired the State Armory band, which was marching along Main Street. The peppy musicians drew tremendous numbers of citizens into a procession toward the Tredegar works. There, with the band playing the "Marseillaise," about three thousand Richmonders cheered as Tredegar workmen hoisted the new flag of the Southern Confederacy and a cannon broke the sound barrier. The air was charged with the excitement of war.

Anderson spoke a few words and then introduced Attorney General John Randolph Tucker. In a fierce speech, Tucker declared that "Yankee tyranny" was over and promised that Virginia would secede. When he announced that cannon cast at the Tredegar had breached the walls of Fort Sumter, even the meek and mild like Ginter cheered skyward until the veins in their necks bulged.

On April 17, the Virginia Convention voted to secede. The news was supposed to be kept a secret while the government threw up defensive measures along Virginia's northern border. But word leaked out. So, on the night of April 19, Richmond had the most magnificent torchlight procession in its history. Thousands of men and women marched along Marshall, Broad and Main Streets brandishing the Stars and Bars, while pyrotechnics lit up the sky. Bands blared the new national airs, and marchers shouted along until they were hoarse.

The Confederacy was in dire need of provisions of all sorts, and Ginter and his friends were on the verge of donating their brilliant, individual skills.

But first, President Lincoln dealt the Confederacy a sobering blow with the Union blockade of Southern ports. It put five hundred ships of the Union navy to task, closing twelve major ports—including Richmond. Lincoln wanted to prevent the passage of goods, supplies and arms to and from the Confederacy—and to nip the war in the bud.

For the most part, the blockade worked. It prevented Southern goods like tobacco and cotton from reaching their markets abroad, crippling the economy even more in cities like Richmond. It also meant that Virginia merchants like Ginter who relied exclusively on European imports were cut off from their livelihood. The career of steamship *Virginia Dare* ended just months after it began.[51] Blockade runners—high-speed boats built to evade the blockade—became more and more unsuccessful as the war progressed.

The Federal government was making it almost impossible for merchants like Ginter to conduct their businesses. That fact filled him with violent rage. Perhaps the words of Thomas Jefferson were ringing in his ears: "I hold it

that a little rebellion, now and then, is a good thing, and as necessary in the political world as storms are in the physical."

On April 23, the *Richmond Enquirer* turned up the heat on the crisis with an emotional appeal to Virginians. "For the third time in your history," it said, "you are called upon to take up arms in defense of your homes against the invasion of a foreign foe."[52]

Ginter, Alvey & Arents—along with twenty-three other Richmond merchants—announced that it would cut back its hours of operation "for the purpose of enabling our employees to attend to their military duties."[53]

The *Richmond Enquirer* inflamed the public by railing against the tyranny of President Lincoln:

> *Every act of the present despot in Washington, is a usurpation of power, and an invasion of constitutional right. Underlying the slavery question, it is now manifest that a great contest is to be between Constitutional States rights liberty on the one hand, and unlimited despotic power on the other. If the negro question were entirely out of the way, this battle would still have to be fought. The Southern States would have to fight for the assertion and maintenance of their equality with the Northern States.*[54]

As a devotee of the *Enquirer*, Ginter read every single word. The paper had become the "Democrat Bible" in 1804 under editor Thomas Ritchie and was Thomas Jefferson's favorite.

Poet John R. Thompson responded to Lincoln's show of force with "Coercion, A Poem for the Times." In part, it read:

> *Who prates of coercion? Can love be restored*
> *To bosoms where only resentment may dwell—*
> *Can peace upon earth be proclaimed by the sword,*
> *Or good will among men be established by shell?*[55]

Joseph Anderson of the Tredegar put his thoughts on paper too, but in much more steely terms. "We are a unit here in defense of our liberties," he wrote, "and will die before subjugation."[56]

Then there was Robert E. Lee's declaration. He announced his resignation as an officer in the U.S. Army to come to the defense of his home state of Virginia. It was his job to whip an army into shape.

Within seven weeks of Lee's appointment, three more upper-South states seceded: Arkansas, North Carolina and Tennessee. That brought the total number of Confederate states to eleven. Things seemed to be escalating by the hour.

Not long after, the city of Richmond—with all its economic and industrial might—beat out Montgomery as the capital of the Confederacy. Instantly, the Confederates recognized their most important goal: keep Union troops from capturing the city.

On May 29, when Confederate president Jefferson Davis made his arrival in Richmond by train, "the air resounded with the most deafening cheers, oft repeated, for Davis and the Southern Confederacy, from several thousand willing mouths, honest hearts, and warm hands," reported the *Dispatch*.[57]

Now that the war was heating up, the Tredegar Iron Works became the industrial heart of the Confederacy by supplying high-quality munitions and artillery. Its importance was one of the main reasons the authorities chose Richmond as the capital of the Confederacy in the first place. For Anderson, the pressure was on. He fired up his furnaces at the vast complex, churning out cannons, cannonballs, coastal defense guns, armor for warships and torpedoes.

To protect this vital source of munitions—and the seat of political power for the Confederacy—men dug fortifications hard and fast around Richmond.

Meanwhile, many of Virginia's white male property owners invoked the states' rights argument—that the state had the right to live in peace under its own laws, even if those laws defended slavery. They also felt compelled to defend their honor in light of the long line of verbal attacks from the North. According to historian Bertram Wyatt-Brown, slavery stirred up the secessional crisis, but "southern honor pulled the trigger."[58] Ginter and his friends also acted on raw emotion to the invasion. They perceived it as a serious threat to hearth and home.

At first, Reverend Hoge opposed secession, but once the issue was decided, he became as impassioned as anyone else. He insisted that the war involved principles "more important than those for which our fathers of the Revolution contended."[59] He went to great lengths to serve the welfare of the soldiers, materially and spiritually. It began with preaching to a virtual revolving door of troops in training at Camp Lee on Broad Street (the site of today's Science Museum). But he was just getting warmed up.

Also entering the fray were Ginter's partners in his fancy goods store. John F. Alvey joined the Quartermaster Department, and George Arents— Ginter's nephew and a native of New York—enlisted as an artilleryman in the Richmond Howitzers. Ginter's other nephew, Frederick Arents, joined the Richmond Howitzers as well.[60]

Merchant tailor John C. Shafer, now forty, remained in Richmond, putting his business to work for the effort by making Confederate uniforms.[61]

Poet John R. Thompson promptly returned from Augusta to Richmond and wrote:

> *Our town is threatened with invasion by Lincoln's armies. My parents, my widowed sister, my home are here; every consideration of filial and patriotic duty would oblige me to remain and share the fate of my native Virginia apart from any convictions I might entertain of the original folly of secession.*[62]

Although Thompson's will was strong, his body was weak and in precarious health. He joined President Davis's Confederate cabinet as assistant secretary of the commonwealth. Also a war correspondent, he wrote letters to the *Memphis Appeal* under the pen name "Dixie." He would give a passionate, literary voice to the war.

Of course, the last things needed in the effort were fancy goods, but Lewis Ginter had precisely the kind of business experience desperately needed in the Quartermaster Department just a block northwest of his store. Well versed in supply, and with a knack for organization and coordination, he was appointed to a high position at the department shortly after the war broke out. The Confederate army needed blankets, tents, uniforms, knapsacks and loads of other supplies.

Before long, having accumulated a fortune of $200,000 with his fancy goods business (in 1861 dollars), Ginter sold out, investing all of his means in tobacco, sugar and cotton. It was all stored in warehouses by the canal as a postwar investment; many prudent businessmen did the same. Their stores were safe—or so they thought.

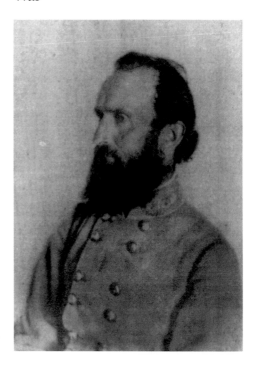

Lieutenant General Thomas "Stonewall" Jackson, for whom Major Ginter would perform a special mission. *Library of Congress.*

The first major land battle of the war came on July 21, 1861. A violent clash of passions with the boom of cannon fire, it was the First Battle of Manassas. That same day, General Thomas J. Jackson earned the nickname "Stonewall" for his calm demeanor and stout defense.

The battle was a huge Confederate victory, so Richmonders were stunned when hundreds of soldiers with ghastly war wounds arrived by train at the station at Eighth and Broad. The government had already set up some war hospitals throughout the city, but not nearly enough of them. The authorities turned the city almshouse into General Hospital No. 1. Carts hauling the wounded left trails of blood in the streets.

Meanwhile, as the Union troops put Manassas behind them, they were out to capture the real prize, chanting, "On to Richmond!"

There was no denying it: Ginter's beloved city—the very place where he'd found success—was caught in the eye of the Civil War storm. With his "inexorable sense of duty,"[63] he would soon give up his comfortable life and cast his fortune with the state of his adoption.

But first, Ginter and seven other leading Richmond businessmen discovered another avenue toward Southern independence that had the

potential to aid the war effort. They incorporated the Virginia Chemical Works, with urgent plans to begin tapping into Virginia's "indispensible" mineral ores.[64] Copper was in especially high demand since the Tredegar needed one thousand pounds of it to make a single cannon and the foundry's supply of copper had been cut off by the blockade. It appears the men didn't get far with this enterprise, probably because they were sidetracked by events beyond their control.

A GENTLEMAN'S PATH TO ARMY LIFE

I, Jefferson Davis, President of the Confederate States of America, do proclaim that Martial law is hereby extended over the city of Richmond.[65]

In late April 1862, less than two months after President Davis's declaration, New Orleans fell to Union forces. It was a crushing defeat for the Confederates. And by now, they were hugely outnumbered.

Then, on Friday, May 9, 1862, Federal gunboats inched up the James River, and the Federal army arrived on the Virginia peninsula. The people of Richmond suddenly felt the terror of war. Many abandoned the city southward by the trainload.

But not Lewis Ginter.

Devoted to the cause and the defense of his city, the thirty-eight-year-old Ginter promptly entered the Confederate army. Perhaps this marks the moment at which his heart forever cemented its concern for Richmond's welfare.

With the rank of major, Ginter was assigned commissary of subsistence for a brigade composed of four Georgia regiments and placed under the command of a leader he knew exceptionally well: Joseph Anderson of the Tredegar, now *General* Joseph Anderson. With his martial fervor and West Point training, Anderson had requested a field command. He'd been stationed near Richmond to help the army defend the city. It was certainly no coincidence that Ginter ended up under Anderson. Maybe Anderson had personally requested the able assistance of his friend, or maybe the two simply wanted to go through the war together. Regardless, Ginter would soon prove there was no arena in which he couldn't distinguish himself.

On May 26, Confederate colonel A.P. Hill was promoted to major general in the Army of Northern Virginia to join the urgent defense of Richmond.

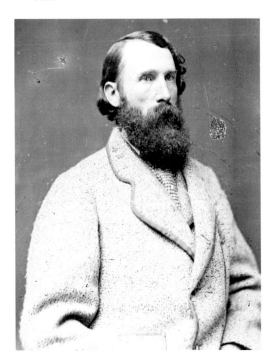

General A.P. Hill. To Major Ginter, the brave and dedicated leader was immortal. *Library of Congress.*

The next day, he took command of what he called his "Light Division," which included Major Ginter's brigade.

A Virginian by birth, A.P. Hill had a slight build but was a bold and skillful leader. Nothing exhilarated him more than "the fierce joy of victorious fight," and in battle his intense hazel eyes "lit up with a steely glint."[66] Possessing a magnetic and genial personality, he took good care of his men. And they loved him.

Major Ginter, as an officer in the Army of Northern Virginia, would remain in the eastern theater of the war for its duration. The general feeling among Confederates, however, was that they would quickly crush the Union troops. They had absolutely no concept of the vile and convoluted drama that lay ahead.

In his role as commissary, Major Ginter bought and stored army rations and issued them to the men of his brigade. He kept charge of a covered commissary wagon drawn by a horse or mule. Typically, he would follow his division to the fields of engagement, in line with quartermaster, ordnance and ambulance wagons that camped as a group two or three miles behind the battlelines.

When commissaries like Major Ginter were lucky, they had herds of cattle, sheep, hogs and other seized farm animals and penned them up for the use of the troops. At times, Major Ginter's position involved mundane tasks like weighing nonperishable rations for the men such as pickled pork, cornmeal, dessicated peas and coffee. (Tobacco was sometimes included in Confederate rations.) He also telegraphed reports up the chain of command.

But Ginter wasn't there just to do a job and put in his time. Like so many of his war comrades, he had what he considered lofty ideals. He was doing his duty by trading his soft bed for a camp cot out in the cold. He was fighting for the independence that Founding Father Thomas Jefferson had championed. In Ginter's mind, it was far better to die than submit to the North.

By the end of May, Richmond was being menaced by McClellan's Army of the Potomac. Confederate general Joseph E. Johnston attempted to repulse an attack in surrounding Henrico County called the Battle of Seven Pines. There were heavy casualties on both sides, dwarfing the confrontation at Manassas. Suddenly, there were more than 4,700 wounded and bloody men who had to be cared for.

With an urgent need for hospital space, the Confederate surgeon general ordered many stores and storehouses along Main Street to be taken for care of the wounded. Even Ginter's store was taken temporarily and renamed the Ginter, Alvey & Arents Hospital.[67] In a show of unity, many Richmonders threw open their homes to the wounded as well.

Reverend Hoge performed loving pastoral work at the various hospitals, perhaps even at the one in Ginter's old store. "No one knows what war is who has not seen military hospitals," Hoge wrote. "Not of the sick only, but of the cut, maimed and mutilated in all the ways in which the human body can be dishonored and disfigured."[68]

With the war in full surge, Reverend Hoge also "evangelized" to the troops in the field. He even served as honorary chaplain to the Confederate Congress, offering prayers for heavenly intervention in the ongoing struggle: "We beseech Thee [to] interpose for our defense. Stretch forth Thy hand against the swarm of our enemies—do Thou defeat their councils, disappoint their designs & fill them with confusion & dismay."[69]

In the Battle of Seven Pines, a shell fragment had thrown General Johnston off his horse, so President Davis placed his military advisor, General Robert E. Lee, in command of the Confederate army.

About two weeks after Seven Pines, news arrived in Richmond that had its citizens aflutter. Twenty-nine-year-old Confederate captain William Latané had been shot and killed in Hanover County. After William's death, his brother John removed the body to a nearby plantation called Westwood. The plantation's white men were away serving in the Confederate army, but Mrs. William Spencer Roane Brockenbrough, the lady of the house, assured John that his brother would receive a proper burial. She summoned the family minister, but Union pickets blocked his arrival. So Latané was buried at Westwood, attended only by the lady of the house, a handful of other women and children and a few slaves.

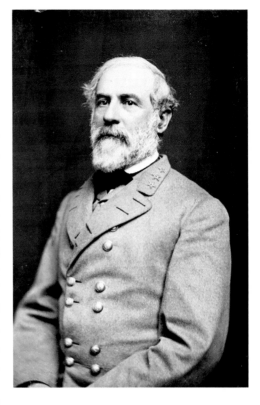

General Robert E. Lee. One day, Major Ginter would have an important meeting in Lee's tent. *Library of Congress.*

The incident inspired John R. Thompson to compose "The Burial of Latané." Memorializing the death of the "martyred son" among strangers, the restrictions placed on funerals during the war and the patriotism of the women in the struggle, it ended with these touching lines:

And when Virginia, leaning on her spear,
Victrix et vidua; the conflict done.
Shall raise her mailed hand to wipe the tear
That starts as she recalls each martyred son.
No prouder memory her breast shall sway
Than thine, our early-lost, lamented Latané.

The Burial of Latané, 1864, by William D. Washington.

The poem was an instant classic. It would soon inspire a painting that became an icon across the sorrow-filled South.

Incredibly, the early campaigns of the war near Richmond were victorious for the Confederates. This seemed to confirm the notion that the war would end quickly. Spirits were higher than high.

During the Seven Days Battle—a series of six battles from June 25 to July 1, 1862—General Lee drove the invading Union Army of the Potomac away from Richmond and into a retreat down the Virginia Peninsula. As part of General A.P. Hill's Light Division, Major Ginter's brigade assisted in the campaign. But because commissary officers occupied a strictly noncombatant post, Major Ginter hadn't been given the chance to join the fight.

Yet.

THE FIGHTING COMMISSARY

He was an incorruptible patriot.[70]

During the Seven Days Battle, Ginter's commanding officer, General Joseph Anderson, had been slightly wounded in the face. Now, the Tredegar was calling his name. Anderson wrote a well-worded letter of resignation and then returned to Richmond and the foundry. No one else could so expertly manage its ever-shifting demands and feverish schedule. He knew it, and Lee knew it.

While General Edward L. Thomas took Anderson's place, Major Ginter retained his position. It was at this time that A.P. Hill's Light Division was assigned under the command of the legendary General "Stonewall" Jackson.

In his role as commissary, Major Ginter was facing a chronic challenge— food shortages from the very top. This was partly a result of the Union blockade of Southern ports, which caused shortages of food and other

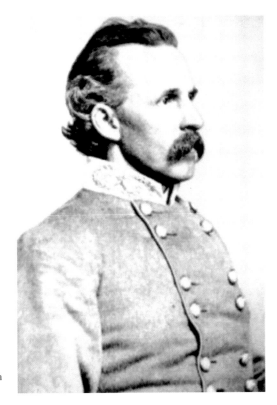

General Edward L. Thomas, who assumed command when Anderson retook the helm at the Tredegar.

goods and weakened the Confederate economy. To make matters worse, transportation was tied up because of the poor condition of railroads. Or red tape. There were stories of meat destined for the South being allowed to spoil on the wharves of Bermuda because blockade-running captains preferred more profitable cargoes like medicines, liquors and silks.

Cash was also a huge problem. The Confederacy had a shortage of funds and a depreciated currency, on top of an early loss of food-producing territory.

And then there was the sheer incompetence of the Confederate commissary general, Lucius B. Northrop. Although he inherited numerous challenges in providing for the troops, it didn't help that he was abrasive and overbearing and had a "brutal indifference to the sufferings of Confederate soldiery." Most Confederates believed Northrop was kept in office largely because he was one of President Davis's "pets."

Sadly, due to all these challenges, commissaries were ordered to reduce the men's rations—sometimes by half and sometimes by two-thirds. Troops were almost always hungry.

Although the shortages put Ginter in an awkward position, Thomas Jefferson once said, "Only aim to do your duty, and mankind will give you credit where you fail." Those words proved true in a July 25 report from Brigadier General Joseph Anderson to Major General A.P. Hill. In part, it read, "My brigade Commissary, Major Lewis Ginter, and Quartermaster, Major R.T. Taylor, more than justified my favorable estimate of their qualifications."[71]

In late August, General Stonewall Jackson led his troops through the forests and fields of Northern Virginia en route to Salem (now Marshall), determined to do something about the food shortage. He selected Major Ginter and sent him forward, protected by a number of Black-Horse Cavalry, to ask the city to send food to the troops.

The citizens of Salem were short on food themselves because the Union troops had stolen almost everything. Regardless, they hitched up their ox carts and emptied their meat houses and storerooms into them. Major Ginter led the ox carts back to the men as they marched by. That night, Stonewall Jackson thanked Major Ginter personally for his splendid efficiency.[72] He had served the Confederacy well that day.

Days later came the fateful Battle of Second Manassas. The leader of the Union troops was Major General John Pope, whose boastful and abrasive

tone earned him the scorn of troops on both sides. But the Confederate troops were angered because he advocated harsh, cruel treatment for their fellow civilians. The Confederates saw this as their opportunity to end the war—once and for all.

It was here, at this critical juncture, that Major Ginter proved his gallantry on the battlefield.

Captain William Norwood was wounded and unable to command his company of Georgia troops. On the second day of the campaign, Union forces planned to thrust themselves through a gap in the Confederate line along an unfinished railroad bed and cut General A.P. Hill's division in two. Unbeknownst to them, Major Ginter volunteered to serve in Captain Norwood's place. Ginter was more fired up than ever.

When the Union forces charged, Major Ginter rallied his men into the thick of battle with a countercharge. Other soldiers rushed in, and in a coordinated effort—through crossfire and dense, acrid smoke—the men drove back the enemy.

All the while, Major Ginter "appeared to be as cool and collected, as if he were on dress parade," remarked fellow officer Colonel T.J. Simmons.[73] Thomas Jefferson once said, "Nothing gives one person so much advantage over another as to remain always cool and unruffled under all circumstances."

The daring and courageous maneuver that Major Ginter undertook that day made a lasting impression on the men who witnessed the act. His superior officers even sought to make him a brigadier general. He modestly declined the honor.

In the middle of the intense fight, another one of Hill's brigades had run out of ammunition and resorted to throwing rocks at the enemy. It was all they had. General Hill quickly ordered his staff to collect ammunition in their pockets and haversacks and then rode on horseback to address the rock throwers. "Good for you, boys!" Hill cried out. "Give them the rocks and the bayonets, and hold your position, and I will soon have ammunition and reinforcements for you!"[74]

Dutifully, Major Ginter collected all the ammunition he could in his hat and then scurried it to the men on the front line, with shells flying all around and the ground littered with the dead and dying. Later that day, with the fight over, Major Ginter said to a fellow officer, "It is by the grace of God that I am here."[75] Thousands of his Confederate comrades had been shot, cut and maimed and lay dead in a sprawling, bloody heap.

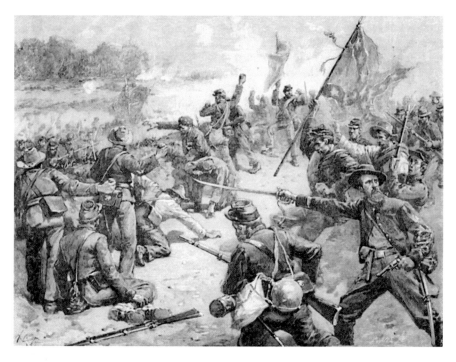

The Battle of Second Manassas, 1862, where Major Ginter won over his comrades with his daring bravery. *National Park Service.*

Yet the Union troops fared even worse, because Union general Pope had made some grave tactical errors. At the end of that three-day campaign at Second Manassas, having lost twice as many men as the Confederates, he retreated to Centreville, where he was promptly fired.

The heat was off the Confederate capital—at least for the moment. Poet John R. Thompson mocked General Pope's missteps in "A Farewell to Pope." It ended with these lines:

> *And fate may decree that the end of a rope*
> *Shall award yet his highest position to Pope.*[76]

General Lee saw the light, too, calling the Second Manassas campaign "a signal victory." The Confederacy was suddenly at the height of its power.

Meanwhile, Ginter's comrades awarded him the brightest badge imaginable—the nickname "The Fighting Commissary."

THE LONG AND BLOODY FIGHT

*Many a gallant brother in arms have we buried in Old Virginia's soil,
many a disabled comrade has left our side, bearing on this body the marks
of the terrible battle field. We are now few, but we are still undismayed.*[77]

As the Army of Northern Virginia took its fight onward into Maryland, Major Ginter didn't miss an opportunity to join in battle. "In all the other battles in which he was engaged, he displayed the same courage and ability that he did in his first one," said Colonel T.J. Simmons.

For officers like Major Ginter, such displays of personal courage cemented the respect of his comrades. "He was popular with both officers and men," said Colonel Simmons. "I know he did not have an enemy in the brigade. I never heard officer or man say a word against him, but all spoke of him in the highest terms of respect and love."

Painting a picture of Major Ginter in his role as commissary, Colonel Simmons said, "I have seen him when his wagons were full of rations, and have seen him when he did not have a pound of beef or flour, and he was always the same—a perfect old Virginia gentleman. No undue elation when his wagons were full; no undue despondency when they were empty. A real pleasure to him when he could feed us; a plausible excuse for the government when he could not."[78]

A seemingly never-ending stream of Southern men joined the "glittering lines of steel and gray, moving down the battle's way," as John R. Thompson put it.[79]

In September, Ginter's brigade migrated with the rest of General A.P. Hill's division to Antietam, Maryland, where they helped save Lee's army from destruction by the advancing Army of the Potomac. It was the Light Division's finest day.

The sobering reality that this war would be a long one settled in. But Major Ginter trudged onward. Many years later, one of his friends would trumpet his "unfaltering spirit."[80]

On October 26, Major Ginter was commended by General Thomas in his report up the chain of command. He wrote, "Major Lewis Ginter, Lieutenant William Norwood, of the staff, and Lieutenant John Tyler, acting Aid-de-camp, performed their duties with gallantry on the field, and I take this occasion to acknowledge their valuable services to me."[81]

On May 3, 1863, General Thomas's brigade fought near Chancellorsville, where they lost about two hundred men and officers.[82] It was there that Stonewall Jackson got shot in his left arm, requiring that it be amputated by his personal doctor in the field, Hunter McGuire. A week later, Stonewall Jackson died of complications from pneumonia at the Fairfield plantation, about forty-five miles north of Richmond. The Confederate nation mourned his death. Days later, Major Ginter suffered a loss that hit closer to home. His nephew Frederick Arents was killed in a boiler explosion aboard the CSS *Chattahoochee* at Blountstown, Florida.[83]

Although Major Ginter must have ached terribly for his sister and her lost son, he somehow managed to shine in his work. "As a commissary, we thought that Major Ginter was the best in the army," said Colonel Simmons.[84] To earn such high praise, Ginter probably pulled all the stops in trying to keep the troops fed, whether it was leading "foraging parties" in Union camps, harvesting local crops or—as gruesome as it sounds—slaughtering pigs and cows for desperately needed meat.

Two members of General A.P. Hill's staff asserted that if every division of General Lee's army had had a commissary like Major Ginter, General Lee would never have retreated from Pennsylvania after the Battle of Gettysburg.[85] Historians have long viewed that battle—which took place July 1–3, 1863—as the turning point of the war. General Lee had suffered heavy losses, putting an end to his northward advance.

Thomas's brigade didn't participate at Gettyburg but, in heavy skirmishing, was hit by massive artillery fire. It was a gory scene during which 152 of the brigade's men were killed. It must have been heartbreaking for Major Ginter to watch the ranks of his brigade fall away due to battle wounds and disease. These were men whose brave faces he saw every day.

The summer's bloody defeats reverberated all the way back to Richmond. Inflation soared, and spirits plunged. By that fall, Major Ginter had returned to Virginia, where he would remain for the duration of the war.

Reverend Hoge, meanwhile—distressed that the troops had no Bibles to sustain them—undertook a legendary mission. Running the blockade to England, he campaigned for help from the British and Foreign Bible Society and ended up bringing back tens of thousands of donated Bibles and Testaments for the Confederate army. During the dangerous mission on the high seas, Hoge didn't know if he'd end up at "the bottom of the sea, Richmond, or some Northern Bastile."[86] His ship faced enemy shrapnel,

shell and solid shot, but not one struck the craft. Hoge managed to return to Richmond with nary a scratch.

In January 1864, with General Lee facing severe food shortages for his troops, he made another in a long line of pleas to the government—this time to Secretary of War Seddon. "Short rations are having a bad effect upon the men, both morally and physically," Lee wrote. "Desertions to the enemy are becoming more frequent, and the men cannot continue healthy and vigorous if confined to this spare diet for any length of time. Unless there is a change, I fear that the army cannot be kept together."[87] They were ominous words that went unheeded; even the men at the top had their hands tied.

A death knell for the Confederacy came in March 1864. President Abraham Lincoln made Ulysses S. Grant commander of all Union armies. It was Grant's mission to obliterate the Confederate forces and their economic base. While some Union troops captured key cities and attacked railroad supply lines, others moved against Lee near Richmond.

Confronting Monumental Odds

That was the best onion I ever ate in my life.[88]

Another tremendous assault on the food supply came in the fall, when Union general Philip Sheridan unleashed his "scorched earth campaign" on the Shenandoah Valley. Trying to force the Confederate troops in Virginia into starvation, his troops torched crops, mills, barns and factories. Major Ginter's resources dried up more than ever. And soon his beloved city of Richmond—now tattered and poverty-stricken—would face near famine.

At the Tredegar, Joseph Anderson had long been struggling with a severe shortage of his own: raw materials for the foundry like pig iron. He couldn't produce nearly enough munitions to meet the demands of the Confederate government.

The cold, hard truth was becoming clear: the South was doomed.

When news of this sad state of affairs reached poet John R. Thompson, he nearly had a nervous breakdown. Already in precarious health from tuberculosis, his friends convinced him to seek solace in Europe and had to literally carry him in their arms onto a blockade runner in which he was to sail for Nassau.

Shortly after arriving in London, Thompson regained strength and went to work for the *Index*, a Confederate propaganda magazine. President Davis hoped Thompson's writings would finally shake the British government from its position of neutrality concerning the war. Unfortunately for the Confederates, that didn't happen.

By February 1865, Confederate troops were engaged in a gritty, months-long trench warfare campaign at Petersburg, freezing and famished. Many of these men—the last hope for Richmond's survival—were without shoes and overcoats in the snow. General Lee sent for Major Ginter, whom he'd known and respected even before the war.[89] Lee told him to go down into North Carolina to try to find something with which to feed and clothe his army. Major Ginter did as he was ordered, stopping first in Danville, Virginia. There, to his surprise, he found warehouses "bursting" with food and clothing.

But there was a hitch.

The quartermaster in charge said he couldn't get use of the trains to send the provisions to the army because—by order of the Confederate government—the trains were being used instead to ship wines, whiskey and cigars to Richmond. Controlling the trains were civilian provisioners to the army post, known as sutlers.

Major Ginter traveled to Charlotte, North Carolina, and other cities in the vicinity. Everywhere, he found goods in plentiful supply—but again, the transportation was monopolized by sutlers. He returned to Petersburg to report back to General Lee. Entering the general's tent, Major Ginter urged him to send orders to the quartermasters to seize the trains and send the provisions. Then, pressing the point, he said, "General, will you order the supplies?"

General Lee sat deep in thought. Then, raising his hand, he said, "No, Major, I can't violate the law. If the departments at Richmond choose to let this army be destroyed for want of food and clothing, it will have to perish."[90]

By March, the Confederacy's days were numbered. At Petersburg, Lee's army had been thinned by desertion and casualties, and the remaining men were weakened by hunger.

"If the Army of Northern Virginia had been kept supplied with food and clothing, General Grant would have found his work cut out for him when he undertook to drive it away from Petersburg," said Ginter's friend and fellow veteran William L. Royall.[91]

On April 2, 1865, the city fell.

THE ANARCHY OF EVACUATION SUNDAY

I rose quietly and left the church.
—*Jefferson Davis*[92]

After the fall of Petersburg, the Confederate army lost its last shred of hope, and "the besieged dwellers of Richmond" felt the "death-clutch at its throat."[93] General Grant was fully prepared to take Richmond. What he didn't know, though, was that General Lee had already sent word to evacuate the city. News arrived during Sunday services. The day would go down in history as "Evacuation Sunday."

At St. Paul's Episcopal, a church official handed the Confederate president a telegram. Davis immediately left the church to make arrangements to move the Confederate capital to Danville.

Meanwhile, just four blocks west, Reverend Hoge was mid-sermon at Second Presbyterian. A messenger scampered up the aisle and handed him a note. Reverend Hoge read it and bowed his head on the lectern for a moment. Then, looking up, he said:

> *Brethren, trying times are before us. General Lee has been defeated; but remember that God is with us in the storm as well as the calm. We may never meet again. Go quietly to your homes, and whatever may be in store for us, let us not forget that we are Christian men and women, and may the protection and blessing of the Father, the Son and Holy Ghost be with you all.*

Abruptly, Hoge left the church.

By chance, Major Ginter was also in Richmond that fateful day. He'd arrived the day before, delivering a requisition to the Confederate States Treasury on behalf of division commissary D.T. Carraway, who desperately needed funds to acquire subsistence for the troops in southern Virginia. Major Ginter was at home—presumably with his sister—when someone frantically searched him out to report the terrible news: Union forces had broken the lines at Petersburg and everyone must evacuate Richmond.[94]

As with all the city's people, this was Ginter's worst nightmare. The city he loved and had fought for was about to be ceded to the enemy, and his ideal of Southern independence was shattered.

But there was no time to mourn. Things had to be done. As he stepped out into the street, news of Lee's retreat spread through the city like wildfire. Government vehicles scrambled to move Confederate archives and gold to the Danville station. Citizens frantically pulled a few possessions into the streets and planned their escape. Confusion and panic were setting in. A lady down the hill yelled, "Richmond has fallen! What shall we all do?"

Ginter needed his calm and rational side now more than ever—he had to make his own plan, and he had less than twelve hours to carry it out. Foremost on his mind would have been to see Jane, Joanna and Grace to safety. They were perhaps fearful, like many Richmond ladies, not knowing how the Federals would treat them. Ginter also needed to collect his personal papers and valuables. The banks opened up on this Sunday for this purpose, and citizens lined up in a crush.

Then came even more devastating news. Early that morning at Petersburg, Ginter's beloved corps commander, A.P. Hill, had been shot and killed. Terribly ill for weeks, he and one of his couriers had rushed to rally a break in the Confederate lines. They came upon two Federals, who answered their call for "surrender" with gunfire.

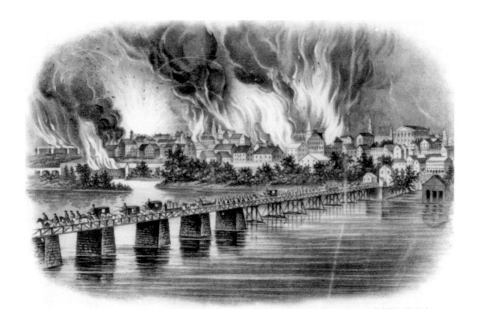

The evacuation of Richmond. One eyewitness wrote, "No human tongue, no pen, however gifted, can give an adequate description of the events of that awful night." *Library of Congress.*

Just as Ginter was trying to absorb the shock, Hill's body reached the south end of the Mayo bridge. It was being transported from Petersburg by two of his nephews, who, according to family wishes, were attempting to have the body brought to Hollywood Cemetery for burial. But at that moment, going north on the bridge was totally impossible. Soldiers and panic-stricken Richmonders were flooding southward in their escape with wagons, carriages and horses. All Hill's nephews could do was wait.

Some Richmonders headed west on the canal towpath in a chaotic mass exodus. Others hunkered down in their homes to await their fate. Terrorized, guards at the state penitentiary fled from their posts. The prisoners escaped and "roamed over the city like fierce, ferocious beasts."[95]

About midnight, President Davis and much of his staff boarded their train and chugged toward Danville. Reverend Hoge hastily joined the party on the advice of friends, since he was not willing to take the oath of allegiance to the United States as long as the Confederate government existed. Besides, he was perceived as a prominent Rebel and could face harsh treatment (and imprisonment) by the Federals.

Not long after President Davis's train left Richmond, the traffic on the Mayo bridge eased up enough for Hill's relatives to cross northward toward the paymaster's office at Twelfth and Franklin Streets. But by then, the city had fallen into anarchy.

By order of the city council, all the city's liquor was poured from barrels into the streets. The plan was meant to keep citizens from getting out of control, but it backfired. With liquor flowing deep in the gutters, men and women scooped it up—and some were down on the ground, lapping it up. Drunken mobs pillaged and looted the stores.

Hill's nephews weaved their way through the mayhem in the streets, finally reaching the Confederate paymaster's office, where a relative awaited them. Then, the nephews headed out in search of a coffin. Most of the stores had been pillaged, and some were in flames. Finally they came upon Belvin's Furniture store on Thirteenth between Main and Franklin, a half block north of Ginter's store. It, too, had been looted, and the doors were standing wide open. With no one there, the nephews rushed in, snatched a coffin and ran out. Although the coffin was a bit too small, the men managed to fit Hill's body inside. But with madness in the streets and Union troops expected at any hour, a burial in Hollywood was out of the question. They reloaded their wagon and headed to the home of G. Powell Hill, a relative in Chesterfield.

At about 2:00 a.m., while the Hill boys were still on their mission in the city, the Confederate powder magazine exploded. One eyewitness said, "The earth seemed fairly to writhe as if in agony, the house rocked like a ship at sea, while stupendous thunders roared around."[96]

Since General Lee didn't want the Union troops to benefit from the Richmond invasion, soldiers were given orders to set fire to the armory and supply warehouses. At the warehouses near the canal, in the dark of night, men torched the tobacco. The air was calm at the time. But all too quickly the wind picked up from the south and fanned the flames. Sparks and burning fragments leapt from roof to roof. The fire headed straight for the commercial district and Capitol Square.

Meanwhile, up-wind at the Tredegar Iron Works, the intrepid Joseph Anderson had armed his men, who were fending off the arsonists. Officials threw open all the storehouses of the commissary depot at the northwest corner of Fourteenth and Cary Streets, and a crowd of thousands stormed the place with bags and buckets. One witness said, "A demoniacal struggle for the countless barrels of hams, bacon, whisky, flour, sugar, coffee, etc., etc., raged about the buildings among the hungry mob."[97] By this time, the streets were strewn with baggage, furniture, papers and wares of every description.

Shortly before dawn, the Confederate ironclads in the river were blown up by their officers. As if the city had been hit by a giant earthquake, windows were blown out everywhere, including Reverend Hoge's church. Then came the sound of tinkling glass as it fell to the ground.

At daylight on April 3, the last of the retreating troops and cavalry finally trotted across the Mayo bridge. With the evacuation complete, officials set the bridge afire, along with the Danville railroad bridge.

Then, about 8:00 a.m., yet another huge explosion rocked the city. The arsenal, with nearly 750,000 loaded shells, blew up. Reverend Hoge's wife, Susan, wrote, "The house rocked so, I thought it would tumble it over."[98]

Richmond, once the greatest city in the South, was being devoured by a roaring fire—and with it, the hopes of the Southern Confederacy. A thick cloud of black smoke rose high in the sky.

As massive fires advanced toward the Tredegar in the early morning light, Anderson ordered his men to set up bucket brigades to put out any fire started by sparks.

At the same time, with Union troops marching toward Richmond, eighty-year-old Mayor Joseph Mayo and several other officials headed eastward in a dilapidated hack. They were bound for the Union lines to surrender the city. About 7:00 a.m., they met three Federal officers near New Market Road and Osborne Turnpike and handed them a note. It asked that they take possession of the city "with an organized force, to preserve order and protect women and children."

At 8:15 a.m., the city was formally surrendered to U.S. general Godfrey Weitzel at city hall. It was official: Richmond was now Union territory. Confederates' spirits sank lower than low.

As the fire raged and shells exploded overhead, the victorious Union army came into Richmond via Main Street. Surprisingly, the soldiers joined the fight to quench the fires.

Major Ginter remained in the city at least until mid-morning, helping protect his friends' property from the hungry fire. Susan Hoge would write to her on-the-lam husband, "The house caught on fire three times though the house was covered with wet blankets and shawls. The lecture room [the birthplace of Second Presbyterian] caught also and it was a little while before we could get a ladder and put it out—but fortunately Lewis was here—he was very attentive and so was sexton Robert."[99]

Ginter evacuated the burning city shortly after this mission of mercy, rejoining his brigade that night forty-five miles away, near Amelia Court House. It was an agonizing departure from his beloved Richmond, the once glorious city where he had forged a successful career and many warm friendships. It was the city he and his war comrades had been willing to die for. He faced the possibility that he may never see it again.

As Major Ginter took one last look at the burning city, he borrowed one more scene from Thomas Jefferson's life. While governor of Virginia in 1781, Jefferson had fled southward to escape capture as Benedict Arnold's men swooped in and torched the city. This coincidence was enough to send a shiver up Ginter's spine.

As Union soldiers fought the blaze, they had to blow up buildings to create a firebreak. By 3:00 p.m., the situation was under control. The heart of the business district was utterly destroyed. Everything. Everything from the north side of Main Street to the river and between Eighth and Fifteenth Streets was gone. The devastation spread over nearly twenty square blocks.

Meanwhile, President Lincoln just happened to be heading up the James River toward Richmond to survey the fallen capital. On April 4, he arrived at Rocketts Landing. As he stepped ashore, he was recognized by several slaves, and before long an exultant mob swarmed him. He was their long-awaited Messiah, and they rejoiced wildly.

His entourage clearing a path, Lincoln took his son Tad by the hand and walked up Main Street. Smoke rose from fires still blazing near the Tredegar, and the streets were, in Lincoln's words, "alive with the colored race." Some shouted in glee. Others fell on their knees in gratitude.

Accompanying Lincoln was U.S. admiral David D. Porter, who said that "a beautiful girl came from the sidewalk and presented Lincoln with a large bouquet of roses." The card attached read, "From Eva to the Liberator of the Slaves."

After passing Libby Prison, Lincoln's entourage continued along Main until they reached Fourteenth Street. Here, just a block shy of Ginter's store, the complete devastation and debris blocked their path. The procession turned north and wound its way to the former White House of the Confederacy. There, Lincoln conferred with Weitzel and his officers.

Then several prominent Richmonders ascended the steps of the mansion, seeking an interview with the president. One was Assistant Secretary of War John A. Campbell. Another was Joseph Anderson of the Tredegar.

Anderson knew that his foundry was subject to seizure and sale by the Federals since he had given aid to the rebellion; it had all been spelled out in the Confiscation Act of 1862. Suddenly, he was ready to talk peace and reconciliation.

The president agreed to meet with Campbell and Anderson. By the time their discussion was over, there was a tentative plan to bring a speedy end to the fighting in Virginia.

The next morning, Campbell and Myers met with the "magnanimous" president. His terms: restoration of the Union, abolition of slavery and the disbanding of all hostile forces. But, to pacify the Confederates, no oath of allegiance would be required, and property would be restored to those who laid down their arms.

Unbeknownst to Lincoln, however, General Lee was on the verge of giving up anyway. He was fleeing west from Petersburg to elude Grant and to find provisions for his starving army. As he and his army pushed onward throughout the night, numbers of soldiers collapsed from hunger. The

remaining men never reached those provisions. By April 8, Lee's army was surrounded by "overwhelming masses."

General Lee agonized over the most responsible course of action. But the next day, April 9, 1865, he came to a decision. He had no choice but to see General Grant. They met in a house near Appomattox Court House.

As news reached the troops that surrender was inevitable, they were overcome with anguish. Of all the trials that Ginter and his comrades had faced during the last four years, this was perhaps the most difficult to endure.

FINAL CURTAIN AT APPOMATTOX

I reciprocate your desire to avoid useless effusion of blood.
—*General Lee to General Grant*

Face to face, the two generals agreed on the terms of Lee's surrender, which—at President Lincoln's urging—included a supply of food rations from Grant for Lee's starving army. Finally, the men would eat.

General Lee rode his horse, Traveller, back to the troops, who gave him a rousing chorus of cheers. With tears in their eyes, hundreds of men pressed around Lee to express their deep affection. The next day, General Lee gave his farewell address to his army in an expansive field at the Appomattox Court House. Thousands of gaunt Confederate soldiers and officers witnessed the historic moment, including Major Ginter and the remnants of his brigade. It was a heart-wrenching speech they would never forget.

A formal ceremony and parade were scheduled for two days later, April 12. But when the sun rose that morning, Major Ginter awoke uneasy. In possession of his valuable personal papers, he feared that Union officials would search his person during the proceedings and confiscate them. He had an idea: to slip away to the mountains before the ceremony began.

Major Ginter discreetly mentioned his plan to D.T. Carraway, his division commissary. But Carraway advised against it, telling the Major that he would probably find the woods scoured by "bummers" and stragglers from the enemy's lines and that he would fare much worse in their hands than with the army proper. Major Ginter saw his point.[100]

Later that day, the ceremony came off as planned. One by one, some twenty-seven thousand Confederate soldiers marched in between rows of

Union troops, stacked their arms and then received their parole. It was humiliating. Many war-hardened Confederates wept.

For Major Ginter, as with all the men, it was so hard to say goodbye. There was a bond that could never be broken. During their long and bloody fight, rallying behind the cause they firmly believed was right, they had experienced the most exhilarating highs and the gloomiest lows.

The four-year drama was over. Altogether, 620,000 soldiers had died.

Because of the war's outcome, the slaves and millions of Northerners were positively delirious with delight. The South, on the other hand, faced total desolation and despair—emotionally, psychologically and economically.

A DEVASTATING RETURN TO THE FALLEN CITY

Thieves, murderers and pickpockets swarmed in the streets.[101]

As the Confederates laid down their arms, the Federals were nine days into their occupation of Richmond. Despite the citizens' plight, they were thankful that the Federal officials treated them humanely and tried to ease their troubles.

On Saturday, April 15, under a heavy drizzle, General Lee entered the fallen capital. With a small entourage, he crossed the James River at Seventeenth Street on a pontoon bridge built by the Union troops. According to D.T. Carraway, Major Ginter was "probably in the same party."[102]

The city, devoid of fanfare, was nothing but a sprawling mass of charred rubble and rain-soaked ashes. Richmond's splendor and gaiety was merely a memory.

As Ginter wandered among the ruins, he saw that his city—indeed, his world—was a vast wasteland. The fire had devoured hotels, warehouses, stores and houses by the hundreds. Even the grand, stylish American Hotel on Main, where he'd once lived, was totally gone. The same went for the legendary Gallego and Haxall flour mills and both of the railroad depots. Every bank in the city was wiped out. Where stately buildings once stood were smoking ruins, naked chimneys and tottering walls. Even Ginter's store had been reduced to ashes and charred rubble. Despite his obvious strengths, he was not invincible—so we can only imagine how his emotions presented themselves at this moment.

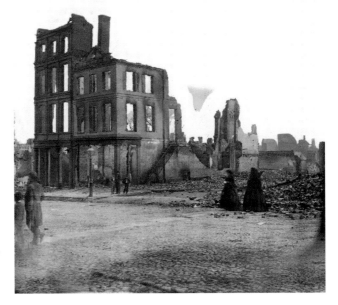

Right: Two ladies in mourning attire, grieving the lost Confederate citadel. *Library of Congress.*

Below: Ruins of Main Street, looking east from Twelfth. Ginter's store once stood proudly at left. *Library of Congress.*

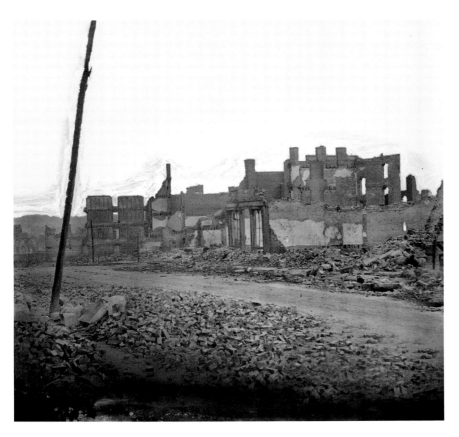

In all, nine hundred buildings were destroyed. The same went for three-quarters of Richmond's food supply. The city's people were facing stark hunger. But, with Jefferson's Capitol Building having escaped the fire, the famished Richmonders lined up on Capital Square to receive provisions from their occupiers. Yet another humiliation.

Once a prosperous industrial city and the envy of the South, it was now without trade or capital. Its economy was absolutely devastated. Years later, Ginter described how this profound change affected his fellow citizens: "When everything was swept away; when they had lost so largely; when our great flour and grain trade was ruined, they were hopeless."[103]

Unfortunately, there's no written evidence of Ginter's own thoughts when he found the city ruined, but without a doubt, he was changed forever.

Part of the gloom and depression sweeping the city was a result of all the Richmond men who were either dead or maimed. But there was nothing more crushing to Ginter and his Southern brethren than the Lost Cause.

The very night of Lee's return—just when Richmonders thought matters couldn't get any worse—word arrived that President Lincoln had been shot in Washington by John Wilkes Booth. Northern radicals set out to punish the South for Lincoln's assassination, so the Federal occupation of Richmond quickly turned sour. Faced with all these extremely difficult and bewildering circumstances, life seemed grim to the citizens of Richmond.

As for Ginter, not only was his store a total loss, but his Confederate currency and bonds were worthless as well. The tobacco and sugar he'd stored in the warehouses had been destroyed by fire. The wealth he amassed before the war had all but evaporated.

Incredibly, however, he was never one to wallow in his own misfortune. Thomas Jefferson once said, "When we see ourselves in a situation which must be endured and gone through, it is best to meet it with firmness, and accommodate everything to it in the best way practicable. This lessens the evil, while fretting and fuming only increase your own torments."

At least Ginter still had his home, his faithful friends and some stored cotton, which was a lot more than many could say. As all of them pulled together—perhaps more than ever—Ginter's levelheadedness and warm support for his friends must have been invaluable.

John C. Shafer's business had just barely been spared in the evacuation fire, but he reportedly lost $8,000 in real estate—a large sum in those days. As for Reverend Hoge, he was still on the run in North Carolina with some

of the Confederate cabinet. Meanwhile, Joseph Anderson was in the fight of his life. Although his foundry had been spared in the evacuation fire, Federal authorities prevented his taking possession of the Tredegar and were even threatening to confiscate it *and* his home. They also denied him amnesty. But Anderson—a born fighter—mounted an elaborate campaign to salvage his possessions and life work.

When word of the war's end reached John R. Thompson in London, he wrote in his diary, "I long to see dear old Virginia. I love her deeper for her impoverishment. Her wasted fields seem more beautiful than this richly cultured England."[104] But with work commitments, Thompson wouldn't return to Richmond for over a year.

Because Richmond was in captivity and ruin, many Richmonders considered fleeing, even to faraway places like Europe and Brazil. The common question on the street was, "When and where are you going?"[105]

The profound sense of tragedy in the city tested the limits of human endurance.

But Ginter was no ordinary man. Incredibly, he had the fortitude and resilience not only to survive but to stage a brilliant comeback.

Chapter 3

Renewal

In the last year of the war, there was little doubt to reasonable men what the final outcome would be. That realization wasn't the least bit comforting to thousands of Richmonders. The most unimaginable tragedies had enveloped their city. Death. Disease. Desolation. Life could get no darker.

———⊰⊱———

In mid-May 1865, after Reverend Hoge returned from his life on the run in North Carolina, he felt like he'd been shot right in the heart. "The idolized expectation of a separate nationality, of a social life and literature and civilization of our own…all this has perished," he wrote, "and I feel like a shipwrecked mariner thrown up like a seaweed on a desert shore."[106] Countless Richmonders felt the same way.

Ginter tapped into his inner strength. Somehow, he "accepted the inevitable gracefully," reported the *Times*.[107] He knew the time had come for reconciliation. It had been preached not only by President Lincoln but also by General Lee. The former leader of the Confederate forces believed it was now "the duty of every good citizen to frankly acquiesce in the result, and endeavor to avoid all that kept open the bleeding wounds of the country."

But that didn't mean Ginter would forget the cruel war or its barrage of turbulent and catastrophic dramas. Focusing on the future was important, but it also helped to look back. Jefferson taught him that. In fact, the war would give shade and meaning to Ginter's brilliant life from then onward.

CLEANUP AND RECONSTRUCTION: THE NEW FIGHT

Every name brings up a picture.[108]

Almost as soon as the evacuation fire was put out, some Richmonders—as depressed as they were—began putting the city back together. It was a monumental task. They were about to find out, however, that they had some fight left. The first mission was clearing all the debris from the streets. Some Confederate veterans went to work cleaning bricks in the destruction zone, or took on equally lowly tasks.

There would have been almost a complete lack of goods in Richmond if army sutlers hadn't come in behind the Union troops.

Since all the banks had been destroyed, the city's business community charged forward to establish a bank. On May 10, the First National Bank opened for business—albeit in a small room in the customhouse and post office on Main between Tenth and Eleventh Streets. Built of cast iron and granite, the customhouse and post office stood alone amid the rubble in the financial district. Except for a little soot, it was as handsome as ever.

A leader in establishing the new bank was a top Richmond businessman, Wellington Goddin. One of the biggest names in Richmond real estate, he was a partner in the banking and brokerage firm of Harrison, Goddin & Apperson, formed a year earlier. Their offices next door were leveled by the evacuation fire.

Ginter had had strong ties with the three partners for years, joining them in an array of business and civic endeavors. With the war over, they reunited to figure out how to pick up the pieces and move on. The men faced powerful opposing forces. Perhaps most significantly, they couldn't borrow money to get things moving. Local financing had dried up. What they needed desperately—along with the entire South—was an infusion of Northern capital.

Another challenge was exorbitant rents. Since so few buildings had survived the evacuation fire, landlords of commercial and residential buildings were

Ruins of Goddin's
Hall on Main Street
at Eleventh, with the
Capitol Building in
background.
Library of Congress.

charging whatever they could get. This slowed down the rebuilding process and discouraged the Richmonders who hoped to reestablish their businesses.

Ginter briefly considered reestablishing his wholesale dry goods business. But since Richmond had been profoundly altered physically and economically, it was impossible to pick up where he'd left off. Practically the entire mercantile sector had been wiped away. It was clearly going to be a long time before it could be firmly reinstated.

As desolate as Richmond now was, it offered almost no opportunities for ambitious men like Ginter. Soon enough, however, he would display his incredible ability to reinvent himself and, once again, plant a flag at the top of the hill.

RISING TO THE OCCASION

It is not believed that the capital can be secured at home to rebuild our city, and that efforts must be resorted to to procure money elsewhere.[109]

Instead of living amid the war's ugly aftermath—a mere shell of a city under harsh and humiliating Federal occupation—Ginter decided to head north.

While Harrison, Goddin & Apperson reopened its banking and brokerage firm in Richmond, Ginter made plans to open a sister firm in New York City. While it appeared that Ginter was *abandoning* Richmond in its hour of need, he was actually *fighting* for the city in its hour of need.

With his professional ties to the Richmond firm of Harrison, Goddin & Apperson, one of his duties was to make purchases on Wall Street for the firm and its clients. Even better, he could serve as a conduit of Northern capital to assist in the rebuilding of Richmond. He could, for example, seek Northern investors to purchase real estate in Richmond for housing and development or simply loan desperately needed funds to his sister firm in Richmond.[110] In fact, Harrison, Goddin & Apperson would soon target Northern investors in the sale of huge farms and estates all over Virginia, giving Ginter the opportunity to help bring the state back from desolation.[111]

This really wasn't much of a detour for Ginter's career. He was well versed in the world of high finance and had strong instincts in the marketplace. (As mentioned before, he had predicted the financial panic of 1857—which you can bet his associates never forgot.)

It may also seem odd for Ginter to decide to head north so soon after the Civil War, but New York City had sympathized with the South. There were valuable trade relationships to protect. There had even been draft riots in New York City.

Richmond businessmen had long viewed New York City as a model of manufacturing and commerce. Even during prewar tensions, they heralded it for shining out "amid the general blackness of the Northern horizon with all the effulgence and beauty of the Aurora Borealis."[112]

There were certainly other forces drawing Ginter to New York. He was born and raised there. It's also possible that his sister, Jane, wanted to flee war-torn Richmond and return to her native state. Ginter felt a duty to watch over her. He may have had other relatives living in New York as well who offered to open their homes.

Whatever his reasons, Major Ginter sold his cotton to enter the banking partnership. He bid farewell to his good friends and his beloved, war-torn Richmond and headed out for the Northern metropolis to revive his fortune.

Banking on Wall Street

Here he found that the North had prospered during those eventful years of the Civil War.[113]

In the summer of 1865, the streets of New York City bustled with the signs of cultural and economic vitality. This was especially true on Wall Street, where Ginter worked in the banking and brokerage business with the firm of Harrison & Co.[114] Inside its offices just a block away from the New York Stock Exchange, Ginter dealt primarily in stocks, bonds, securities and gold.[115]

Ginter was among the first Southerners to establish themselves in business in New York after the war. But there was a personal side to his relocation as well. It was a sort of homecoming that set him on a sentimental journey back to his roots.

New York was first settled in the early 1600s by Dutch colonists, who named it New Amsterdam. Ginter's ancestors—who originally went by "Guenther" before they Anglicized the name—settled there in the 1700s. Ginter considered himself a genuine Knickerbocker. It was said that he "frequently referred to his good old Knickerbocker ancestors, and always with a kindly smile that left no doubt of the high esteem in which he held them."[116] Perhaps what inspired Ginter most was that the Dutch were the first to recognize the commercial possibilities of the New World and were driven by a tough, pioneering spirit. He had the same gene.

Along the northern boundary of the New Amsterdam settlement, the Dutch built a wall to protect them from English colonial encroachment and from attack by the Native Americans. In 1685, along the lines of that original stockade, surveyors laid out a street. And here Lewis Ginter was, working within just feet of it—"Wall Street."

His father, John Ginter, had been a grocery merchant in a thriving community near the mouth of the Hudson. Tragically, he died when Lewis was just an infant. Ginter's mother was Elizabeth Somerindyke, whose eighteenth-century ancestors owned a large farm on the current site of Manhattan's Upper West Side. She died when Lewis was just ten years old. No one knows how close they had been. The young Ginter moved in with his sister, Jane, who had married a year earlier. The two siblings had remained extraordinarily close ever since.

New York's Central Park was about eight years into its development. Its designers, Frederick Law Olmsted and Calvert Vaux, would end up with an idyllic and naturalistic landscape. The farm owned by Lewis's ancestors, on his mother's side, was just a short distance west of the Central Park site, and Ginter had a particular fascination with the park and its progress (he would become so impressed by Olmsted's artistic eye for nature that he would enlist it many years later).

In the Northern metropolis, Lewis Ginter reconnected with arts and culture. Just months after living in a tent amid the horrors of war and deep deprivation, this new scene reinvigorated him. He discovered life's finest offerings all over again.

In mid-1866, Harrison & Co. scored a major coup—it brought aboard two expert partners who expanded the firm's influence throughout the South. One of them had actually been a financial agent for the Confederacy: the "distinguished" Robert A. Lancaster of Richmond.[117] His counsel had been eagerly sought by the authorities of the Confederate treasury.[118] The other new partner was a well-known merchant and capitalist, David J. Garth. The men changed the name of their firm to Harrison, Garth & Co.

An advertisement appeared in *Scientific American* for the sale of Franklin Paper Mills in Richmond, which had been destroyed by the evacuation fire. It directed Northern capitalists "wishing any further information in regard to this truly valuable property" to refer to "Messrs. Harrison, Garth & Co."[119]

While there is no paper trail to document the firm's transactions, it was in a prime position to bring an infusion of Northern capital to the South and bring it back from the ravages of war. Major Ginter, as it turned out, was still quite the soldier—and Richmond was never far from his thoughts. He heard from his old friends all about the harsh Federal occupation and the agonizing progress of Reconstruction.

Joseph Anderson was finally pardoned by President Johnson—on personal appeal, no less—on September 21, 1865. Even though the Tredegar was returned to him, he desperately needed capital to get started in business again. Luckily, the Tredegar had invested in cotton during the war, which Anderson sold to realize $190,000 in greenbacks.

In early October, there were at least 100 buildings under construction in Richmond's burnt district, some the result of Northern capital. By December, 11 stores had been completed along Main Street, and 35 more

were in the process of construction. In total, the burnt district had about 120 buildings either completed or in progress.

Yet in January 1866, the *Daily Examiner* reminded Richmonders of the bleak circumstances. "The State Treasury is empty—very empty," it said. "Like the pockets of the people, it is in a melancholy state of exhaustion and collapse. The credit of Virginia is a corpse, well picked and fleshless."[120]

By the following month, the new building activity wasn't making an appreciable difference in the lives of ordinary Richmonders. Reverend Hoge summarized the situation in his eloquent way: "Our people are becoming increasingly depressed. There is scarcely any business done, and the scarcity of money and the gloomy prospects of the future causes care, like a vast shadow, to rest over everything."[121]

In early 1867, one of Ginter's longtime Richmond friends moved to New York City: John R. Thompson. He had returned from London to Richmond in the late autumn of 1866 only to find that it remained an economic wasteland. He was heartsick. There were no literary opportunities at all, partly because the *Southern Literary Messenger* had ceased publication. Reluctantly, he left his beloved Southland for New York and found work as the literary editor of the highly reputable *Evening Post*.

With Ginter and Thompson now working in the same city again, it's almost a given that they reconnected. Perhaps they sat in Central Park to commiserate about the Southern defeat. Or perhaps they attended the theater together as they had in their younger days. Unfortunately, Thompson was in failing health from tuberculosis, and the insidious disease was causing him to waste away.

By late 1867 or early 1868, Ginter had started up his own banking and brokerage firm, known as Ginter, Colquitt & Co. His offices were about two blocks from the Stock Exchange on Broadway—another street laid out by the Dutch settlers. Ginter's main partner in the new firm was John H. Colquitt, who had been an entry clerk with Ginter, Alvey & Arents in Richmond before the war.

By the summer of 1869, just four years after the war ended, Ginter's small bank was flourishing. He was once again a very wealthy man. But just ahead, there were two conspirators—lurking in the shadows—intent on undermining his every objective. New York speculators James Fisk and Jay Gould hatched an elaborate, underhanded scheme to manipulate gold on the New York Gold Exchange. Their plan was to make a fortune by controlling the inflated price.

Gould knew that his plot would only work if U.S. Treasury gold were kept off the market. After some backroom arm-twisting, the secretary of the treasury announced during a speech that the department would keep its hands off.

Gould and Fisk began hoarding gold. The price shot up, and the gold shortage panic was on. Depositors flooded the banks, demanding their gold, and the scene became so violent that militias were called in to keep order. One can only imagine the scene at Ginter's small bank.

Once President Grant was tipped off to the devilish Gould-Fisk scheme, he quickly released treasury gold for sale. But before that news got out, the price of gold kept soaring, with riotous mobs in a bidding frenzy. One of Ginter's business partners got swept up in the madness.

BLACK FRIDAY

Ruin stared him in the face.[122]

On Friday, September 24, 1869, the secretary of the treasury poured millions of government gold into the market. Within minutes, the gold bubble burst, and investors scrambled to sell their holdings. The day would go down in history as "Black Friday."

Through their own selfish motives, Gould and Fisk left the stock market—and the nation—in absolute disaster. The scandal left thousands of stock

operators and jobbers ruined—including Lewis Ginter. The overnight failure of his bank, coupled with the loss of some $300,000 in the stock market, easily made Black Friday the most devastating day of Ginter's life. When the war was reaching its disastrous end, he could at least see it coming. Not only had Ginter lost his fortune—for the second time—but he was also unemployed and in deep debt at the age of forty-five.

A few days after the crash, when a close business acquaintance expressed his sympathy, Ginter had already mustered his characteristic poise. He thanked the man cordially and said, "True, it isn't the most cheerful prospect I ever saw, but I trust I may get to work soon and settle up everything satisfactorily."[123] It would not be long before his hope would be realized.

Resilience was, after all, Ginter's middle name.

In the immediate aftermath of Black Friday, Ginter toughed it out in New York and struggled to pay his debts. Then came news of a "calamity" back in Virginia. Robert E. Lee—his general in chief during the war—died on October 12, 1870, in Lexington, Virginia. Since the autumn of 1865, Lee had been serving as president of Washington College (now Washington and Lee University).

Even though the war had ended five years earlier, the South reeled with sorrow. In Richmond, gloom pervaded the city, presenting "a scene of mourning hardly witnessed in a generation."[124] Public buildings were draped, and nearly every home in the city had crepe on its door. On October 15, General Lee was buried in a crypt at the Washington College chapel in Lexington. Bells were tolled in Richmond from morning until night. Before Lee's solemn service was over, a movement was begun to erect monuments in his memory.

Ginter mourned the general's loss as much as anyone. But soon, things were looking up. He was about to prove a happy, lifelong devotion to tobacco, the medium that always brought men together.

A NEW ALLIANCE IN THE TOBACCO TRADE

He came down from New York one day and had a long talk with his friend.[125]

In late 1870 or early 1871, Ginter formed an alliance with an old Richmond acquaintance: John F. Allen. A childhood classmate of Edgar Allan Poe and a lifelong bachelor, Allen had more than thirty years of experience with cigars and chewing tobacco. The men developed a plan: Ginter would set up a wholesale tobacco depot and office in New York City and travel the country to sell Allen's tobacco products on consignment.

As Ginter looked ahead to staffing the depot, a particularly strong candidate came to mind. Two or three years earlier, while running his small bank in New York City, he had met an industrious lad who delivered packages for an express office. With a sparkle in his eyes, the boy would jump off his wagon to rush in for packages Ginter's firm had to send by express, and Ginter would pass a word or two with him. Ginter was impressed by the boy's "systematic and business-like approach"[126] and learned that the young man's family had fallen on hard times.

The war and the hardships it wrought created a culture of charity, especially among Richmonders, and the compassionate Ginter wanted to help. Besides, workers like this were exactly the type he wanted in his depot, so it was a win-win proposition.

There was just one problem: he didn't know the boy's name. On a lark, he contacted the express office officials and gave them the boy's description. Finally, he was tracked down at his family's home in Brooklyn. The boy's father, then a shoemaker, was struggling to make ends meet. After reacquainting himself with the boy, now about fifteen years old, and working out the details with his family, Ginter offered the boy a job, probably as office boy and packer. He accepted.

The lad's name, by a strange coincidence, was John Pope. The name had a familiar ring to it. But he was a far cry from the malevolent General John Pope whom Ginter and his fellow Confederates had vanquished at Second Manassas. In fact, although Ginter was unaware just now, this new John Pope would eventually become the most important ally of his entire life.

Renewal

Ginter's tobacco depot, established by 1871, was in Lower Manhattan, about a block off Broadway. According to Trow's New York City Directory, Ginter was living much closer to Central Park at 41 West Forty-sixth Street with a cloth merchant named Stephen Utley, and Ginter's sister Jane lived two doors down with her children George, Grace and Joanna.[127]

Ginter found success in this venture but yearned for broader opportunities. He was also anxious about his financial obligations and eager to get back into a prosperous business by which to pay them off. And although New York was a cultural paradise, its politics had become ultra corrupt by the wealthy Tammany Hall "boss" William Tweed.

Naturally, Ginter's thoughts turned back with fondness to his sweet old home of Richmond. It was where he'd made a name for himself among countless friends and where he'd spent nearly twenty happy years. No longer under Federal rule, it was well on its way to postwar recovery—at least outwardly.

Ginter couldn't start up his old wholesale fancy goods business again because, he said, "no merchant could possibly buy goods, and being forced to pay for them in gold, come out ahead."[128] But with the railroad industry back to its former self and Richmond rising again as a manufacturing center, this gave Ginter an idea.

His scheme was to join John F. Allen in a partnership at Allen's Richmond factory in charge of sales and marketing. Ginter quickly gained Allen's consent, and their firm was named John F. Allen & Company. Once again, Ginter had proven himself the master of his own destiny.

He had good reason to believe he could find prosperity for the Richmond firm if he put his shoulder to the wheel. "Tobacco is king, in Virginia at least," he would soon attest in company literature. "It is to the state what the grape is to France or tea is to China."[129]

The tobacco trade had been a staple of the Virginia economy ever since the early days of the Jamestown settlement—in fact, tobacco was the currency of the colony. Richmond itself had long been a center for the trade of tobacco. Even before Revolutionary times, the leaf was brought to the city by land or water to be received and inspected at warehouses along the river. From there, it was traded, exported or manufactured into various

tobacco products. Tobacco had, over Virginia's history, been the wellspring of more large fortunes than anything else.

Naturally, since Ginter had already lost two fortunes, he was eager to enter a stable field. Then, too, he saw the tobacco trade as time-honored—swirling with stories of the Native Americans, John Rolfe and Sir Walter Raleigh.

The Prodigal Return to Richmond

Old friends to love!—true soul bound to true soul
With olden memories, and traces dear
Of the dead past, claiming the happy tear
That still at sight of each will fondly roll!
—John R. Thompson[130]

When Ginter made his return to Richmond around 1872, he boarded at the Ballard Hotel, an elegant, four-story Italianate building on Franklin Street across from the Exchange Hotel. This put him back in the old capital of the Confederacy, where he was received with open arms. Many of his close, longtime friends were still here, including Joseph Anderson, John C. Shafer and, of course, Reverend Hoge, who was celebrating the twenty-fifth anniversary of his pastorate at Second Presbyterian. John R. Thompson was still in New York.

Although the Confederacy had been lost forever, memories of the war were still fresh. Richmonders felt deeply indebted to the men who had fought for the cause. Known as "a Confederate quick in action, cool in time of danger, and courageous at the most critical point in a charge," Ginter would forever be addressed as "Major Ginter."[131]

By the time he returned to Richmond, the city had undergone the most arduous phase of Reconstruction and was beginning to blossom once more. Many homes had been rebuilt, along with most of the burnt district. The five blocks of Main Street east of Ninth had become—according to architectural historian Mary Wingfield Scott—"one of the most beautiful and harmonious business districts in the country."

The same couldn't be said for a few pockets of the burnt district. John R. Thompson romanticized the ghostly ruins in 1872, writing, "The broken walls of the warehouse are more picturesque than would be the smooth front of a factory that might give occupation to 500 operatives."[132]

Meanwhile, Richmond's economy was hugely different from its prewar boom. All three of its major industries prior to the war—metalworking, wheat and corn milling and tobacco manufacturing—were now crippled. As Ginter pointed out, the tobacco business had "gone to Louisville, New York and other places."[133] Soon, however, he would reenergize tobacco manufacturing in Richmond—and do so beyond anyone's imagination.

THE LITTLE TOBACCO FACTORY ON FRANKLIN STREET

What bread is to the inner man, tobacco is to the pocket of the Virginian.[134]

As a new day dawned, Major Ginter joined John F. Allen at his small factory on the north side of East Franklin Street near Fifteenth. This was just a short block down the hill from the Ballard Hotel, where he was boarding.

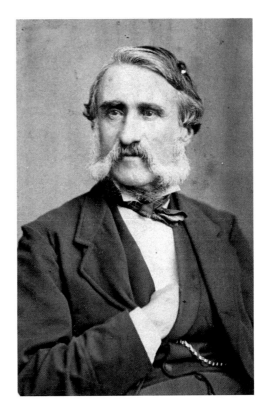

Ginter's first partner in tobacco, John F. Allen. *Photo by C.R. Rees. Valentine Richmond History Center.*

John F. Allen & Company manufactured chewing and smoking tobacco as well as cigars, with its output small at first. Facing stiff competition, Ginter gave 100 percent to building up a flourishing trade. While Allen spent most of his time managing the factory, Ginter traveled extensively to place the company's goods on the market. He also managed all the advertising.

Because Ginter wanted to keep the incredibly industrious John Pope as an employee, he offered the boy a job at the Richmond factory and a place in his household. Ginter assured John's parents that he would take good care of the lad and train him in business.[135] John's parents consented. Over the previous several months, Ginter and Pope had worked closely together and bonded.

Upon John Pope's arrival from New York, he worked Saturdays as a shipping clerk at the tobacco factory and went to school during the week. But he was a born worker, just like Ginter, and he wanted to quit school to work full time. Ginter saw himself in the lad's ambitious eyes. When Ginter was only twelve years old, he had refused to go to school any longer and began working at a store to earn money.[136] There was certainly no way he could deny John Pope his wish now.

Although Pope had no education to speak of, he was quick, ambitious and remarkably energetic. "He was always ready to work and seemed deeply interested in any task allotted to him," said the *Times*. "His extraordinary thrift and executive ability was at no time overlooked by Major Ginter. He watched Pope closely, and was proud of his protege."[137]

By all accounts, Ginter was Pope's mentor in every sense of the word—teacher and trainer; host and guide; sponsor and career role model; and, last but not least, friend and confidant.

In the spring of 1873, about a year into his new career, Major Ginter received horrible news. His old friend, poet John R. Thompson—who'd given voice to the war and its gallant heroes—had died in New York. He'd fallen victim at the age of forty-nine to tuberculosis and the consumption that often accompanies long battles with the disease.

Renewal

The citizens of Richmond were crushed. On May 2, a mass meeting was convened in the hall of the House of Delegates, composed of the press, the bar, alumni of the University of Virginia and many of Thompson's old friends, including Ginter. Mourning their well-known native son, they proposed formal resolutions to his genius, character and achievements, at which time Reverend Hoge spoke of Thompson as "a man pure in morals as well as in taste."[138] The group prepared to receive the returning Virginian with a fitting ceremony.

According to plan, twenty-seven prominent Richmonders—including Reverend Hoge, George W. Bagby and Major Ginter—met Thompson's casket when it arrived by train at the Byrd Street Station at Eighth and Byrd Streets. The funeral was the next day, May 3, at St. Paul's Episcopal Church. During the service, Reverend Hoge delivered a touching eulogy, recalling that Thompson had composed a hymn sung at the church's dedication back in 1845.

Richmonders weren't just mourning the talented writer in death; their hearts ached for all the misfortune he had faced in life. Thompson had long suffered the agonies of tuberculosis and meager wages. Since he had strongly supported the Confederacy, his works had little chance of getting published in the North. Since he'd used pen names, he wasn't credited for much of his work. And two collections of his work that he'd planned for publication had gotten destroyed—one burned in the New York fire of 1856, and the other vanished after it was sent through the blockade to Europe. As Thompson's biographer put it, one collection was "brought to naught by fire, and the other probably frustrated by water."[139]

Buried in Hollywood Cemetery, Thompson was long remembered as a pioneer of Southern literature and—through his moving verse—a celebrant of the brave Confederate warrior. Sadly, however, he would fade into almost complete obscurity.

———◦◦◦———

Yet another disaster came the very same year. This time the tragedy struck the restored Union's economy. Several U.S. banks failed, spurring a depression.

Joseph Anderson and the Tredegar took a big hit because the panic led to the failure of some railroads, which were now their bread and butter.

Within three years, the Tredegar fell into receivership. A number of other Richmond manufacturing plants closed as well, and many local citizens were thrown out of work.

Tobacco prices fell, which may have actually been to Ginter's advantage. By early 1874, he had moved into a two-story house at 4 South Fifth Street in the heart of one of Richmond's most architecturally distinguished residential sections. Fifth Street had been a favorite among tobacconists since the 1850s, so Ginter fit right in.

There, under his new roof, Ginter entertained many prominent Richmond gentlemen like Judge W.W. Crump, J.H. Montague and, of course, Reverend Hoge, who lived just half a block away.

Before long, Ginter even found the means to build his first Richmond home, a three-story brick town house at 405 East Cary Street. The house was convenient to his factory just ten blocks away and nestled among many prominent Richmonders. Across the street was a stucco house with a stately magnolia tree in front—the home of his business partner, John F. Allen.

Major Ginter's sister, Jane, and her daughters, Grace and Joanna Arents, relocated from New York to live with him on Cary Street. Also included in the little family was the diligent clerk for John F. Allen & Company, John Pope, whom Ginter is said to have formally adopted around this time.

Meanwhile, their lives were about to take a dramatic turn.

───◦◦◦───

In Ginter's travels to New York City, ever aware of trends in the marketplace, a new product caught his eye for which there was a mounting fascination. Soon, his biggest secret to marketplace success would become crystal clear: capitalizing on the vogue.

Around late 1874, Ginter made the most momentous decision of his life: to begin the manufacture of a new kind of smoke, called the cigarette. It would profoundly alter the course of his life and have tremendous implications for his beloved city.

Chapter 4
Wealth

S oon, all across the American continent, Major Lewis Ginter would be proclaimed a "Napoleon in Finance."[140] Resembling Napoleon in face and figure, he had a sixth sense in the marketplace and acted on his instincts with lightning speed. But there were many powerful forces at work, some of which this new Napoleon may not have understood.

Either way, five years after his bank was obliterated—and nine years after his Southern home was conquered—Major Ginter would accept nothing less than absolute victory.

PROFFERING THE FASHIONABLE NEW SMOKE

He courted fortune with all the ardor of a lover.[141]

With the depression of the 1870s over, Ginter was convinced that the cigarette verged on mass popularity in America. As ambitious as he was, he wanted to be the one to meet the demand. Over the previous twenty years, he had been afforded a rare view of the emerging popularity of the cigarette overseas and its introduction to America. Now, he was quite possibly the only tobacco manufacturer already in place outside of New York to witness that evolution. It was as if he had a front-row seat at the opening-night premiere.

Back in the 1850s, when Ginter had traveled abroad to purchase fancy goods for his store, the hand-rolled cigarette was a relatively new phenomenon

among the elite of England and France. During the Civil War, the cigarette gained favor among soldiers. There was no time or money for a cigar, and the cigarette calmed nerves before entering battle. Soldiers were often given tobacco with their rations by commissaries—including Ginter himself—and rolled their own. Major Ginter probably shared a few smokes between battles with his war comrades, enhancing their warm, intimate circle.

For a brief time immediately after the war, the cigarette fell out of vogue. But in 1868, while Ginter was running his small bank in New York, the firm of F.S. Kinney was beginning to expand the market. It manufactured hand-rolled cigarettes called Sweet Caporals just seven blocks down Broadway from Ginter's bank.

Since moving back to Richmond in 1872, Ginter had made frequent trips to New York on business. With each successive trip, he saw more and more people take favor with the convenient little smokes. They puffed in the finest hotels. The fanciest restaurants. The clubs. Major Ginter was attuned to all things refined and fashionable—partly because of his well-trained eye in marketing. Compared to the cigar, the slender cigarette seemed to lend an air of savoir faire. It was new. It was chic. Its clean white matched a gentlemen's white tuxedo shirt exactly, making it the perfect accessory along with the bow tie and top hat.

The depression of 1873 gave the cigarette industry a boost. Consumers were eager for the penny-apiece Sweet Caporals and other regional brands made with a blend of domestic and Turkish tobaccos. Toward the end of the depression, Ginter cooked up a competitive edge and talked John F. Allen into entering the nascent cigarette market. But to preempt any other would-be opportunists, the Major knew he didn't have a moment to lose; he had to rush forward with a smart, well-coordinated strategy.

THE ALLEN & GINTER BRAND

Made a lively bid for popular favor.[142]

To get a leg up on the Sweet Caporals, Major Lewis Ginter replaced the expensive Turkish leaf with white burley tobacco grown in Kentucky, which lent itself to the absorption of flavorings and sweeteners like glycerine, rum and licorice. In making a cigarette that compared in flavor to the Turkish

blends but at a lower cost, he helped pioneer the American-blend cigarette, made entirely with domestically produced leaf.

In 1875, Ginter's Richmond factory manufactured its first hand-rolled cigarettes, called Richmond Straight-Cut No. 1. Ginter hired twenty white girls and women with nimble fingers to do the rolling, but his workforce would soon number in the hundreds.

Besides bringing hand-rolled cigarette manufacture to Richmond, Ginter's enterprise showcased his gift for marketing and innovation. Allen & Ginter became the first firm anywhere to package cigarettes, using tight paper wrappers with attractive labels.[143] Ginter designed the packaging himself. "He got up beautiful designs for packing, and many of his conceptions in this line were works of art," said a Richmond newspaper.[144] In effect, his packaging bespoke the quality of his product, much as it had for his linens before the war.

Skilled at attracting the public eye, Ginter stepped up the Allen & Ginter brand advertising. The firm was the first cigarette manufacturer to widely market and distribute its goods in America. Its judicious advertisements touted the superiority of Richmond Straight-Cut No. 1 cigarettes, which were "made from the brightest, most delicately flavored, and highest cost Gold Leaf grown in Virginia."

Ginter also cooked up an ingenious device that would keep the cigarette packages from getting crushed, simultaneously helping promote his brands. He called it "the cigarette card." Inserted into each tiny package of ten filter-less cigarettes, the cards were lithographed with beautiful, color pictures on one side and a tasteful presentation of Allen & Ginter brand information on the other. He would soon develop them into numerous series, featuring an endless variety of subjects. Birds of the Tropics. Flags of All Nations. The "American Presidents" series featured an engraving of Thomas Jefferson.

Ginter's giveaway encouraged collecting, as well as brand loyalty. The ploy, an instant success, is considered the progenitor of the premium marketing concept in America. Anything from baseball cards to Cracker Jack toys can be traced straight back to the marketing mind of Major Ginter.

That first year, Allen & Ginter made more than three million cigarettes. But while interest in cigarettes was on the rise, cigars and chewing tobacco still outsold them by far. Major Ginter had a mighty force to overcome: a certain prejudice against cigarettes. Many felt that cigars were more manly. Pipes were more dignified. And chew was more honest and straightforward.

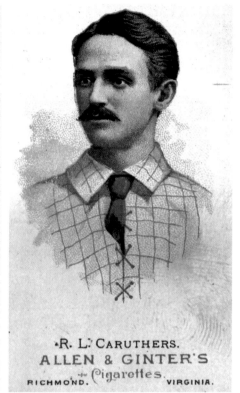

THE WORLD'S CHAMPIONS

ONE PACKED IN EACH BOX OF

TEN CIGARETTES

BASE BALL PLAYERS.	PUGILISTS.
CHAS. W. BENNETT.	JOHN L. SULLIVAN.
JOHN M. WARD.	JAKE KILRAIN.
MIKE KELLY.	JEM SMITH.
JOHN CLARKSON.	CHARLIE MITCHELL.
TIMOTHY KEEFE.	JIMMY CARNEY.
JOSEPH MULVEY.	JACK DEMPSEY.
ADRIAN C. ANSON.	IKE WEIR.
CAPT. JACK GLASSCOCK.	JACK MCAULIFFE.
R. L. CARUTHERS.	JOE LANNON.
CHARLES COMISKEY.	JIMMY CARROLL.

OARSMEN.	RIFLE SHOOTERS.
WM. BEACH.	CAPT. A. H. BOGARDUS.
JOHN TEEMER.	DR. W. F. CARVER.
E. A. TRICKETT.	HON. W. F. CODY (Buffalo Bill)
ED. HANLAN	MISS ANNIE OAKLEY.
WALLACE ROSS.	
JACOB GAUDAUR.	
GEO H. HOSMER.	BILLIARD PLAYERS.
ALBERT HAMM.	WM. SEXTON.
JOHN MCKAY.	M. VIGNAUX.
GEO. BUBEAR.	J. SCHAEFER.
	JOS. DION.
WRESTLERS.	MAURICE DALY.
JOE ACTON.	GEO. F. SLOSSON.
WM. MULDOON.	YANK ADAMS.
THEO. BAUER.	
MATSADA SORAKICHI.	POOL PLAYERS.
J. H. MCLAUGHLIN.	
JOHN MCMAHON.	ALBERT FREY.
YOUNG BIBBY. (Geo Mehling).	J. L. MALONE.

LINDNER EDDY & CLAUSS LITH. N.Y.

·R. L. CARUTHERS.

ALLEN & GINTER'S

Cigarettes.

RICHMOND. VIRGINIA.

Allen & Ginter cigarette card, 1887. *Library of Congress.*

Advertising alone had its limits in reaching Ginter's audience and changing perceptions in a timely fashion. So he decided to bring the people of the world to him.

In 1876, the year after Major Lewis Ginter began manufacturing cigarettes, the centennial celebration took place in Philadelphia. He decided to make good use of this, the first World's Fair in the United States. Looking to entice tobacco merchants and consumers—and tapping into his talents as a fancy-

goods window-dresser—he planned a magnificent display. It was probably the best investment he ever made.

Some of the consumer products making their debut at the fair included Alexander Graham Bell's telephone, Heinz Ketchup and Valentine's Meat Juice, a patent medicine made from beef juice developed by prominent Richmonder Mann S. Valentine II.

There at the centennial, Major Ginter displayed his chewing tobacco, smoking tobacco and, most significantly, his new package of cigarettes. They were called Richmond Gems. Lauded for his "cigarettes of beautiful finish and excellent quality," Ginter carried off numerous prizes—including the coveted bronze medal.

There were ten million visitors to the centennial during its six-month run, although many of them were repeat visitors. Tobacco merchants from all over the world were fascinated by Ginter's smart packaging. And once people sampled the Richmond Gems in those smart packages, cigarette prejudices quickly melted away. In fact, the centennial marks the birth of the cigarette—and the telephone—in America.

Ginter discovered the ideal vehicle for his cigarettes to reach an international market—the World's Fair—and would do repeat performances in Paris, Sydney, Melbourne, Chicago and New Orleans.

Encouraged by the Centennial Exposition and his growing success in the States, Major Ginter began expansion to Great Britain. Around 1877, he hired an agent named John Morgan Richards, who had gotten Londoners excited about the patent medicine Carter's Liver Pills. Richards said there wasn't a single American cigarette sold in England at the time, adding, "Englishmen did not then care for cigarettes."[145]

Richards printed up hundreds of posters and posted them throughout London in the middle of the night. The next morning, thousands of people saw the poster, with an engraving of a Quaker smoker wearing a broad-brimmed hat and this headline: "Smoke Richmond Gems." This "teaser ad," as we now call it, created quite a stir. Soon, many orders were coming in from London for Allen & Ginter's cigarettes.

The Allen & Ginter trademark, "the Quaker smoker," plastered everywhere throughout the civilized world.

Major Ginter, with help from Richards, had popularized the cigarette in London, and the Quaker smoker became the Allen & Ginter trademark. For about two years, Allen & Ginter were the only American cigarettes available in London.

In 1877, Ginter displayed his goods at another exposition—this time in Sydney, Australia. Though it technically wasn't a World's Fair, he proudly stated that his firm "received the highest premium awarded by the New South Wales Agricultural Society…a silver medal and honorable mention."

Then, in 1878, he displayed his goods at the World's Fair in Paris, the biggest and most exuberant World's Fair to date. There, among hundreds of exhibits, Thomas Edison displayed his phonograph. In a ceremony at the fair's end, John F. Allen & Company was awarded a silver medal, along with 223 other exhibitors.

Then Ginter went directly to Paris. After engaging the services of agent Monsieur Jacques Zebaume, his Richmond cigarettes quickly "became even more popular than in London, and a large trade was established in the gay capital."[146]

———<>———

In 1880, Major Lewis Ginter was crowned king. The Allen & Ginter brand had become the uncontested leader in ready-rolled cigarettes on the North American continent. That same year, while the firm's number of employees climbed to 350, Allen & Ginter won yet another prize medal at the World's Fair—this time at the Melbourne International Exhibition in Australia.

Major Ginter's ambition didn't let up for a second.

An Eye to Mechanization

As of 1876, the cost-per-thousand for the standard factory hand-rolled cigarette was ninety-six cents, of which all but ten cents went to pay the rollers.[147]

Almost from the start of his enterprise, Ginter knew that mechanization could lead to enormous savings in production. Industrial America was on the rise; machines were knitting stockings, stitching shirts and dresses and producing nails by the boxcar-load. Some cigarette-rolling machines had already been developed, but they were clunky and practically worthless. They had inconsistent results, tore the rolling paper and often broke down.

Just as the Gilded Age began, with men plotting their fortunes, Allen & Ginter offered the then-enormous prize of $75,000 to anyone who could create a *practical* cigarette-rolling machine.

In 1876, a young man living near Lynchburg, Virginia, spotted Allen & Ginter's announcement. James Bonsack had practically grown up at his family's woolen mill in Lynchburg, Virginia. He entered Roanoke College in 1878 but left within a year to set up a workshop at his father's mill. Then he began to experiment.

One technical issue was measuring the tobacco consistently and accurately, but Bonsack found the answer right there with the mill's carding machine. Another issue was how to form the paper cylinder. Bonsack planned to use a tapered tube for the task but learned that a New Yorker had patented a similar but ineffective device in 1876. Bonsack's father reportedly

paid $18,000 for the rights to the earlier patent. The only remaining issue was cutting the cigarettes into a uniform length, so Bonsack devised a complicated blade.

In September 1880, one month shy of his twenty-first birthday, Bonsack filed a patent for his one-ton behemoth and on March 8, 1881, received patent number 238,640. Soon, he loaded the steam-powered prototype into a boxcar to ship to Allen & Ginter.

But disaster struck. The boxcar burned in the railyard at Lynchburg, and Bonsack's new machine was destroyed. Once he collected on insurance, he went right to work making another machine, even better than the last. Major Ginter would simply have to wait.

<hr />

In 1881, while Allen & Ginter had achieved considerable success with its cigarettes, the cigar and chew still dominated the tobacco market.

Major Ginter's enterprise shifted gears into overdrive. First, it moved to bigger quarters at the southwest corner of Seventh and Cary Streets. The structure had a long history as a tobacco factory and had been taken over for use as a hospital during the war. Right beside the Allen & Ginter factory, at the southeast corner of Sixth and Cary, was Valentine's Meat Juice Factory.

Ginter was "exacting in his demands during business hours," yet his employees loved him.[148]

When Major Ginter moved to larger quarters—with mechanization a potential game changer—John F. Allen grew uneasy. He decided to retire. Allen "had always been conservative and very timorous of his partner's enterprise and dash." For one thing, Allen thought Ginter spent too much on advertising. But it could have also been the prospect of mechanization and the $75,000 prize offer that sent Allen over the edge. "Wealth had no allurements for Allen, particularly if its acquisition brought cares and risks," said the *Dispatch*. "Ginter was of a more ambitious turn of mind."[149]

Reportedly, Ginter bought Allen out for an amount between $65,000 and $100,000. Then Allen was free to pursue his passions: painting and promoting music appreciation in the city. He even painted stage scenery.

Finally, in June 1881, Ginter took delivery of Bonsack's cigarette rolling machine for a trial period. Overflowing with anticipation, he installed it and set it into motion. Although this machine may have been a little better than its predecessors, it had some of the same old problems—the results were inconsistent, the paper tore and the machine sometimes got jammed with flying bits of tobacco and broke down.

Major Ginter was at a crossroads. One consideration, of course, was the $75,000 reward offer. At the same time, his fears mounted that the cigarette—up to then a handcrafted luxury item—would not sell if made by machines. Perhaps they seemed cold and impersonal compared to his award-winning handmade product. There was also the fact that mechanization would force him to reduce his labor force—a difficult choice for a kind Southern gentleman and philanthropist. Ginter had a soft heart for the women and girls who did the hand-rolling work. Many of them provided support for their families—prominent Richmond families—so he would have found it difficult to injure so many of his fellow citizens.

After carefully evaluating the situation, Major Ginter decided to pass on Bonsack's machine. In just a few short years, that decision would prove to be the most monumental miscalculation of his career.

<p style="text-align:center">⸺◦∞◦⸺</p>

As Ginter continued onward in his established ways, the savvy Joseph Anderson had finagled Tredegar out of its debt crisis. Now, it was successfully funded and back on track. Anderson also served another two-year term in the House of Delegates.

Meanwhile, Reverend Hoge had just celebrated his thirty-fifth year as pastor of Second Presbyterian Church. Although Ginter wasn't a member of the congregation, he was well acquainted with Hoge's oratory. One of Richmond's most highly demanded public speakers, he opened practically every public gathering with prayer. In 1875, he gave a long and lofty speech at the unveiling of a Stonewall Jackson statue on the Capitol grounds—the first monument to a fallen Confederate leader in the city. The Lost Cause movement was just striking up its band.

With about forty thousand people in attendance—some of whom had served under Jackson—the sprawling crowd surpassed Reverend Hoge's view. As eloquently as ever, he expressed hope for the Union, quoting Thomas Jefferson and George Washington. At the close of his delivery, looking to the Confederate past, he repeated the words of Stonewall Jackson that for many had defined the war effort: "What is life without honor? Degradation is worse than death. We must think of the living and of those who are to come after us, and see that by God's blessing we transmit to them the freedom we have enjoyed."

Then, Hoge shouted, "Heaven! hear the prayer of our dead, immortal hero!" The massive crowd roared—with Major Ginter perhaps the loudest.[150]

CIVIC ENGAGEMENT AND PHILANTHROPY

He was in every sense a public-spirited man.[151]

With his phenomenal business expertise, energy and enthusiasm, Major Lewis Ginter was devoted to serving the city he loved—and the veterans of the war—however he could. While answering the same sense of duty that had propelled him into war service, he embraced the virtues of self-sacrifice extolled by the Lost Cause.

In the spring of 1881, while Richmond's homes, businesses and streets were still lit by gas, Ginter was looking to the future. Again. He joined forces with five other men and took the initiative in the new field of electrical power in the state. On the heels of Thomas Edison's demonstration of the incandescent light bulb and the installation of New York City's first streetlights, they chartered the Virginia Electric Lighting Company. But just as their enterprise was poised to capture this burgeoning market, they faced competition from the city itself. In 1883, Richmond's Common Council chartered two power companies in hopes that competition would bring lower rates and better service. Two years later, the city began work on its own power plant, and in 1886, the plant generated electricity for the city's first streetlights.

While it's rumored that today's Virginia Power is an outgrowth of Ginter's electric company, there's no evidence to suggest that his enterprise even got off the ground. Perhaps he sold the rights to it. Or perhaps the competition from the city was just too, well, overpowering.

Ginter became active in the Richmond Chamber of Commerce and, in 1885, served as one of its thirty-eight vice-presidents, along with Joseph Anderson and James Dooley. Dedicated to Richmond's prosperity, the chamber also appropriated funds for the city's charitable organizations. Ginter made proposals to fill gaps in city services, like urging the creation of an emergency hospital.

He was also involved with the Lee Camp Soldier's Home. Organized by a group of Confederate veterans, it opened in Richmond in 1885 as a place to care for the needy ex-Confederate soldiers. It originally consisted of an old house on thirty-six acres on the west side of the Boulevard at Grove Avenue. Then, with many ex-soldiers applying for admission to the home, several gentlemen built and donated "handsome and commodious" cottages. Major Ginter was one of the first. In 1885, construction began on his Stonewall Cottage. He felt indebted to the maimed and battle-scarred veterans who had staked everything on the South's "great issue," so he also served on the home's Board of Visitors.

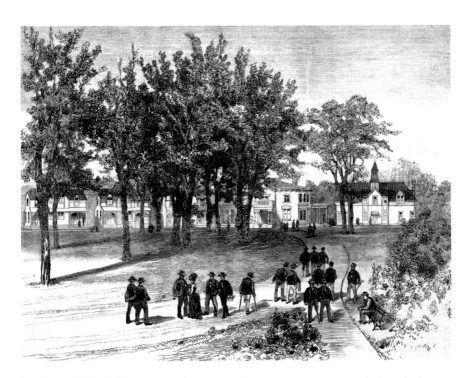

Lee Camp Soldier's Home was a place to care for needy veterans, some of whom had missing limbs. *VCU Libraries.*

Major Lewis Ginter's philanthropic stance may seem at distinct odds with his manufacturing of cigarettes. Yet he was very much a product of time and place. As Richard Kluger points out in his Pulitzer Prize winner, *Ashes to Ashes*, the then-prevailing view was that smoking was harmless if done in moderation.[152] Doctors, in their white coats, nodded their heads in agreement. Some even asserted that smoking was *good* for the health because—among other things—it aided digestion, reduced stress and cured gout. An editorial in the *Richmond Dispatch* (reprinted from the *Boston Pilot*) went so far as to say that "the habit of smoking is…not more injurious to health than the habit of pie-eating."[153] As ludicrous as all of this sounds today, the medical establishment would hold firm to its position until the 1950s.

Richmond had always been immersed in the tobacco culture. Not only was tobacco use widespread, but the "divine herb" was seen in a positive light for its role in the city's economic well-being. Reverend Hoge reflected public sentiment when praising Ginter for "sustaining the great enterprises by which the prosperity of the whole community [was] advanced."[154] Smoking Ginter's cigarettes was equated with civic pride and patriotism.

For centuries, tobacco had been proclaimed "the great consoler, and the democratic luxury." It shouldn't be surprising, then, that Allen & Ginter's company literature said that tobacco was "the material through which the enjoyment of one of the greatest luxuries of life, that of smoking, is attained," and even that "viewed as regards health and comfort, it may be looked into with decided profit."[155]

Back then, as Ginter was successfully popularizing the cigarette across the globe, Virginians were no doubt impressed that he was perpetuating the tobacco tradition in an innovative way. And anyone who smoked his cigarettes certainly appreciated the new brand of pleasure.

GUSTO FOR LIFE

We hold these truths to be self-evident, that all men are created equal, that
they are endowed by their creator with certain unalienable Rights, that
among these are Life, Liberty and the pursuit of Happiness.
—Thomas Jefferson

By 1881, a few small Richmond firms had followed Allen & Ginter into the manufacture of cigarettes. That year, cigarette manufacture in the city jumped to sixty-five million, up from three million just six years earlier.

The Richmond Chamber of Commerce couldn't have been happier. "The bulk of the cigarettes used in the London clubs are made in Richmond," boasted a chamber publication in 1882. Most of those Richmond cigarettes were crafted by Allen & Ginter.

Then, in February 1883, a momentous change came for Major Lewis Ginter. He proudly announced the addition of John Pope to the partnership.[156] A natural in business and a dedicated worker, the twenty-seven-year-old had quickly climbed the corporate ladder from packer to superintendent. Having been molded by Lewis Ginter, there was a deep level of trust between the two men. In fact, Ginter and Pope were much more than just workday business partners. Over the last eleven years, as

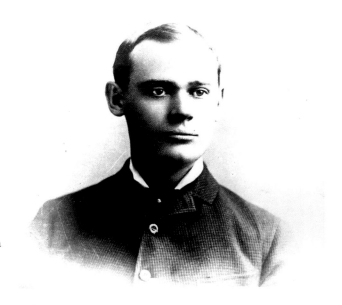

John Pope, Ginter's business partner and close companion, circa 1884. *Cook Collection, Valentine Richmond History Center.*

Pope came into his own as a businessman and became Ginter's right-hand man, they had cemented a lifelong personal and professional relationship.

And while Ginter idolized Thomas Jefferson, it seems that John Pope had an idol of his very own. His name—Lewis Ginter. Pope adopted Ginter's business and civic principles to the letter. Although Ginter was more outgoing than Pope, they had similar interests and were both modest, unassuming and compassionate. The pair continued sharing homes.

This close relationship was clearly an important element of Ginter's pursuit of happiness—an ideal that was at the core of Thomas Jefferson's beliefs. Jefferson actually asserted it was a nothing less than a moral obligation.

Ginter lived life with joy, a true *joie de vivre*. He was enthusiastic about everything around him. He took time to smell the roses, literally, and enjoyed all the other simple pleasures in life. The rich purple of the Virginia mountains. The sparkle of fine crystal. The comforting warmth of close family.

Not to mention the fact that he was playing a major role in building Richmond back up as a business center after the war. In 1883, the editor of

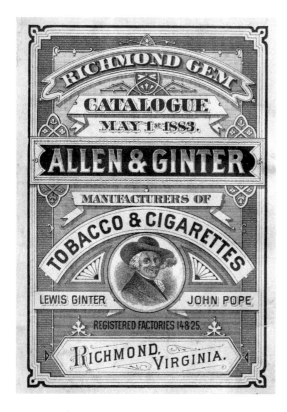

Ginter and Pope's *Richmond Gem Catalogue*, 1883. *Valentine Richmond History Center.*

the *Richmond Mercantile and Manufacturing Journal* wrote, "The steady growth of the manufacturing interests of Richmond is the most assuring and gratifying evidence we can have of the increased prosperity of our city." He pointed to the rise in cigarette making as a big part of the picture.

Then the cigarette got another boost: the federal tax charged to manufacturers was reduced—savings that could be passed on to the consumer.

Just eight short years after Major Lewis Ginter began manufacturing cigarettes, he found wealth for the third time. According to one paper, "His sudden and rapid rise from competence to wealth is one of the most phenomenal instances to be found in the commercial history of Virginia."[157]

But there was trouble. A devious, well-armed man was hiding behind all those mountains of tobacco leaf.

A redheaded upstart named James Buchanan Duke, who had begun making cigarettes in Durham, North Carolina, decided to give the Bonsack machine a try. Encountering technical problems, the Bonsack Company sent a mechanic to work out the kinks. On the last day of April 1884, Duke's machines worked perfectly for an entire ten-hour day, making some 120,000 cigarettes. Swiftly and secretly, he entered into detailed negotiations with the Bonsack Company.

Apparently unaware of this development, Ginter threw a lavish ball and supper for his employees in February 1885, with about seven hundred people in attendance. John Pope officiously managed the event. For musical entertainment, Ginter hired a band and a twenty-five-member orchestra. The musical program consisted of forty-two numbers, beginning with the peppy march "Richmond Straight-Cut No. 1." The Allen & Ginter employees danced with pride and glee into the night.[158] But the Major's firm was dealt a sobering blow just two or three months later, when Duke cemented his deal with the Bonsack Company. Duke's cutthroat tactics were beginning to show. In the event that one of his competitors decided to take up the machine, the deal gave him a 25 percent lower royalty fee. Suddenly, Duke was able to cut the price of his cigarettes in half.

As if that weren't enough to challenge Allen & Ginter and his other top rivals, Duke started advertising heavily, overwhelming his rivals' resources. Also adopting Ginter's innovation—the cigarette card—it didn't take long for Duke to win top market share.

To say the very least, Ginter regretted having not seized the Bonsack machine when he had the chance. Even after finally adopting Bonsack's machines in 1887, he maintained a large force of women and girls for hand rolling and machine operation. It allowed the girls to maintain their livelihoods. It also allowed him to offer the traditional, handcrafted item for those who preferred it.

This gentlemanly, Victorian approach to business was at the opposite end of the spectrum from Duke's—as would soon become painfully clear.

DISTINCTION IN THE NEW SOUTH ECONOMY

This house has no merely local fame, its goods are known and appreciated wherever the fragrance of the weed in silvery clouds floats upon the breeze.[159]

By embracing industry, Major Lewis Ginter exemplified the entrepreneur of the New South. Virginia's economic picture was much rosier since the state was focusing less on agriculture, and Richmonders could see the signs of economic progress.

In 1887, the same year Ginter adopted rolling technology, *Harper's Weekly* ran a feature story about Richmond's postwar resurgence. "The leading industry of the city now, as before the war, is the manufacture of tobacco," it said. While comparing three of the largest factories, it described "Allen & Ginter's immense establishment, in which nine hundred white girls and a hundred men and boys make nearly two millions of cigarettes on every working-day during the year." Further, it said:

> *This factory is also characterized by the extremes of neatness and system, and over the moral as well as the physical health of their operatives the proprietors exercise a careful supervision. Among the several beneficent schemes for their mental improvement is a large library filled with the best standard literature, from which every employee is entitled to take, and keep for two weeks at a time, such books as she chooses.*

Major Ginter manning the phones at Allen & Ginter, circa 1885.
Valentine Richmond History Center.

Richmond didn't have a public library at the time, so this was quite a corporate benefit. Ginter even provided a physician and medicines for all his employees free of cost.

Harper's also noted that Allen & Ginter's "colored" male employees sang "old plantation melodies and expressive negro hymns" while they worked. There was even an "intense musical rivalry" between the city's various tobacco firms, "and the acquisition of the good soloist by any one of them" was "hailed with joy."

By the time this issue of *Harper's* came off the presses, Allen & Ginter's cigarettes got yet another boost—receiving an unsolicited endorsement from royalty. Ex-Congressman Hewitt was in Turkey on business and was invited to dine with the sultan. After dinner, the sultan asked his guest to smoke with him and had some cigarettes brought out. But they weren't the highly prized Turkish variety—they were Richmond Straight-Cut No. 1s.

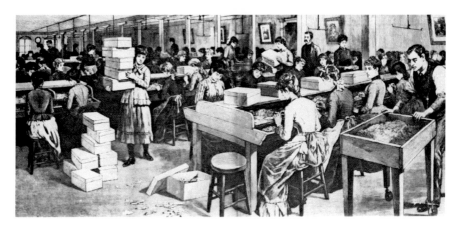

Allen & Ginter's cigarettes were first hand-rolled by white women and girls. *Harper's Weekly.*

"Why, this is unusual," Hewitt said. "I had expected, of course, that His Majesty would smoke his far famed domestic brand. Is this done as a compliment to me?"

"I much prefer the Richmond Straight-Cuts," replied the sultan. "They are my favorites." He, the generally acknowledged connoisseur in such matters, sent over large orders for them.

Allen & Ginter's expansive line of cigarettes also included such names as Napoleon, Dandies, Virginia Brights, Little Beauties and Opera Puffs.

Around late 1887, Ginter and Pope planned to incorporate the successful and prominent firm of Allen & Ginter. About the same time, Major Ginter joined forces with other prominent Richmond businessmen—many of them former Confederates—and put his well-honed entrepreneurial skills to the test.

CHAMPIONING THE NEW NEWSPAPER

A Complete Daily Newspaper For One Cent. Independent, Conservative, Bold, Truthful.[160]

On October 22, 1886, the *Daily Times* made its debut in Richmond. It was an advocate of the Democratic Party, which at the time was dominated by a conservative, pro-business platform.

Five Richmonders chartered the Times Publishing Company. A leading spirit was a man named Page McCarty, who was president and editor-in-chief. A little-known fact is that John Pope was also a charter member and investor and served as secretary for the company.[161] Editor Page McCarty had made headlines himself back in the spring of 1873, when he killed John B. Mordecai in a duel. The lady over whom the duel was fought was Mary Triplett, a ravishing Richmond belle. Like all duels, it was considered an act of honor. McCarty was maimed for life.

But that hadn't stopped him—in fact, now he was an icon to conservative Democrats. As the former editor of the *Democratic Campaign* based in Lynchburg, Virginia, McCarty's "trenchant pen" helped bring an end to the Readjusters' control of Virginia politics in 1883. That put conservative Democrats back in control in the legislature and energized Grover Cleveland's successful run for the presidency in 1884. Now their sights were set on 1888, to keep Cleveland in office.

The *Daily Times* got off to a shaky start financially. McCarty appealed to the Major for help. Since Ginter didn't want McCarty and Pope's paper to fail—and was a staunchly conservative Democrat himself—he agreed to finance it.

Suddenly, Major Ginter was a publisher. He offered the position of office secretary to his old friend Robert T. Brooke. "I don't know anything about running a newspaper," Brooke said. "Never mind about that," the Major replied. "All you've got to do is to come down once a week and pay off."[162]

As things got rolling under Major Ginter's leadership, he felt a lively interest in the paper. He would drop in at the *Daily Times* office on Main Street between Eighth and Ninth to check on things—that is, between his many other pressing engagements.

The paper became popular as a "penny sheet." The problem was, it had stiff competition from the morning *Dispatch* and the evening *State* and couldn't turn a profit. Ginter realized that the paper's incessant demands required more of his time than he had to give. For the first time in his career, perhaps, he realized he'd spread himself too thin.

He decided to cut his losses. Informing his friend Brooke, Ginter said with a smile, "Well, I think I shall resign as president of the company."

"Then I shall resign as secretary," Brooke replied, and the two shared a chuckle.[163]

Luckily for the conservative Democrats, there was someone interested in taking over the paper: the fearless Confederate and member of Mosby's

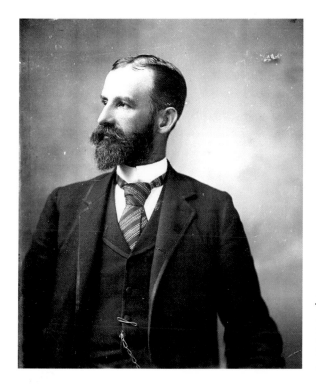

Joseph Bryan, circa 1880, about the time Major Ginter made his acquaintance. *Cook Collection, Valentine Richmond History Center.*

Rangers, Joseph Bryan. He was Major Ginter's close friend and partner in business and civic affairs.

The gist of the deal was revealed by Joseph Bryan's great-grandson, John Stewart Bryan III. "Major Ginter told Joseph Bryan that if he would draw up papers relieving him from any of the *Daily Times*'s future debts, he could have the paper free and clear," he said.[164] In 1887, Bryan had himself a newspaper.

He took over the editorship from McCarty and began learning the ways of publishing. Joseph Bryan was also a leader in Alabama's iron industry and an investor in several railroads, making him a key Southern industrialist. Quite the political firebrand, Bryan would eventually turn the *Daily Times* into a successful advocate of industry, conservative politics and traditional Virginia culture. After a series of mergers, it would become the *Richmond Times-Dispatch*—one of the most successful newspapers in Virginia.

During the 1880s and 1890s, Bryan's newspaper reported on Major Lewis Ginter's remarkable career, civic work and philanthropy, while honoring his desire for privacy in his personal life.

Forging the Richmond Locomotive & Machine Works

An immense locomotive, the property of the Chesapeake & Ohio Railroad Company, was recently sent to Chicago, where it will be exhibited at the World's Fair. Its number was 350, weight 145,000 pounds, with a capacity for holding 3,500 gallons of water. It was built at the Richmond Locomotive Works.[165]

The Tanner & Delaney Engine Company in Richmond borrowed heavily in the mid-1880s to finance its growth. Since the company couldn't repay its loans, bondholder Joseph Bryan had no choice but to take control of the company in 1887. Major Ginter joined forces with the mighty Bryan, reorganizing it into the Richmond Locomotive and Machine Works.

Tanner & Delaney had a long history of manufacturing steam engines, boilers and milling machinery and had begun expansion into locomotives. Bryan and Ginter—in the midst of the railroad boom—aspired to expand the business.

The first president of the Richmond Locomotive & Machine Works was William R. Trigg, and Joseph Bryan was its first vice-president. Major Ginter served as one of the company's directors. He was also a large stockholder.

With all this entrepreneurial muscle—and the money to back it up—the Richmond Locomotive & Machine Works quickly chugged to new heights. Specializing in machinery for steam power, the company manufactured locomotives, stationary engines and boilers. It also made sawmills, gristmills and even street railway equipment, including streetcars.

The company had two plants, both built prior to the reorganization. One was in Shockoe Valley at the north end of Seventh Street, built in 1882. The other was at Boulevard and Leigh Streets, built in the mid-1880s.

In 1887, the Richmond Locomotive & Machine Works rolled its first locomotive off the line. By the next year, it could provide complete steam plants for electric light and power stations—a technology in its infancy.

The next year, the works shipped a twelve-ton boiler for use in a towboat in New York. Then the firm won the contract from the U.S. government to build the propulsion machinery for the battleship *Texas*. In 1891, fire struck the Shockoe Valley plant. Destroyed were the boiler shop and much of the machinery then under construction for the *Texas*. Despite the setback, the firm successfully completed the contract.

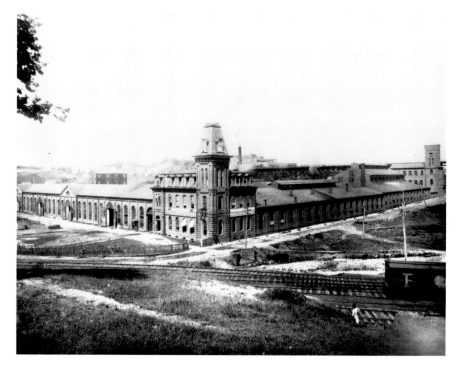

Richmond Locomotive & Machine Works in Shockoe Valley. The firm capitalized on the railroad boom. *Library of Virginia.*

Within two years of the fire, the works were rebuilt, and the shops—covering some twenty-four acres—employed more than eight hundred men.

In 1893, the Richmond Locomotive & Machine Works exhibited one of its steam locomotives at the World's Fair in Chicago. The Tramp, as it was called, advertised Richmond as a manufacturing center.

In 1895, while the Richmond Locomotive & Machine Works employed a whopping 1,200 men, the press heralded it as the only locomotive manufacturing plant in the entire South.

Three years later, when the company's president, William R. Trigg, left to start up a shipbuilding company in Richmond, Joseph Bryan stepped into the top slot.

Despite outward signs of success at the Richmond Locomotive & Machine Works, Bryan and Ginter had their disappointments. Because of the economic downturn of the 1890s and the bankruptcy of weak railroads, the company struggled financially. Another problem—at least until the late 1890s—was that it relied almost entirely on brute strength rather than

efficient mechanization. At times, "the operation of nearly a whole shop [was] suspended while a swarm of colored laborers were moving heavy parts that a crane would have carried to its place in a few minutes."[166]

At its peak, the Richmond Locomotive & Machine Works produced about two hundred locomotives a year. They were sent all across the United States, as well as to Sweden and Finland.

Since Ginter was involved in this enterprise along with his massive cigarette factory, it was said in the 1890s that he "was instrumental in keeping a larger number of people employed than any other man that ever lived [in Richmond]."[167]

<center>—◦∞◦—</center>

In 1887, the same year Major Ginter adopted rolling technology and formed the Richmond Locomotive & Machine Works, he took his first step in moving out of his home on East Cary Street. He was responding to a new trend—not to mention his wealth and creative urges.

Many of his friends had built their homes in what was called the "new west end" of the city, which was emerging as the fashionable residential district. It centered on Franklin Street, between Belvidere and Allen Avenue. Several connecting lots were available at the southwest corner of West Franklin and Shafer Streets.

Shafer Street had taken its name from John C. Shafer himself, Ginter's longtime friend. Shafer's home bordered the street on Park Avenue. In fact, he had gotten into the real estate development business and owned several lots throughout the area—including the ones of Ginter's fancy.

The relationship between Lewis Ginter and John C. Shafer was "almost brotherly," and now they would be close in more ways than one.[168] In May 1887, Ginter purchased the large lot with plans for building his dream home back to back with Shafer's residence.[169]

Thomas Jefferson once said, "In matters of style, swim with the current; in matters of principle, stand like a rock," and Ginter latched on to an architectural style that had recently hit the scene in major U.S. cities. At the same time, he zeroed in on a brilliant architectural firm from Washington, D.C.

AN AUSPICIOUS VOYAGE AROUND THE WORLD

Uncle Lewis made us laugh saying he had not expected to get into the bush so soon.[170]

In the summer of 1888, just weeks after Richmond became the first American city with a successful electric streetcar system, Major Ginter took a first-class trip around the world with his favorite niece, Grace Arents. Their ultimate destination was Australia, where Ginter was to exhibit the goods of his tobacco firm at the Centennial International Exhibition in Melbourne. Although he was unaware just now, Australia's lifestyle would inspire him to change the face of Richmond.

Fortunately, Grace kept a travel diary—one of the few journals in Ginter's family to survive. It gives us the extraordinary opportunity to travel with them and get a crisper view of their personalities.

Their departure on Thursday, June 14—to their surprise—was filled with fanfare. Grace wrote:

> *Uncle Lewis and I left Richmond by the 11 AM train—starting on what may be a trip round the world. On our way to the station we passed the [Allen & Ginter] factories and the farewell demonstrations were quite wonderful & touching. Every window of the two buildings was crowded with faces…and there was great waving of handkerchiefs and shouts of goodbye. Quite a party of friends were at the station to see us off, and we had a serenade there from a band of colored men, employees of the firm.*[171]

This whole sendoff rings of John Pope's handiwork.

After a brief stop in Washington, it took a little more than twenty-four hours to get to Chicago. There, they checked in to the exquisite Palmer House hotel, a favorite among American presidents. The next afternoon, they went for a long drive by carriage and were impressed by the architecture and public parks.

Leaving Chicago by train, they traveled through the rich farmlands of Iowa and onward to Omaha, Nebraska. There, they boarded the Overland Flyer, an express train to San Francisco through the breathtaking, Sierra Nevada range. Even in June, the mountains were still capped with snow.

Finally, after a four-day train ride, Ginter and his niece pulled into the station at Oakland, California. After crossing the San Francisco Bay on a double-decker ferry, they checked in to San Francisco's deluxe Palace Hotel. Over the next few days, the pair toured the city, with its steep hills and cable cars. They attended the theater together. They also took a two-night jaunt to Monterey, touring the breathtaking Pacific coastline by carriage.

Once back in San Francisco, they took another scenic drive along the Bay Shore through the old Spanish fort called the Presidio. Then, just about the time Ginter and his niece were lunching at an eatery on a bluff overlooking the ocean and the Golden Gate—watching seals play on the rocks below—John Pope was at an auction in Richmond, bidding on a seventy-three-acre estate about three miles north of the city's commercial district. It was known as Westbrook, and Ginter supposedly had expressed some interest in it before his voyage. When the auction ended, Pope was the highest bidder. Soon the estate would be a summer residence shared by he, Ginter, Jane and Grace.

From San Francisco, Ginter and his niece set sail on July 1 aboard the *Mariposa* of the Oceanic Line. The next day, as they steamed across the Pacific, Allen & Ginter was officially incorporated back in Virginia.

After Grace and her uncle made a brief stop in Honolulu, they began their long voyage to Australia. Part of it was rough—nearly tossing them out of their berths in the middle of the night—so they were glad to arrive on schedule at Sydney Harbor on the afternoon of July 25. There, they were greeted by Allen & Ginter's agents in Australia, Mr. Todman and Mr. Hyde.

After dinner, they took a local train to Hyde's home in the suburbs and arrived at his stop in Homebush within forty-five minutes. "Uncle Lewis made us laugh saying he had not expected to get into the bush so soon,"[172] Grace wrote.

After being served cake and wine, their hosts took them to see their conservatory and orchid house. "It was large & full of beautiful palms, ferns and many strange plants," Grace wrote. "There was also an orchid house where many varieties of these strange plants were quite at home."[173]

Spending a day in Sydney, they made a point to visit the botanical gardens. Grace was unwittingly drawing inspiration for Richmond, much like her uncle.

They went by train to the province of New South Wales and then by carriage to the city of Melbourne on June 27. Finally, they'd reached their ultimate destination, where the World's Fair was to begin just days later.

After they took a "one-horse shay" to their hotel and had lunch, Ginter headed for the exhibition buildings with his agent. In the run-up to the fair, while Ginter was busy putting his elaborate exhibit together, Grace explored the city on her own.

On Wednesday, August 1, she attended the fair's opening ceremonies, which were filled with pomp and circumstance. The fair had hundreds upon hundreds of exhibits, from sewing machines and carriages to beer and bitters.

Because of Ginter's gift for presentation, his tobacco was "arranged with strikingly picturesque effect." One showstopper was a model of his factory, eight feet by four feet, made from tobacco leaf. Another, made from the same material, was a model of the globe, nine feet in circumference, with "the leading continents, islands, and seas being carefully mapped out." Also, built out of cigarettes, was a cannon. Ginter had his attractive packages of smoking tobacco and cigarettes on full display, while Allen & Ginter was the number one seller of cigarettes in Australia.

Grace spent two days visiting the exhibits. On Sunday, August 5, she and her uncle took a walk through some of the city parks and out to the botanical gardens. "It was a beautiful afternoon, bright and sunny, and we enjoyed it ever so much,"[174] Grace wrote, describing a lovely lake with striking black swans.

A few days later, they were invited to dinner at a home in the suburb of Hawksbury.

Since this may not have been Ginter's first trip to Australia, he had previously become enchanted by the beauty and lifestyle of these country estates and streetcar suburbs. For Ginter, these images were as indelible as those of the war.

On August 10, Grace and her uncle began their long voyage back to the States—but there were still many glorious sights ahead of them. First, they took a train to Balladat, the third largest city in Victoria. "We went to the botanical garden of which every town in Australia seemed to boast,"[175] Grace wrote.

That evening, they boarded the train bound for Adelaide. There, they took a carriage ride, delighting in the broad, handsome streets and imposing public buildings. "We decided if we had to live in Australia we should like our residence to be in Adelaide," Grace wrote. "We were charmed with the botanical garden. I think it decidedly the best we have seen at all."[176]

The following afternoon, after a pleasant tour of the zoological gardens, Grace wrote, "This is our last Sunday in Australia—tomorrow we sail again. It has been but a short visit to this faraway land—yet I think I shall carry away some pleasant vivid memories."[177]

The next day, they took a train from Adelaide to Largs Bay, where they boarded the SS *Arcadia*. After thirteen days on the Indian Ocean, their long sail home took them up the Red Sea, through the Suez Canal and across the Mediterranean Sea to the ancient country of Italy.

On their long journey back to the States, they made a stop in the fashionable city of London. Ginter knew the streets of London as intimately as those of Richmond, so they no doubt enjoyed some of the finest cultural sights, like Trafalgar Square or the regal Buckingham Palace, perhaps.

Even though Major Ginter's trip around the world was over, there was one more sight to see: Westbrook, the country estate that John Pope had purchased for them. It's unclear whether Pope informed him of the

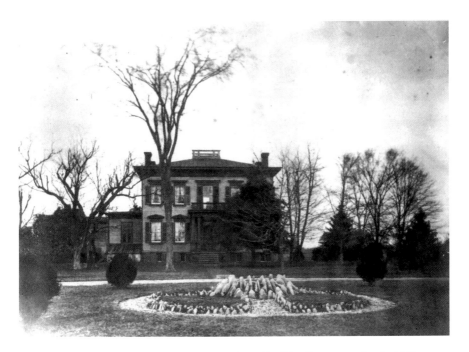

The original Westbrook plantation home, purchased by John Pope at auction in 1888. *Valentine Richmond History Center.*

purchase during the trip or waited until Ginter returned to surprise him. Regardless, Ginter would soon live the lifestyle that had so captivated him in Australia.

Not coincidentally, his new country home was about a mile north of Laburnum, the palatial 1885 home of close friend Joseph Bryan. Chances are, Bryan and his Victorian-style mansion on Brook Turnpike helped spur Ginter's interest in the area.

But the area already held deep significance for him. When General A.P. Hill first arrived in Richmond in 1862 to defend the city, his first camp was in the woods at Young's Pond just across Hermitage Road from Westbrook. It was there that Ginter entered field service and began his long association with the general.

In 1888, when Westbrook became home to Ginter and Pope, it included an antebellum mansion, a kitchen and several other outbuildings. It also had a first-class apple, peach, pear and cherry orchard, as well as a fine terraced garden, making it one of the most desirable suburban residences near

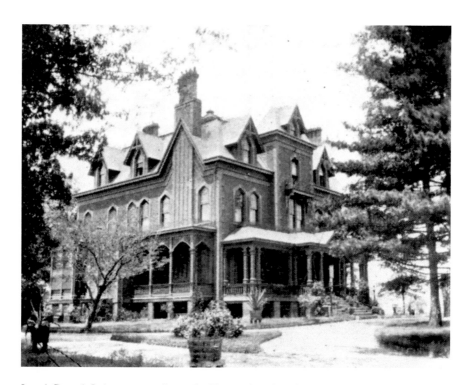

Joseph Bryan's Laburnum, easily reached by carriage from Westbrook. *VCU Libraries.*

Richmond.[178] It was about half the size of the original Westbrook Plantation established by Thomas Price in the 1770s, which encompassed nearly six hundred acres. Westbrook was originally named for its situation west of the Brook Church, which was near the southwest corner of present-day Brook Road and Dumbarton Road. By 1888, the church was just a memory, having gotten torched during the Civil War.[179]

The most recent long-term resident of the Westbrook estate and its 1815 mansion was the "noble-looking" John Brooke Young. One of the most celebrated criminal lawyers in Virginia, he had been a longtime prosecuting attorney for Henrico County. He died there at the Westbrook mansion in 1886, and it was from his 279-acre estate that John Pope purchased the house on 73 acres.

With his typical enthusiasm, Ginter embarked on a massive renovation of the house. He put his faith in the twenty-seven-year-old Richmond architect Edgerton S. Rogers, whom he'd probably met through the city's social clubs. Born and educated in Rome, Rogers would soon design James Dooley's mansion of stone, called Maymont.

The new Victorian design for Westbrook, however, would require tearing down part of the original structure and enlarging it—with attention to style and good taste, of course. (Thomas Jefferson once said, "Architecture is my delight, and putting up and pulling down one of my favorite amusements.")

The Bloomingdale Stock Farm Comes Alive

The cattle barn to shelter the beautiful herd of thoroughbred Jerseys...is a model for comfort and cleanliness, so important for health of cattle and purity of milk.[180]

Major Ginter, together with four other gentlemen, chartered a new enterprise in December 1889. The Bloomingdale Stock Farm bought, raised, bred and sold livestock. Encompassing 280 acres, it included a farmhouse and barns for its herd of Jersey cattle. Just to the north of Ginter's Westbrook estate, it was bounded on the west by Old Hermitage Road and on the east by Upham Brook.

The name "Bloomingdale" was probably suggested by Ginter in homage to the area in New Amsterdam where his Dutch ancestors lived. (The word

"Bloomingdale" was Anglicized from "Bloemendaal," the village in Holland that was home to Ginter's ancestors.)

Beginning in 1819, the Bloomingdale Stock Farm property was part of the Mordecai family plantation called Spring Farm. For two years in the early 1830s, it was actually the site of the Virginia Baptist Seminary. Since then, the institution had relocated to the city. Later, it would become Richmond College and, even later, the University of Richmond.

When Ginter and the others secured the Bloomingdale property, it was "almost a desert waste." But before long, the place was "well-cultivated, producing yearly a splendid crop of grain and forage, while the stables and barns cover[ed] an area of several acres."[181]

The Bloomingdale Stock Farm operated a first-rate dairy. In fact, it was there in 1891 that the first steam-powered butter extractor was introduced in Virginia. Its farm brand of butter was proclaimed "fit for the most fastidious epicure."[182]

In raising horses for market and preparing them for various competitions, the farm trained them in jumping, hunting and trotting. Not surprisingly, Bloomingdale earned a reputation as a "model stock farm."

The men who headed up the enterprise brought an impressive balance of business expertise to the farm table. Serving as president and a director was Milton Cayce, manager for Allen & Ginter's leaf department and a cattle breeder. John Pope served as vice-president and a director, and Lewis Ginter served as a director. Another director was Harry C. Beattie, experienced in high finance and cattle breeding, who would manage the day-to-day operations of the farm. The last director, serving as secretary and treasurer, was E. Victor Williams. Only in his twenties, he was working his way up in Ginter's tobacco firm, having started out as an office boy at the age of sixteen. Ginter was "a true friend and adviser" to him "in many hours of trial."[183]

Many promising Richmond businessmen came to Ginter for advice, and he took pleasure in mentoring them. He "surrounded himself with young men," said John Stewart Bryan I. "He made money for some of them, he made friends with all of them."[184]

THE NEW CONFEDERATION: AMERICAN TOBACCO

The rumor of the sale began to take shape Thursday night.[185]

Throughout the 1880s, Major Ginter's cigarette enterprise gained strength and, by the end of the decade, was one of the largest enterprises of any kind in Richmond. At Allen & Ginter's mammoth cigarette factory in 1888, there were "500 people preparing the weed, and 1,000 young ladies with nimble fingers converting it into cigarettes and packing them into the dainty boxes preparatory to being sent to all parts of America, Europe and the world," said the *Times*.[186] Machines were still doing their part, too. According to one source, the machines made Ginter's production increase from one million cigarettes a month to two million a day.

Around this same time, Allen & Ginter's prominence in the tobacco industry was touted by a Manhattan magazine. In part, it read:

> *The firm-name of Allen & Ginter is celebrated throughout the world as that of the leading manufacturers of cigarettes and smoking tobaccos. Their fame is based strictly upon the merits of their goods, which are pronounced by the most critical experts. There are few, indeed, who cannot speak from personal test of the superiority of such delicious fragrant cigarettes as "Richmond Straight Cuts," "Pets," "Richmond Gems," etc…To-day the house ranks first every way, and the partners, Mr. Lewis Ginter and Mr. John Pope, are worthy exponents of one of the leading American industries. The works at Richmond are most extensive, from 1200 to 1500 hands being employed, and the outfit of machinery for making cigarettes, etc., the finest in the world.*[187]

What this article didn't mention, however, was that Duke was the sales leader and on an anything-goes mission of monopoly. Not only was he callously swallowing up smaller companies, but he was also primed to buy out his top competitors. When he tried pressuring Ginter into selling out, the Major stood firm. He made it clear that his business wasn't for sale and claimed that Duke couldn't borrow enough to meet his price anyway.

Duke threatened him with escalation. "I make $400,000 out of my business every year. I'll spend every cent of it on advertising my goods as long as it is necessary," Duke declared. "But I'll bring you into line."

By this time, for the sake of competition, the top five cigarette manufacturers were spending loads of money on advertising and picture cards. The cutthroat contest took a big bite out of profits.

The president of the Bonsack Company stepped in, suggesting to Duke that he form a peaceable combination of the five companies. Before long, Duke was pushing for a trust.

Major Ginter "put his foot flat down against it," said the *Times*, "and positively declined to become in any way associated with it. He said that he was willing to join a legalized corporation that met with the approval of his fellow business men, but that a trust was unlawful, and he would have nothing to do with it."[188]

This argument got traction with the other top manufacturers, and they agreed to join Duke in his American Tobacco Company. The proud Major Ginter remained a holdout—that is, until Duke secured exclusive rights to the Bonsack machine for his new corporation. Duke had Ginter up against a wall—it was either join or die.

The roles between Duke and Ginter could have been reversed, if Ginter had taken hold of the Bonsack machine years earlier at his first shot. If he had, his firm would still be number one, and *he* would be holding all the cards instead of Duke.

Negotiations between the heads of the five leading cigarette manufacturers began on April 23, 1889, at a hotel on lower Fifth Avenue. They continued until year's end. Ultimately, the men decided to form a holding company. The business leaders would simply sell their companies outright in exchange for stock in the new holding company and continue running their individual branches.

In the end, Duke and Ginter each received equal shares—30 percent. The Kinney company received 20 percent, and William S. Kimball & Co. and Goodwin & Co. each received 10 percent. Since the new corporation was capitalized at $25 million, Allen & Ginter's stock was valued at $7.5 million—*in 1889 dollars.*

Ginter was offered the presidency of the new company but declined due to his age. Buck Duke got the job, and John Pope—businessman extraordinaire—was made vice-president.

With the negotiations over, the men looked to chartering the American Tobacco Company in Virginia. In December 1889, their charter was approved by the state legislature and signed by the governor. But then, "a

great hullabaloo was raised about the matter," Ginter said. "The newspapers published many foolish things about it and the Legislature hastened to repeal the act."[189]

So, in early January 1890, while the Virginia legislature nervously debated the matter, the five tobacco companies quietly chartered the American Tobacco Company in New Jersey. Rumors swirled in Richmond, causing anxiety about the welfare of the Allen & Ginter employees. So, on January 5, the *Dispatch* led with a quote from Ginter: "As far as this establishment is concerned, it will not be affected by the change."[190]

A friend of the firm stated that Ginter agreed to seek the charter in New Jersey but only because the Virginia legislature had opposed him. "Major Ginter is a gentleman of tender feelings and had built up his great business with fatherly care," the man added. "He had the deepest regard for all his associates and employees…When he announced the sale he was affected to tears at the thought of any of his employees losing their places."[191]

Ginter also regretted that the action by the Virginia legislature cut the state out of tax revenue, which he estimated at $200,000 per year.

Nevertheless, almost from the day American Tobacco was formed, profits increased for all the constituent companies, largely because of lower advertising costs and their exclusive contract with the Bonsack Company.

———

In just a little over fifteen years, Major Lewis Ginter rose from poverty to become a revered, Gilded Age millionaire. Very soon thereafter, he became the wealthiest man in all of Virginia.

All the while, however, he was harboring the most painful regret. Richmond, he said, "never had a chance to actually and fully recover from the war."[192] He had all-too-vivid memories of that "fateful event" ruining his shining city. Firsthand, he'd seen how it caused Richmond to decline, deteriorate and be overrun by undesirables. And in the war's final chapter, he'd watched as much of his beloved, glorious city was engulfed by a tremendous blaze and wiped off the map.

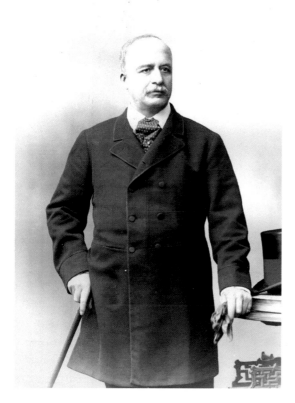

Lewis Ginter, circa 1890, when American Tobacco became one of the nation's first major holding companies. *Photo by Eug. Pirou, Paris, France. Valentine Richmond History Center.*

Although Richmond had proudly risen from its ashes, he had a deep desire that the city be lifted up into the league of premier cities. He wanted to reclaim its former glory on the national stage, if not the world stage.

With his enormous new fortune, and gathering all the other resources he could gather, the Major staked out to do just that.

Chapter 5

Beauty

The fabulously wealthy Major Lewis Ginter could easily have lived a life of leisure and excess. But he was no Gilded Age robber baron vainly obsessed with decadent parties, jewel-encrusted rings and the flashiest mansion on the block. If anything, his wealth only sharpened his sense of duty to his community.

Joseph Bryan's son, John Stewart Bryan I, knew the tobacco magnate during his lifetime. He said, "Major Ginter was one of those generous men who regarded wealth as a means of public service and not for private indulgence."[193]

Public service can come in many forms, and for Lewis Ginter, bringing beauty to Richmond was one of them. Combining his wealth with a strong aesthetic sense and natural love of art, he delivered a steady, rapid fire of dazzling creations.

Yes, his homes were exquisite. But he worked tirelessly for the higher principle—and greater joy—of gracing his beloved city. Beauty and refinement were more important to his psyche than ever—perhaps they helped compensate for the haunting images of the cruel and ugly war.

But the Major didn't simply want to put Richmond back together as it had been before that fateful event. He was out to redefine beauty for the city on an unimaginable scale. Better yet, as we'll see, that beauty wasn't just for its own sake.

The New Westbrook Gleams

One of the loveliest country houses in America. [194]

Completed around late 1889, the new Westbrook mansion was a fresh take on the Victorian Queen Anne style, teeming with gables, dormers, verandas and turrets. With its picturesque massing and towering chimneys, its central gable featured a sweeping roof. The wide wraparound porch had an attached porte-cochère for carriages.

The mansion's eclectic interior combined Queen Anne, Colonial Revival, Chateauesque and Romanesque details, the likes of which had charmed Ginter during his travels in America and abroad. Throughout was dark wainscoting in oak, birch, cherry and mahogany.

The deep entrance hall featured a large fireplace on the right wall, its hearth faced with shimmering, imported tiles and its overmantel reminiscent

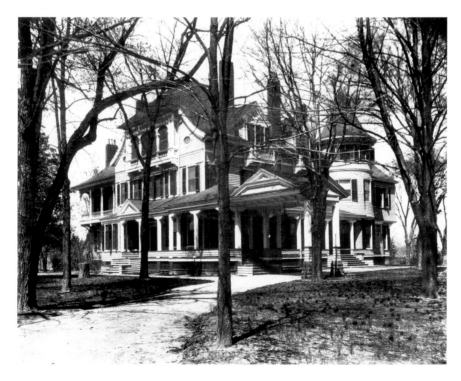

Major Ginter's newly renovated Westbrook. His architect would next design James Dooley's Maymont. *Cook Collection, Valentine Richmond History Center.*

of sixteenth-century French chateaux. The double parlors opened into the music room as well as the dining room, which had a box bay with leaded- and stained-glass windows. The arched doorways were decorated with delicate wooden grillwork and columns with Romanesque basket capitals. The floors were primarily wood parquet. (Jefferson's Monticello boasted the first parquet floors in America.)

In the cherry-paneled billiard room, there was a built-in bar with a stained-glass window above. In the conservatory, sunlight shimmered through more leaded- and stained-glass windows. Each room had its own fireplace in its own, unique style. Throughout the house were exquisite, ornate light fixtures.

Bedrooms were located upstairs, with a window seat on the stairway landing. In a turret on the third floor, Ginter set up his own circular barbershop. He called it his "tonsorial parlor."

The library was Ginter's favorite place in his palace home. His extensive collection of volumes was the envy of the South. Because he traveled extensively, he spoke fluent French and read German and Italian with ease. His library boasted books in those languages.

But Ginter didn't create Westbrook to impress anyone; he was simply expressing himself artistically.

An ardent admirer of music, Ginter was an accomplished pianist. He remained modest, so few of his friends knew of his talent. Westbrook was also a depository of countless works of art, making for one of the finest private collections in the country. There were exquisite paintings, tapestries, sculptures and tabletop pieces. Taken in its entirety, Ginter's household was said to be "the seat of intelligence and refinement."[195]

Out of doors, the picturesque summer estate—with its large stable of horses, an icehouse, dairy and crops—was abuzz with activity. Servants handled the farming and domestic work. Ginter and his family took advantage of the abundant recreational opportunities, such as horseback riding. If Ginter followed Thomas Jefferson's advice, he spent many hours walking the lovely grounds.

That first summer, however, darkness descended upon the household. Ginter's beloved sister, Jane, died at the home. It was a profound loss. She was described as a woman "universally loved and respected for her loveliness of character and charitableness,"[196] and ever since Ginter's childhood, she'd showered him with love and devotion.

But while Ginter lost his sister—and surrogate mother—he would hardly be alone in the world. He and John Pope were practically inseparable.

At this stage of their open relationship, Pope had become Ginter's "companion," a term then imbued with tenderness and sophistication in high society. The war romanticized the brotherhood of comrades. Besides being close business partners, they attended social functions and the theater together. They even vacationed together with other prominent Richmond families at the fashionable Hot Springs resort. A society page blurb in the *New York Times* titled "Gay Days at Hot Springs" said, "Major Lewis Ginter and John Pope of Richmond have taken possession of one of the Virginia cottages."[197]

Joseph Bryan's *Times* stated forthrightly that Ginter was "considerate toward women, and sometimes gallant," yet "never pointedly sought their company."[198] In similar tones, the *Dispatch* said, "Mr. Pope lived quietly with Major Ginter, for whom he possessed the most ardent affection."[199] Yet Ginter was a private man, even among his closest friends.

Nevertheless, Ginter and Pope clearly respected each other, trusted each other, depended on each other and loved each other. And through this, their lives were filled with all the world's riches.

In that spirit, John Pope deeded the seventy-three-acre Westbrook property to Lewis Ginter in 1891 for one dollar.[200]

Facing south, the striking Westbrook mansion sat about one-third of a mile northwest of the intersection of Brook Turnpike and Westbrook Avenue. There were at least two entrances into the estate—one on Brook Turnpike and another on Westbrook Avenue. Both driveways provided a lovely, tranquil scene for anyone coming or going by carriage. Bordering the property on the northwest was Upham Brook, which wound its way through an inviting glen.

By 1892, Ginter had enlarged Westbrook 41 acres to the north and 46 acres to the west, making the estate a total of 160 acres. Once Ginter made his mark on the Westbrook landscape, it featured lawns, neatly trimmed

hedges, a picturesque lake and formal French gardens bursting with color. In fact, Ginter's taste for landscape gardening was "little short of inspiration."[201] (Thomas Jefferson remarked, "No occupation is so delightful to me as the culture of the earth, and no culture comparable to that of the garden.")

One form of entertainment at Westbrook was bowling. Ginter fitted one of the outbuildings with a one-lane bowling alley just behind the mansion. It boasted a commodious lounge area, complete with a bay window and fireplace. From here, the players and spectators cheered on the games. At a bowling party given by the younger set in 1895, the guests included Miss Irene Langhorne, then called "one of the most beautiful and popular women in America." She was about to marry the noted New York illustrator Charles Dana Gibson, who would develop the iconic "Gibson Girl"—using Irene as his model.

The main reason Ginter wanted a country home was for the purpose of entertaining his circle of friends. With a hearty yet unostentatious hospitality, his guests found him a pure pleasure. One of his good friends, James N. Boyd, said, "I can truthfully say that I never heard him say a harsh word against any one, but whenever any one would bring charges against his fellow man he was the first one to throw the cloak of charity around him."[202] Naturally, Ginter often spoke of Thomas Jefferson and was a walking encyclopedia of Jeffersonia. It was said that to hear Ginter talk of the statesman was to "[regale] a thorough knowledge of the great man."[203]

Before Ginter knew it, he grew so fond of his country place that he spent much of his time there. Nothing short of a celebrity in Richmond, he treasured his privacy and family time.

When he wished to travel to the city for business or pleasure, he would step to the back of the entrance hall and press one of the fourteen buttons to summon the vehicle of his choice. Depending on the weather and his particular fancy, he would select from the broughman, landau, carriage, open carriage, cabriolet, several kinds of buggies, the Westbrook wagon, the saddle horse or the jumper. His loyal, mulatto coachman, John Haywood, would drive him to his destination of choice. Richmonders easily recognized Major Ginter's covered carriage as it strode through the city streets.

FRANKLIN STREET MANSION: THE SOCIAL CENTER OF THE CITY

*Timon of Athens in his unbroken fortune was not
more generous to his friends.*[204]

Thomas Jefferson spoke frequently about architecture, calling it "among the most important arts." The refined Lewis Ginter couldn't have agreed more and had his finger on the pulse of architectural fashion. He was quite enamored by the Richardsonian Romanesque style, developed by architect Henry Hobson Richardson. Its fortress-like look featured round-headed Romanesque arches, recessed entrances, richly varied rustication and cylindrical towers with conical caps. As the architects of his city residence, Ginter chose the power duo of Harvey L. Page and W.W. Kent of Washington, D.C., both in their late twenties.

Harvey L. Page perpetuated Richardson's style and was known for his fashionable and innovative residential architecture in D.C.'s Dupont Circle area. Disavowing "overdone decoration" and prizing simplicity, breadth and strength, he designed the floor plan, structure and exterior massing for Ginter's mansion.[205]

Page's ambitious partner, W.W. Kent, was another rising star. He'd actually worked in partnership with H.H. Richardson and was an expert in ornamentation. For Ginter's commission, he supervised the brickwork, stonework, wrought iron and other architectural detailing—all with an eye to understated elegance. "Ginter is a man of fastidious but quiet taste, and has no desire to be known as the owner of the grandest house in the city," said the *State* in early 1888. "What he designs having will be a residence where he can have every comfort and convenience, and entertain his friends in a hospitable and homelike atmosphere."[206]

———— ∞∞∞ ————

In the spring of 1891, when Major Lewis Ginter's imposing and exquisitely detailed city mansion was finally completed, it brought West Franklin Street to the pinnacle of vogue.

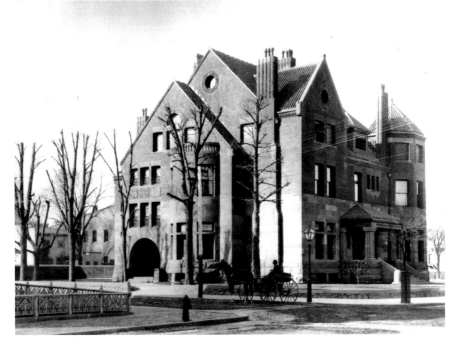

The Franklin Street mansion, in Richardsonian Romanesque style. *VCU Libraries.*

The exterior of the home was composed of a number of natural materials, well crafted and artfully combined. The basement was clad in rock-faced, red sandstone, and the first floor was finished in pecked, red sandstone. Upper floors featured deep-red brick accented with basket weave patterns. Inset into the exterior were several molded brick panels. The roof was clad in Spanish tiles. This was the golden age of wrought iron, which was apparent in the mansion's exquisitely crafted hardware, including its grilles for windows and doors.

The front porch featured cut and carved stone columns with Romanesque basket capitals. The first-floor windows had transoms with stained glass. The front door of the home opened into a richly paneled vestibule, and a second door led into the entertainment-sized living hall, featuring an oak parquet floor and oak wainscoting. Above was a leaf-patterned frieze in plaster. On the right wall was a fireplace, and its surround was made of stone, carved into a Romanesque foliate design.[207]

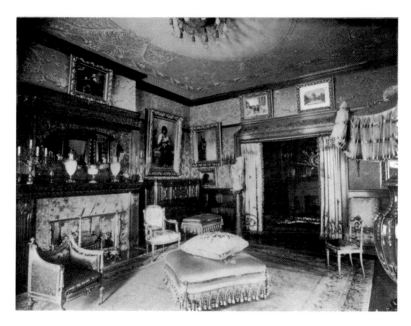

The front parlor. The walls were hung thick with art, much like Jefferson's Monticello. *VCU Libraries.*

Off the living hall, on the front of the house, was a small room with a marble fireplace serving as Ginter's home office. Also off the living hall, and connected by double doors to Ginter's office was the "front parlor." It featured a fireplace with a pink marble mantel with hints of blue, and the stained-glass transoms picked up those colors with devastating effect. During the Victorian era in Richmond, front parlors were traditionally used as withdrawing rooms for women. Ginter's front parlor was quite small, since he had few female relatives or guests.

The rear parlor of the mansion, off the rear of the living hall, was much larger. Serving as the dining room, it featured a dominant fireplace with an artfully carved mantel.

Then there was Ginter's private library, with hundreds of volumes. Like Thomas Jefferson, he couldn't live without books. Off the library were sunrooms, as well as the smoking and billiard room.

Bedrooms were on the second floor, with a pair of master suites on the mansion's front side. Apparently, this was the private domain of Ginter and Pope.

Dr. Charles Brownell, PhD, professor of art history at Virginia Commonwealth University, said, "The Ginter house was, on a national

scale, a jewel."[208] Thomas Wolfe even mentioned the house in his novel *Look Homeward Angel*. It was considered one of the grandest homes in the South, second only to Biltmore, the Vanderbilt estate near Asheville, North Carolina.

<p style="text-align:center">⟶∞∞∞⟵</p>

"Richmond is famed for the cultivation and refinement of its society," said a contemporary sketch of the city, "and nowhere in the world are the rites of hospitality more cordially and generously dispensed."[209] At no time was that statement more true than on February 9, 1892—shortly after Ginter equipped and decorated the home—when the highly sociable Major hosted a magnificent reception.

Since Ginter had a gift for making and keeping friends, there were some five hundred invited guests, embracing the beauty, fashion and wealth of Richmond. The reception would be called "the most elegant private entertainment that Richmond society has ever participated in." Indeed, elegance abounded with an elaborate food display, bunches of roses on mantels and brackets and music from a small chamber orchestra. The *Dispatch* pointed out that the whole house was "brilliantly illuminated" with electric lights—an emerging and exclusive convenience in Richmond at the time.

Ginter's guest list reflected his high social standing and influence. Parading through his door—likely dressed in crisp, stylish tuxedos—were elected officials such as Virginia governor McKinney and Richmond mayor J. Taylor Ellyson. There were key industrialists like Joseph Anderson of the Tredegar Iron Works, and William R. Trigg of Richmond Locomotive & Machine Works. There were also prominent lawyers, influential bankers and powerful railroad executives.

Then there were developers like Otway S. Allen, who donated the land for the Lee Monument. There were prominent doctors, including Hunter McGuire and his son, Stuart McGuire. And, of course, there were several men conspicuous in Richmond's tobacco trade. Other notable gentlemen included the iconic Reverend Moses D. Hoge, the nationally acclaimed

Richmond artist William L. Sheppard and James H. Dooley, a Confederate veteran who'd made a fortune in real estate, railroads and steel.

With "genial manners," John Pope almost certainly attended the reception as well. But he wasn't particularly fond of society.[210] He was more reserved and serious.

Prominent ladies at the gala included Mrs. Mann S. Valentine, whose husband was the wealthy manufacturer of Valentine's Meat Juice; and Ginter's close neighbor, Mrs. John Dunlop, a woman of cultivated intellect and natural wit. Among the younger ladies were two reigning society belles. One was the beautiful Miss Irene Langhorne, whose complexion was said to be "as lovely and as delicate as the apple blossom." And Miss May Handy, described as "perfect in every feature," was said to have "held the social world entranced where'er she went."[211]

While the ladies in attendance at Ginter's gala were dressed in the finest gowns and jewels, they weren't merely fodder for Richmond's society pages. Many were active in local causes like the recently formed Association for the Preservation of Virginia Antiquities—headed by Mrs. Joseph Bryan—to improve historic sites and to "awaken in our people proper appreciation for memorials of the past." Some of the women were also organizing the Confederate Museum—another cause spearheaded by Mrs. Bryan—to be located in the White House of the Confederacy. This was just the crowd to which to make their appeal, since they were raising funds and collecting war artifacts for the museum.

From nine o'clock until after midnight, the genial Major Ginter's home overflowed with music, gaiety and probably more than a little smoke. The successful affair was on the lips of Richmond society for days.

Sharing the Franklin Street residence with Ginter was his business partner and close companion, John Pope, as well as Grace Arents. Jane died before the mansion was completed. By 1895, while mentoring several budding businessmen, Ginter informally adopted one of his factory clerks, Anton "Tony" Thiermann, moved him into the Franklin Street mansion and made

him his personal secretary. Tony would play a major role in conducting Ginter's affairs and shepherding his enterprises. For recreation at home, the men played billiards. Live-in "colored" servants—including Caldwell Wood, coachman John Haywood and the loyal Henry White—did the cooking and all the other domestic work.

When Major Ginter managed to carve out some personal time in the evening, he often retired to his library. Described as "a carnivorous reader with a remarkably retentive mind,"[212] his readings ranged from history and political economy to the classic works in fiction and poetry.

Among Ginter's distinguished neighbors was his friend Ashton Starke, a manufacturer of agricultural implements, who resided at 915 West Franklin. At 917 West Franklin was real estate agent N.W. Bowe, who had recently sold Westbrook at auction to John Pope. And at 602 West Franklin was Captain Philip Haxall of the legendary Haxall-Crenshaw Mills, who had served alongside Ginter early in the war as General Anderson's aide-de-camp. Haxall's wife was none other than Mary Triplett, "a queen in her appearance and manners," who had innocently sparked the famous duel between Page McCarty and John B. Mordecai in 1873.

According to the *Dispatch*, Major Ginter's Franklin Street home was "the social center of Richmond, and a place of generous hospitality to his circle of associates and friends."[213] Now more than ever, his entertainments were on a lavish scale. Many were served by famous New York outfits like the luxurious Delmonico's Restaurant—a name synonymous with haute cuisine.

As always, Ginter's penchant for entertaining also gave rise to informal affairs like a quiet game of cards with several of his closest friends. "Whist was one of his favorite games, while a change to poker now and then for small stakes was refreshing," said the *Times*.[214] The Major's card buddies were active in civic affairs, including attorney John Dunlop, a "bewhiskered Englishman" who lived half a block away at 816 West Franklin Street; prominent tobacco merchant Alexander Cameron; and one of the most prominent financiers in the South, Frederick R. Scott, who lived in a large mansion at 712 West Franklin Street across from Monroe Park. Ironically, when all these wealthy men got together to play draw poker, the limit was twenty-five cents—but each one of them watched his cards as if thousands of dollars were at stake.

It's a well-known fact that Major Ginter held court with his friends, regaling them with stories about his travels and his associations with men

of note. "He could talk entertainingly for hours," said the *State*, "and it was always with a profit to his hearer."[215] As Reverend Hoge put it, "innocent hilarity abounded."[216]

Naturally, Major Ginter also hosted reunions with his Civil War comrades. One newspaper said, "Whenever any members of the old Georgia Brigade came to Richmond they were entertained by Major Ginter, and renewed their old army acquaintanceship with the gallant Major, with expressions of great enthusiasm and love for him."[217]

ENVISIONING GRACIOUS SUBURBS

It cannot be forgotten that Richmond, one of the oldest cities in the Commonwealth, was surrounded with the most unsightly suburbs until Major Ginter undertook the task of making them attractive.[218]

By 1891, the sixty-seven-year-old Major Lewis Ginter had attained phenomenal wealth and success. He had two of the most tasteful homes imaginable. Still, his ambition, civic pride and insatiable appetite for enterprise were as strong as ever. It was as if no challenge was too big for him. He knew no limits.

Joining a new national movement to create the "ideal suburb," his visionary approach would impress a citizenry well beyond Richmond's borders. He had made a career of putting forth creative, forward-thinking ideas. Consciously or not, he followed Thomas Jefferson's example, ascribing to the Enlightenment ideal that intellectual thought could lead mankind to a richer and better life. This would be no sprawling complex of mass-produced tract houses.

It's reported that Major Ginter's avid interest in planned, landscaped suburban development began during his visit to Australia in 1888, where businessmen took trolleys from their homes in the country to their offices in the city. But that was hardly his only source of inspiration. Richmond's population was growing steadily, and the inner city was already overcrowded. The Industrial Revolution turned the city into a virtual cesspool of raw sewage, industrial waste and coal smoke. The unsanitary conditions were even believed to encourage the spread of diptheria, scarlet fever and typhoid fever. Ginter was also probably heeding the admonitions of the Chamber

The late nineteenth-century "ideal suburb," which Major Ginter envisioned for Richmond. *VCU Libraries.*

of Commerce, which had been emphasizing development for the sake of progress and prosperity.

Major Ginter's suburban plan was more than a speculative investment opportunity. It was a way for him to help beautify and vitalize Richmond. It was a way to improve the lives of its citizens. And if other Richmonders had rebuilt the city after the war, this was the least he could do.

According to legend, he chose to develop north of the city because he believed it was "a foolish waste of eyesight to drive east into the rising sun each morning and drive west into the setting sun each evening."[219] There were also granite beds in the Northside that could be quarried for use in the construction of streets and homes.

In 1888 and 1889, Lewis Ginter and John Pope purchased several hundred acres along both sides of Brook Turnpike, parcel by parcel. The "unsightly" area was full of gullies begging for Ginter's attention. There were few houses and trees. Plantations and family farms had stretched far and wide since the 1770s, and the land had seen many a slave working the crops in the hot summer sun.

Transfiguring the Brook Turnpike

The work of the National League for Good Roads is taking hold of the minds of the people.[220]

The Brook Turnpike Company had been established in 1812, even before Ginter was born. That year, it constructed a turnpike along today's Brook Road, from Richmond north to Dabney Williamson's tavern (near today's intersection of Brook and Telegraph Roads). The Brook Turnpike was one of the earliest toll roads in Virginia, and it improved the transport of goods between Richmond and the northern region of Virginia. It also connected Richmond to the cities and country to the north.

In those days, many of the turnpikes in Richmond were in such poor condition that travelers called them "mud-pikes."[221] But then, in 1890, about the time Ginter moved into Westbrook along the Brook Turnpike, he bought controlling interest in the Brook Turnpike Company and served as president. Over the next five years, he transformed the gravel turnpike at his own expense and maintained three tollgates.

The Brook Turnpike had witnessed many illustrious events in history. Lafayette led his troops victoriously along the route from Yorktown. It was a key route during the Civil War, and many forces, concentrated at earthworks along the turnpike, valiantly defended that approach to the city. In 1864, Confederate hero J.E.B. Stuart was mortally wounded at the Yellow Tavern just off the road.

"[Ginter's] investments on the Brook road, for miles around his country home, possibly amount to more than two million dollars," said the *Shenandoah Herald* in the late 1890s. The paper touted the thoroughfare as "one of the finest in the whole country," saying that "the scene presents to the eyes something wonderfully like fairyland."[222] Much of the beauty was derived from all the plantings, with miles of grass and trees and hedges of fragrant honeysuckle and roses.

As with many of Ginter's enterprises, there was an altruistic component. A smooth road wasn't just more enjoyable for carriage or horse riding; it was also far more conducive to Richmond commerce and tourism. The Brook Turnpike made travel into and out of the city much faster and easier for the horses that pulled the loads, helping make for a trade-friendly city and contributing to its economic growth. Ginter certainly knew that Thomas

Brook Turnpike, circa 1896, with charming tollhouse in center. *Library of Virginia.*

Jefferson advocated for good roads; he signed the first "good roads bill" in 1806 while serving as president of the United States.

In the decade before Ginter purchased the turnpike, a national movement for better highways had begun, sparked by bicycle enthusiasts. "Ginter's private turnpike is the best one in the State for cycling," said the *Washington Post* in 1895.[223] Naturally, those traveling by carriage were equally awestruck.

In 1892, then–Virginia governor McKinney named Ginter the ambassador of good roads in the state. Whether he had official duties or not, he was certainly leading by example.[224] Before long, he would enhance the turnpike even further, ushering in a new mode of transportation.

Major Ginter had chartered his land development company in 1891, along with John Pope and a handful of their close friends and associates. They named it the Sherwood Land Company. Due to the economic boom, their plan included large villa sites for the upper-middle class. With a sharp mind for marketing, Ginter was out to give his suburbs every edge.

The name Sherwood was taken from an old estate along the Brook Turnpike that in the early 1800s belonged to Wellington Goddin—the same Wellington Goddin with whom Ginter had partnered in the New York bank after the war. Ginter purchased the old Sherwood estate, near today's Children's Hospital, and folded it into his new development. He also purchased a house called Edgewood in 1889 on the west side of Hermitage Road near Laburnum Avenue. One of the only existing structures in the area, Ginter designated it as offices for his land company, as well as housing for its bachelor workers.

When the Sherwood Land Company was assembled, Major Lewis Ginter took the lead as president and John Pope served as treasurer and secretary. Joseph Bryan served as vice-president, with plans for developing a large tract he owned adjacent to Laburnum. One of the directors of the company was Dr. Hunter McGuire, whose choice of a country home in the area vouched for its healthfulness. Other directors were New Yorkers George Arents and Albert Young. As previously mentioned, George Arents was Ginter's nephew. He had relocated to New York after the war to enter the banking and brokerage business. Albert Young was George Arents's business partner and husband to Ginter's niece, Minnie.

Obviously, there was more than enough capital and investment know-how in the mix. But as Ginter began focusing on the initial phase—and with competitive developers laying out suburbs nearby—he would seek the best designers in the business. Around 1890, he began consulting the firm of Frederick Law Olmsted & Associates of Brookline, Massachusetts. Considered the first full-time landscape architecture firm in the country, it had been established seven years earlier by Frederick Law Olmsted.

Olmsted was the premier landscape architect of the day and would become known as the "Father of Landscape Architecture." His list of park designs reads more like a book and includes New York City's Central Park and Chicago's Riverside Park. He also designed some of the first planned communities in the country and said, "No great town can long exist without great suburbs." The Major was listening.

Ginter was unable to consult with Frederick directly, since the designer was immersed in two mammoth projects: the Biltmore Estate in North Carolina and the 1893 World's Fair in Chicago. Regardless, Frederick's associates—particularly his own stepson, John Charles Olmsted—shared both his vision and talent.

The section that Ginter chose to create first was Sherwood Park, bound by Hermitage Road on the west, Sherwood Avenue on the south, Brook Turnpike on the east and Westwood Avenue on the north. He began negotiating several rounds of designs with the Olmsted staff, planning the layout of streets, gatehouses and tennis courts.

But this was merely one bar in the symphony that Major Ginter was composing.

MEMORIALIZING THE QUINTESSENTIAL WAR HERO

Too long has this superb soldier, whose plume ever waved in the very foremost of battle, been neglected.[225]

Enthusiasm for Ginter's suburbs gained momentum when he helped orchestrate a handsome memorial to one of his most revered Civil War leaders, General A.P. Hill. Even though the war had ended more than twenty-five years earlier, the drama was far from forgotten. Richmond had become the center for memorializing the conflict, and by 1890, its white society was full-flung in the "Lost Cause" movement.

Stoking this sentiment was literature that idealized the defeated South and its magnolia-infused antebellum days. It included *In Ole Virginia* by Richmond lawyer-turned-novelist Thomas Nelson Page and *Lee to the Rear* by Ginter's late friend John R. Thompson. Even Joseph Bryan's *Times* frequently rehashed old battles and praised their "valiant" leaders.

It was in 1890 that the brand-new Monument Avenue—then just west of the city limits—was adorned with its first monument to Civil War leaders, the Lee Monument. Naturally, Ginter was "a liberal contributor" to such an impressive monument erected in honor of his revered chieftain. The Battle of Second Manassas—the battle in which Major Ginter first distinguished himself as a soldier—was the same battle that was called "General Lee's Greatest Victory."

Just about the time the Lee Monument was completed, Ginter was laying out the streets of his new neighborhood. He created several small roundabouts at key intersections for plants and flowers. One was at the intersection of Hermitage Road and Laburnum Avenue, and he intended to someday erect a monument of some description there.

Meanwhile, the Pegram Battalion Association had started a movement to build a monument in Richmond to the gallant and beloved General A.P. Hill. General Lee valued Hill, Longstreet and Jackson as his best commanders, and an idea had been floated for several years to erect a monument over Hill's grave in Hollywood Cemetery. The Pegram Battalion Association thought that Major Ginter's spot was the ideal location and that Hill's body should be reinterred there. There was only the teensiest of obstacles: they hadn't approached Major Ginter about the idea.[226] It wouldn't be a problem in the least. Ginter revered A.P. Hill for his gallantry, leadership and martyrdom for the Southern cause.

On the night of April 6, 1891, a plan was hatched at Ginter's home on Franklin Street. He and a number of other men who had served in Hill's corps met to plan an imposing monument to the man who, "with his sword, carved a name that will [forever] live as the synonym of heroism and patriotism."[227] Ginter was placed on a six-man committee that was appointed to appeal to every single surviving soldier of the Confederacy and the women of the South to aid in the project.

By the time the meeting ended at the Franklin Street mansion, Ginter had donated his plot and the design for the monument had been adopted. The man who had worked up the statue design was William L. Sheppard, a well-known Richmond artist and sculptor with a national reputation. He'd begun as an illustrator during the early stages of the war, sketching soldiers in the field. He studied in New York, Paris and London and created stunning, detailed illustrations for magazines like *Harper's Weekly*.

After Sheppard created the original plaster model of Hill for the statue, the eight-foot bronze form was sculpted by the renowned Caspar Buberl of New York. Among his many works was an elaborate, 1,200-foot-long frieze for the Pension Building in Washington. The Pegram Battalion Association raised the funds for the statue by public subscription, including generous donations from Major Ginter, Major Brander and General Hill's successor, General James A. Walker.

The contract for the monument's stonework was awarded to James Netherwood, also of Richmond. His firm was in the process of building

what we know as Old City Hall at Broad and Eleventh Streets. The granite used for the Hill Monument came from Netherwood's own quarry south of Richmond, and the entire pedestal for the monument was the gift of Major Ginter.[228]

On July 1, 1891, with the consent of Hill's relatives, Ginter and two other committee members had Hill's remains quietly moved from Hollywood to the completed base of the monument. While the entire work was being finished and volunteers from the Soldier's Home stood guard, an unveiling and dedication ceremony was planned for Memorial Day 1892. The event would play out much like the one for the Lee Monument two Memorial Days earlier.

The ceremony kicked off with an elaborate and formal military parade originating at Capitol Square. As the Virginia military and veterans marched by the thousands, with their sabres gleaming in the morning light—and led by distinguished figures on horseback like Reverend Hoge, Joseph Bryan and Colonel Archer Anderson—bands played dirges for solemn effect. Richmond's streets were lined with cheering crowds, and pretty girls waved handkerchiefs to the troops as they passed. A drum corps came last, making the air quake with their happy music. The huge parade, along with masses of citizens, finally converged for the ceremony at the intersection of Laburnum and Hermitage. The sprawling crowd topped fifteen thousand people.

The keynote speaker was Hill's successor, General James A. Walker, whose war-torn and nearly useless arm hung limp at his side. Walker gave tribute to all the soldiers who had fought bravely against overwhelming odds, insisting that those heroes of long ago still commanded deep admiration. Toward the end of his speech, Walker glorified the fallen A.P. Hill himself:

> *Loved comrade, brilliant soldier, chivalrous spirit, true-hearted friend, accomplished gentleman, ardent patriot—Ambrose Powell Hill, we dedicate this monument to thy memory as a feeble token of the love of old comrades and a faint expression of the admiration of the Southern people, for whom you fought and died so bravely.*

When the veil was pulled back to reveal the statue, the crowd fell silent. Then thousands erupted with cheers amid a salutory blast of military gunfire. The statue of Hill—"standing in the attitude so well remembered"—was the ultimate tug at the crowd's heartstrings.

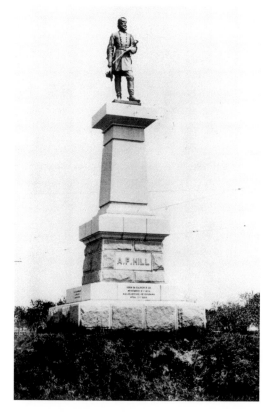

Above: The unveiling of the A.P. Hill Monument, May 30, 1892. An old veteran in the crowd said he well remembered Hill standing "just as he does yonder." *W. Palmer Gray Collection, Valentine Richmond History Center.*

Left: The A.P. Hill Monument, twenty-six years in the making, at the intersection of Hermitage and Laburnum. *Library of Virginia.*

If Major Ginter weren't so averse to making a show of himself, there would have been announcements thanking him profusely for his support of the monument. Instead, his name was listed only once in the program.

After the crowd cleared out, the figure of A.P. Hill remained standing, overlooking the spots at which he assumed command of his first brigade and subsequently of his Light Division. Nearby, he brought on the legendary Seven Days Battle. It was all part of his valiant defense of Richmond, the capital and heart of the Confederacy. It's little wonder Major Ginter put him on a pedestal for eternity.

BEAUTIFICATION CAMPAIGN RUDELY INTERRUPTED

A stubborn fight was commenced, which lasted twelve hours.[229]

About 5:25 a.m. on January 17, 1893, just months after the Hill Monument was dedicated, specially rigged alarms began blaring in both Ginter's and Pope's bedrooms at the Franklin Street mansion. Fire had broken out at the two Allen & Ginter factories at the corner of Seventh and Cary Streets, and the Richmond Fire Department rushed to the snowy scene in the bitter cold as fast as its horses could carry it.

John Pope had left some securities on his desk the day before, worth about $10,000—and another $6 to $7 million worth in iron safes—so he frantically got dressed and fled for the factories. Ginter followed close behind.

When Pope arrived on the scene, he rushed into the burning building in an attempt to reach his office. Overcome by smoke, he backed out. The fire quickly engulfed the entire building, and the firefighters swept into action.

With temperatures just above zero, the odds were stacked against them. One of the nearby hydrants was frozen. The firemen cut a hole in the ice in the canal for water, but it froze again almost as soon as it was pumped onto the building. The men were covered with thick ice, and they had to knock it off just so they could move. While the fire raged, icicles ten feet long hung from the building's eaves. "The scenes during the progress of the fire were as unique and beautiful as they were exciting and distressing," said the *Times.* "The buildings, even while the fire was in progress, were thick with frost and ice, and the ever charming pictures were like a panoramic view of the fairy tale palaces of the ice king."[230]

After he recovered from the smoke, the compassionate John Pope commandeered an effort to build fires along Cary Street in front of the factory for the comfort of the half-frozen firefighters. While he was being interviewed at the scene by a reporter from the *Dispatch*, someone asked him what the company would do for the girls who worked for the factory. "Oh, we'll look out for them," Pope replied.

The fire still raged when many of the girls showed up at 8:00 a.m. to report for work, unaware of the news. With tears in their eyes, they watched the flames destroy the factory. They feared it would be months before they could get back to work, as many of them provided support for their mothers and younger siblings. To make matters worse for the women, January 1893 was so frigid and snowy that the cost of food had skyrocketed.

When Ginter arrived at the scene, he "appeared to take matters very calmly," said the *Dispatch*, "although he examined the wrecked buildings and looked at the desolation wrought by the flames with natural interest."[231] He was silently making all sorts of calculations.

Later, gathering with several of the young ladies in his employ at the scene, Ginter assured them that they would not suffer any loss from the fire. In fact, they wouldn't lose a single day's wages. "The report of this noble speech on the part of Major Ginter excited general admiration, and many were fond in their praises of his generosity," said the *Dispatch*.[232] This would go down in Richmond history as one of the most compassionate and generous gestures ever from a local business owner. It would also completely disregard Pope's front-and-center role in the event.

Although the factory was a total loss, the firm of Allen & Ginter sent a monetary reward to the brave men who fought the fire, along with personal checks from Ginter and Pope. Insurance covered most of the damage.

The two men sought temporary quarters for the enterprise at Twenty-fifth and Cary Streets. Men worked into the night to get the place ready, and within ten days, work operations were resumed. Ginter and Pope decided to build a new factory on the old site—bigger and better than ever. Progressing at a quick pace, construction was completed in late 1893.

The first day work began in the brand-new, well-outfitted building, Ginter entered the workrooms and asked everyone to put up their tools and go upstairs. Once they were seated, he expressed gratitude for their comfortable new quarters as well as the growth and prosperity of the firm. He added, "But we owe all this to a higher power, and I propose

now that we all spend a few minutes in silent prayer." Many were moved to tears.

Ironically, just about the time Ginter was praising that higher power, the entire country was hit with a severe economic downturn. It certainly didn't bode well for the sale of villa sites in Ginter's suburbs, and it all but halted the development along Richmond's Monument Avenue as well. The Gay Nineties suddenly weren't so gay anymore.

To make matters worse for Ginter, one of his partners in the Sherwood Land Company died in 1895. It was fifty-four-year-old Albert Young, a wealthy New York stockbroker and philanthropist. He was married to Ginter's niece, Mary "Minnie" Arents Young. Following Albert's death, Ginter invited Minnie and her children—including Albert Young, Edna Young and Ginter's namesake, Lewis Ginter Young—to make their home with him in Richmond.

Laying Out Richmond's Finest Roads and Avenues

If you could have seen these roads as they were last winter, you would lift up your hands and bless Major Ginter.[233]

Fortunately for the Sherwood Land Company, there were deep beds of granite all over Richmond. Ginter purchased nearby granite quarries, or rights to them, so he could use the stone for road improvements and home construction.

A persistent myth has been that Ginter's quarries were on Rosewood, the farm that would become Bryan Park. Although there were quarries in that general area during the mid-1890s, newspapers and deeds of the time place Ginter's own quarry tract on Old Hermitage Road, just north of Bloomingdale Stock Farm, near today's intersection of Old Hermitage Road and Oakwood Lane.[234]

To transport the crushed granite, Ginter installed his own narrow-gauge rail line. In 1892, he ordered a narrow-gauge steam locomotive from the Richmond Locomotive & Machine Works curiously named the Barbara. The *Times-Dispatch* said, "Fortunate was the child who could obtain a ride on the cars."[235]

Ginter chose not to use the latest "road machines" to construct the thoroughfares. A friend pressed the point, saying, "You can save much time

and labor." After pausing for a moment, Ginter softly said, "And what would become of these two hundred workmen and all these mules and carts?" His friend saw his point and dropped the subject.[236]

In 1895, along one of Ginter's first macademized roads, he began construction of carpenters' cottages. Built for his land company's workers, they exuded Victorian charm with their German siding, gable dormers, single-story porches and slate roofs with floral patterns. Nestled on Cottage Avenue (now Hawthorne Avenue), six of these cottages survive to this day.

By January 1896, Ginter had built a lovely network of magnificent roads. They were considered the finest in all of Richmond, pleasant for driving carriages, riding horses and cycling.

Joseph Bryan's wife, of Laburnum, was so pleased that she composed a poem of sorts: "If you could have seen these roads as they were last winter, you would lift up your hands and bless Major Ginter."

And then there were all the plantings lining them. Ginter had planted twelve miles of fragrant honeysuckle hedges, about ten miles of privet hedges and more than ten thousand trees.

When a New Yorker named Reverend Eliphalet Potter came to Richmond for a visit, a friend offered him a guided tour of the countryside by carriage. It was a fine spring day, and the guide pointed out Ginter's untiring efforts to beautify the entire area with grading, trees and shrubs. The honeysuckle was in full bloom, and the fragrance of a thousand roses filled the air. Birds sang in the trees. Everywhere there was life, freshness, beauty and growth. When the buggy turned onto a smooth avenue, Westbrook came into view, its lawn studded here and there with flowers. Reverend Potter said, "Why, this man works like a Pharoah."[237]

FURNISHING A HOME FOR THE DEEP RUN HUNT CLUB

The fox was caught on Eubank's Farm.[238]

As long as there's been a Virginia, fox hunting has been a tradition for both participants and spectators—particularly among the upper classes. In 1887, a handful of members formed the Deep Run Hunt Club in Richmond. Their chases were sometimes initiated from the A.P. Hill Monument or the gate to

Ginter's Westbrook on Brook Turnpike and were great frolics through the hills and dales of neighboring farms.

On November 30, 1895, the Deep Run Hunt Club held its first Deep Run Races. They were held at Chantilly, about three miles west of the city on Deep Run Turnpike (now called Broad Street). "There was an immense crowd to witness the races," the *Dispatch* reported the next morning. "The Hunt Club is now one of the most enjoyed of all the social organizations, and supplies one feature of English life which has no parallel for healthful recreation."[239] The club's rented facilities on Staples Mill Road near Chantilly were considered too small and "primitive" for the growing membership and "inconvenient" for the spectators—but Ginter would fix that.

He had already purchased more than 270 acres along Hermitage Road just north and west of the A.P. Hill Monument, and in 1894 he purchased the 40-acre Acca Stock Farm to the immediate west. It included a small frame house, stables, barns and a racetrack for horses, and the grounds were "a quiet and pretty stretch of green sward, well-shaded by a clump of young trees."[240]

In early 1896, while the Deep Run Hunt Club membership rolls neared one hundred, Ginter made the club a generous offer. He would erect a clubhouse with all the needed accommodations on the old Acca Stock Farm and allocate 127 acres for its use. The site would include stalls for forty horses, a shed for bicycles and kennels for the foxhounds. The new location would be attractive not only for the club's members but also for spectators who liked to join the social scene and follow the hunt along the smooth roads. As mentioned, it was Ginter who built those smooth roads.

While the other details of the offer are unknown, the club accepted. But make no mistake, this creation was another Ginter enterprise. The club likely leased the property from him with funds generated by the membership.

The first step was to remodel the existing house on the site into a commodious structure in the latest style. Ginter hired the young Richmond architect D. Wiley Anderson. Born in 1864 in Albemarle County, Virginia, he was the son of a respected artisan builder in the region. Around 1888, during Richmond's construction boom, he came to the city and began a six-year apprenticeship with builder-architect George W. Parsons. It was during Anderson's apprenticeship that Parsons built Ginter's Franklin Street mansion, and Anderson was involved at some level in the design of Ginter's library in the home.[241] Anderson would go on to be a prominent and prolific architect in Richmond and beyond.

His renovation for the clubhouse was made of brick, likely from the Powhatan Clay Manufacturing Company, chartered in 1893 under John Pope's leadership. Both the brick and heavy woodwork of the structure were off-white. Among the comfortable and attractive interior spaces was a large dining room for members and their guests. For members who didn't care to follow the hounds but liked to watch the chases, they could do so from the balcony that was constructed over the porch surrounding the clubhouse on three sides. And if they wanted to spend the night "in the country," there were accommodations on the third floor.

The beautiful new clubhouse, Rosedale Lodge, opened on Saturday, October 17, 1896, with a housewarming and reception for members. On the membership roster at the time were some of Richmond's most influential citizens, including Joseph Bryan, Philip Haxall and Otway S. Allen. Ginter's secretary, Tony Thiermann, was one of the club's "crack" riders, never far behind at the finish.[242]

Rosedale Lodge, built for the Deep Run Hunt Club. The hunts were cheered on from the second-story porch. *Library of Virginia.*

Providing the Deep Run Hunt Club facility was more than a generous act on Ginter's part. It was also targeted marketing. The amenity made his suburbs "popular with lovers of fine horseflesh and the chase."[243]

For a time, the Deep Run Races were relocated from Chantilly to Ginter's half-mile track at Rosedale Lodge. One of the most fashionable society events of the year, they would eventually transform into the ever-popular Strawberry Hill Races.

Ushering in Streetcar Service

This will virtually increase the value of your property further from town very considerably.[244]

To give his suburbs world-class appeal, Ginter decided to bring in streetcar service from the city. The Olmsted Associates advised him that the streetcar

The Lakeside Line, which began service in 1897. *Cook Collection, Valentine Richmond History Center.*

would "increase the value of property further from town very considerably, by diminishing its distance in time from the city." They also made recommendations on the configuration of tracks, medians and trees.[245]

By the fall of 1895—just seven years after the city became the nationwide pioneer in streetcar systems—Ginter made final arrangements to have the Barton Heights line extended northward to Brookland Park Boulevard and then westward to Brook Turnpike. There, Ginter planned to erect a "handsome and ornamental depot" called Sherwood Park Station. The streetcar line would connect with his dummy line, which would run north on Brook Turnpike. (A dummy line used a steam engine made to look like an enclosed horse car so it wouldn't frighten horses in the street.) Ginter's plan also called for streetcars to run up Chamberlayne Avenue from Laburnum Avenue to Walton Avenue.[246]

The project was rapidly pushed forward, with tracks laid and wire put in position over the fall and winter. Then, as early as February 1896, electric streetcars were running regularly down Chamberlayne Avenue. And on Brook Turnpike, the dummy line went all the way out to the Stewart mansion, Brook Hill.[247] The large-scale project was far from over and would spur many others.

A NEW DOMAIN FOR UNION THEOLOGICAL SEMINARY

A more beautiful location could hardly have been chosen for the seminary.[248]

In 1895, Major Ginter donated eleven acres of suburban land along Brook Turnpike to Union Theological Seminary. According to most published accounts, he made the offer to entice it to move from the Farmville area and give momentum to his development. But the seminary had designs on moving to Richmond before Ginter's offer. In May 1894, leading faculty member Walter Moore asserted that the seminary would be better served by moving from its isolated location so that its seminarians would have better training opportunities and mission work.

Moore faced stiff opposition. Some of it came from the editor of the *Farmville Herald*, who wrote, "What? Move the Seminary? One might as well speak of moving the Blue Ridge Mountains into the Atlantic Ocean!"[249]

But Moore believed that donors were disappearing because of the poor location and warned that if "the Seminary remains in the backwoods it is

doomed to inevitable decline." Soon the seminary had a change of heart and expanded its search to Virginia's urban areas.

Meanwhile, an alumnus of the seminary made an appeal to the Major. It was his friend, Dr. Robert P. Kerr, the esteemed pastor of First Presbyterian Church in Richmond. "When I first called on Major Ginter and asked him for a site for the Seminary, he told me he did not remember ever to have heard of it before," Kerr said. "But when he understood what an important institution it was, he said he was glad to donate a lot of land for its future home, near Richmond."[250] Ginter gave them a choice between two tracts. Neither of them suited the authorities of the seminary.

"I asked him to give us the block on Brook Road, immediately opposite Mr. Joseph Bryan's residence," Kerr said.

Given the beauty and prestige afforded by Bryan's Laburnum, Major Ginter said, "Why, that is about the best piece of land I own."

"Yes," Kerr replied. "I think it is, and therefore ask for it for our noble Seminary."[251]

Ginter consulted with Joseph Bryan and the other partners. "He took a few days to consider and then made the gift freely and cordially, of the magnificent plot of about twelve acres," Kerr said. The land was to be bound by Chamberlayne Avenue, Westwood Avenue, Brook Turnpike and Melrose Avenue.

The deal was sweetened with a pledge from the new chairman of the seminary's board of trustees, George W. Watts of Durham, North Carolina. He offered $50,000 for the building fund on one condition— that the seminary be located on the Ginter site. Not coincidentally, Watts was secretary-treasurer of the American Tobacco Company and a silent partner in Ginter's suburban development. Another pledge of $25,000, with the same conditions, came from philanthropist William Wallace Spence of Baltimore. Naturally, Ginter's property—with its "healthful benefits" and fifteen-minute streetcar service to the city—won the contest.

Chosen as architect for the campus was Charles H. Read Jr. He started in private practice in Washington, D.C., and returned to his hometown of Richmond in the late 1880s. By February 1896, Read had finished his drawings for the "splendid" buildings. Structures on the seminary campus blended several popular styles: Richardsonian Romanesque, Collegiate Gothic and Victorian Gothic. The main buildings faced a spacious quadrangle. Authorities of the institution hoped the young seminarians

would use the lawn for exercise and sports, in the firm belief that "the day is past when the pale and wasted preacher is the man to win the public heart and sway the minds of men."[252]

While Ginter was impressed with the plans for the buildings and grounds, they were modified a bit to incorporate his suggestions. The three-story Watts Hall was built in 1896, in dark red brick with stone accents, to serve as the administration and classroom building. Its four-story entrance tower, with a Gothic-arched entrance, had a stone battlement. Two more structures were completed the following year. One was Spence Library, featuring decorative, cast-iron porches and a round tower. The other was Westminster Hall, designed as a dormitory, with beautiful cast-iron porches of its own.

The seminary planned to open its doors in 1898, with other handsome structures designed by Read. The bold and striking buildings would set the tone for Ginter's suburbs and—as he'd calculated—give rise to some spectacular mansions along Seminary Avenue and beyond.

Union Theological Seminary. Watts Hall was named for financier George W. Watts, a silent partner in Ginter's land company. *VCU Libraries.*

Constructing the Lakeside Wheel Club

Saturday, there will be a grand bicycle meet at the Exposition Grounds. [253]

In the Gay Nineties, the craze of cycling hit America like a tidal wave. Due to advances in bicycle design, the "high-wheelers" with their large front wheels were *out*, and the safer, more comfortable, "standard" two-wheelers were *in*. Gentlemen organized wheel clubs across the country, like the Owl 'Cycle Club and Independent 'Cycle Club in Richmond.

A number of gentlemen from the Commonwealth Club and Westmoreland Club discussed the feasibility of a retreat for wheelmen in the country, where they could rest and have refreshments. Their plan was presented to Lewis Ginter, who was a member of both clubs. Ginter sensed another entrepreneurial opportunity to enhance Richmond's lifestyle. He offered to erect a handsome clubhouse for cyclists five miles north of the city, fronting an old millpond. The mill dated back to the time of Washington. This was about a half mile north of today's intersection of Lakeside Avenue and Hilliard Road. Ginter purchased the ten-acre site in 1894. [254] Its ownership traced back to Virginia governor Patrick Henry.

Completed in late 1895, the one-story wheel club was built on a high bank overlooking the lake. Its broad verandas had hexagonal pavilions at each end, where a clutch of gentlemen could compare notes on their bicycles or glorify their favorite Confederate heroes. Under the porch was a repair room and stable for their "nickel-plated steeds."

When the clubhouse was formally opened on November 4, 1895, most of the 150 members paraded from the Commonwealth Club on their cycles, toured the lovely building and grounds and then celebrated with an elegant banquet. [255] The interior boasted a parlor, a drawing room, a buffet room and—of course—a smoking room. Throughout the structure were dark oak floors, made cozier with Turkish rugs.

While ladies couldn't become members of the club, they could be invited as guests. The club even provided a room for their enjoyment.

About a year after the opening of the Lakeside Wheel Club, its members could cycle from Richmond to the clubhouse in thirty minutes using the "Missing Link" bicycle track. The lane was composed of smoothly packed cinders and stretched from Broad Street to Hermitage Road, parallel to the Boulevard. At the time, that section of the Boulevard was a rough country

The Lakeside Wheel Club. Painted a buff color with dark green trim, the structure had a red roof. *Library of Virginia.*

road used by carriages. Once the men arrived at the clubhouse, they could refresh themselves in style and comfort. They could sit on the long gallery and enjoy homemade ice cream. Or they could drink spirits, if they so desired. The club's steward, Julius, "officiated with dignity and competence."[256]

THE BRILLIANT CREATION, LAKESIDE PARK

Every pretty afternoon, the lake was dotted with happy rowing-parties.[257]

By the spring of 1896, Ginter had transformed the sixty-three acres opposite the lake from the Wheel Club into the lovely and feature-rich Lakeside Park. This was part of his master plan. He'd purchased the land just five months after chartering the Sherwood Land Company.[258]

Lakeside Park was unlike anything Richmond had ever seen. It was an amalgamation of ideas that the cosmopolitan Ginter had picked up from all over the world. His personal secretary, Tony Thiermann, helped supervise the planning and construction of the enterprise.

Scenic Lakeside Park. At the top of the hill is a dance pavilion called the casino. *Valentine Richmond History Center.*

Again, Ginter had set his sights high, resulting in an incredibly beautiful blending of nature and art. While preserving the natural forest of oaks and pines, the lake was stocked with fish and featured a man-made island, a boathouse and an abundance of rowboats for the enjoyment of visitors.

The waterfowl were truly a sight to behold. Ginter imported many rare and beautiful specimens from the zoological gardens in Antwerp, Belgium. Lakeside's birds were believed to be the largest and most diverse collection in America at the time. The menagerie included white and black swans, Chinese geese and East Indian ducks. There was also a large deer park and even a bear pit. On the lawn nearby, a pair of peacocks could be seen strutting about.

The park offered much more recreation than just fishing and boating. It boasted facilities for bowling, billiards, tennis and dancing. There was a half-mile bicycle track. In the summer, there were fireworks. And in the winter, visitors ice skated on the lake. In keeping with other parks of its kind, there was also a gazebo-style bandstand near the lakeshore, where military bands and other performers played sweet tunes in the evening during seasonable weather.

One of the most unique novelties on the grounds was the labyrinth, a maze of hedges that stretched for an eighth of a mile. It was an exact copy of the famous labyrinth at Hampton Court Palace near London that was commissioned in the late seventeenth century by King William III.

Lakeside Park's café building was designed by D. Wiley Anderson, and it was said that its dining room served "the best cuisine" at "city prices." Attached to the café was the billiard hall.

The casino was a glass-enclosed dance pavilion in Colonial style with a stage for musicians. (At the time, the word "casino" simply meant "a place for social amusements.") There are touching stories of Southern ladies cheerfully entertaining the old Confederate veterans on the dance floor.

Once completed, Lakeside Park was considered one of the most beautiful and complete suburban resorts in the country. The cost of admission in 1896 was ten cents, and children under eight were admitted free.

During the park's first year, it could be conveniently reached by Ginter's dummy line on Brook Turnpike after a delightful ride through a rich and picturesque countryside. By placing his park at the end of his streetcar line, Ginter hoped to entice citizens from the inner city to make their home in his suburbs. It was a tried-and-true strategy in nineteenth-century speculative real estate. And no park in Richmond could rival the multifaceted sparkle of Lakeside Park.

In 1897, just a year after the park opened, the Richmond Railway and Electric Company replaced the dummy line with an electric line. That same year, the *Times* said of the park, "Its fame has spread far and wide, and no one visits this beautiful spot, where the eye can scarcely tell where nature ends and art begins, without feeling that no one without a keen appreciation of beauty and form could have ever planned and put into execution so many striking features."[259]

By the spring of 1898, Lakeside Park featured Richmond's first nine-hole golf course. Some sources say the course was designed by Tony Thiermann, while others credit 1890s golf pro Willie Tucker. Pine forests served as backdrop for the picturesque course. A private golf club was formed, called the Lakeside Country Club, with "fashionables" gathering at the Lakeside Links to witness tournaments.

Since Ginter's suburban development was a lovely fusion of tree-lined streets, state-of-the-art transportation, recreational facilities, a prestigious institution of higher learning and an impressive monument—all with social aspects in mind—he would years later be called "a city-planner after the order of Father [William] Byrd."[260] After the turn of the twentieth century, Ginter's friends would actually discover old, yellowed maps showing that William Byrd himself had planned villa sites northwest of the city. But it took Major Lewis Ginter to make it happen.[261]

In the mid-1890s, Ginter hosted one of his friends on the porch at Westbrook. The man, Charles S. Stringfellow, told him, "Major, you have almost transfigured this country."

"Well," Ginter replied, "I think I have improved things, but they tell me it has cost too much, and I wouldn't get my money back." After pausing for a moment, he added, "But that makes no difference. Those who have claims upon me are already provided for, and I do them no wrong. I had rather use my money and do some good with it than to pile up big balances in [the] bank. This work out here has given pleasure to a great many people and bread, too."

Even as Major Lewis Ginter spoke, he was nearing completion on another commission—one that would astonish not only his fellow citizens but, indeed, the entire world.

GINTER'S TOUR DE FORCE: THE MAGNIFICENT, LEGENDARY HOTEL

The glory of Richmond and the pride of her people.[262]

In 1892, Ginter began work on his Richmond masterpiece, the culmination of his career and his flair for the arts. He would prove—once again—his ability to triumph over seemingly insurmountable obstacles.

The saga began in the early 1880s, when members of the chamber of commerce insisted that Richmond's most urgent need was a first-class hotel. They argued that much revenue was passing the city by—not only from commercial travelers and well-to-do tourists but also by Northern investors who could potentially decide to start up "manufactories" there. The editor of the *Richmond Mercantile and Manufacturing Journal* was blunt—without a first-class hotel, he said, "the growth of our city is retarded."[263]

In the spring of 1888, ten of Richmond's most prominent businessmen and philanthropists banded together. Led by Joseph Anderson, the men included Joseph Bryan and Major Ginter.[264] What they needed now was an agreeable site and enough investors to fund the project. Some of the sites under consideration were at Fifth and Main Streets, at Second and Franklin Streets and at Fifth and Franklin Streets (where the John Marshall Hotel would eventually be built).

After investigating the hotel business in various cities, Ginter recommended that the Richmond project be funded through stock subscription. With all the local papers publicizing the cooperative campaign, Joseph Bryan's *Daily Times* pointed out that an individual or business could purchase shares in the venture to match their means. By December 1888, they had reached half their goal of $250,000, acquiring commitments from Allen & Ginter, Joseph Anderson and the Chesapeake and Ohio Railway.[265]

It wasn't long before things started falling apart.

Not only was funding difficult, but there was disagreement on the hotel site. To make matters worse, Joseph Anderson got a horrible case of the flu in the summer of 1892. He went to the Isle of Shoals, New Hampshire, where he hoped the sea air might help him. On September 7, he died.

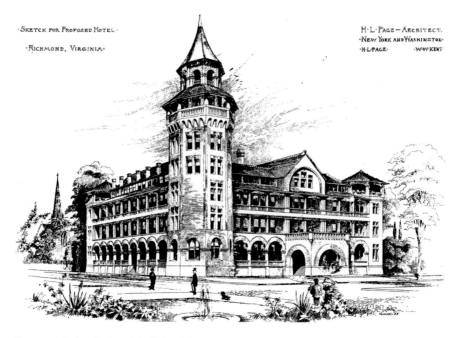

Proposed design for hotel. Building Magazine, *September 1, 1888.*

The *Dispatch* lamented, "Another of Richmond's most prominent and beloved citizens has gone over to the silent majority." It added that "for half a century [Anderson] had been in the van of every movement having for its object the advancement of the social, charitable, and material interests of the city."[266] This was a tremendous shock to the people of Richmond. Reportedly, the crowd at his funeral from St. Paul's Episcopal was the largest yet seen at a private funeral in the city.

For Major Ginter, the death of Joseph Anderson—longtime friend and fellow veteran, entrepreneur and civic leader—was a truly mournful event. It also changed the battle plan for the hotel venture. Major Ginter knew the failures had dragged on for way too many years, so he made a tactical decision. The time had come to take charge.

He made arrangements with Anderson's heirs to purchase the home and to, in its place, erect the most exquisite hotel in the entire South. If the Andersons had any reservations at all about Ginter's idea, his "almost feminine tact" was indispensable.[267] Besides, since Joseph Anderson's widow was planning to build a large town house on Ginter's block of West Franklin Street, the new hotel would be part of her beloved husband's legacy after all.

Major Ginter knew the new hotel site was positively perfect. It was in "a lovely portion of the city" away from the industrial section and on a high spot with commanding views. Not only could the hotel stand proudly and prominently, but it could also beckon incoming travelers. To Ginter, this was a once-in-a-lifetime opportunity—for Richmond.

Most accounts say that Ginter financed the hotel single-handedly, but he had two able assistants: John Pope and George Arents. This power structure would streamline the entire process, which was no doubt the rationale behind it. Richmond's business community had confidence in the three "fearless" men. They were said to "ensure the success of any enterprise where capital and sound judgment are needed."[268] Ginter had done his homework. He knew the traveling public of the day demanded a well-appointed hotel.

He also noted that the great tide of travel to and from Florida and other Southern states was growing larger each year. There was "a demand for a fine mid-way resort hotel, at which the pleasure tourist or the invalid could stop off going or coming, and take a much-needed rest in a hotel as good as any in the land," he declared.[269]

He was also confident that the hotel would attract wealthy classes who spent their winters in the South. "Where better could they find a place to

spend the winter than in Richmond?" he remarked. "It is said that there are more lovely days here than in any city in the Union. Our winters are mild, the air is clear and balmy, and the sun shines here with a gladness that is seen in few sections of the country."[270]

Ginter saw the city itself as a destination. "There is in Richmond more of historic value than in any city of the country," he stated. "A circuit of one hundred miles around the city is the arena of more historic events than any other equal area in this country."[271]

Underneath it all was Major Ginter's desire to improve the city's image in the world. At the time, a fine hotel was the mark of an ambitious city. Without one, it could be left in the proverbial dust.

As the principal owner of the new hotel, Ginter would supervise every detail of the construction and outfitting. And he was shooting for the stars. "Every detail of the house shall be in the most modern and palatial style known to the craft," he said. "Nothing shall be lacking when it is completed that can possibly add to the comfort of the guests. I do not believe in doing anything by halves, and I promise you that Richmond will be proud of our new hotel; in fact, no city in the South will then be able to boast of one more magnificent or elaborate in every imaginable detail."[272]

Ginter had envisioned a hotel with "architectural beauty and grace," and, according to the *Times*, everyone who heard about his plan thought it would be the greatest thing for Richmond's prosperity ever undertaken.

It's no wonder Ginter was so deeply inspired. Throughout his long life journey, there was a man who had shown him the way by oil lamp. A man who taught him the importance of duty to city, nation and humanity. A man who taught him the importance of challenging tyrannical rule and fighting for what's right. A man who proclaimed the virtues of literature, architecture and fine art. And a man who showed him the bright promise of the future while comforting him in the darkest moments of his past.

This grand hotel would serve as a monument. A monument to Thomas Jefferson.

In planning the Jefferson Hotel, Ginter knew where the bar had been set for him. Over the course of his long career, he had frequented dozens of the finest hotels on the globe: The luxurious, French-Baroque Palmer House in Chicago. The opulent Palace Hotel in San Francisco. The incomparable Waldorf-Astoria in New York City. Not to mention the finest in London, Paris and the French Riviera.

In early 1893, Ginter, Pope and Arents received proposed plans from twelve respected architectural firms. After studying them carefully, the choice was unanimous: the Jefferson Hotel project would be awarded to the renowned firm of Carrère and Hastings of New York.

The firm's Beaux Arts–style design for the Jefferson Hotel was inspired by the Villa Medici in Rome—yet wildly more expressive. With grand entrances, towers and a roof garden, it bristled with Classical details like window and door pediments, cartouches and pilasters. Since Ginter had unrivalled good taste and an obsessive eye for detail, it's been said that he pushed his architects to the breaking point with round after round of design changes.

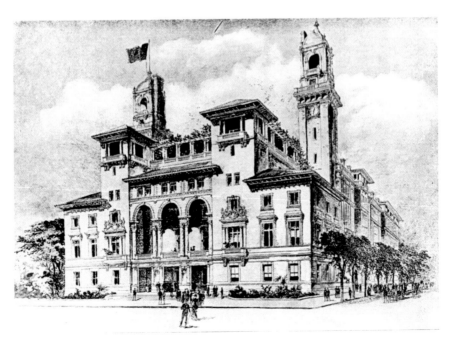

The design for the Jefferson Hotel by Carrère & Hastings, the unanimous winner. *Library of Virginia.*

Construction finally began in the summer of 1893. The final plans called for billiard rooms, a library, a ladies' salon, a grill room, Turkish and Russian baths, plus every contemporary convenience: electric lights, electric elevators, hot and cold running water in the guest rooms, central steam heating and even a cutting-edge device to call for room service. The hotel's boilers would be manufactured by another one of Ginter's enterprises, the Richmond Locomotive & Machine Works.

The elaborate design for the Jefferson Hotel provided three primary entrances. The one on Franklin Street, known as the "ladies' entrance," would be for Richmonders attending social functions. The Main Street entrance leading into the rotunda would be for commercial travelers. And the covered side entrance—the porte-cochère—would be for carriages. The hotel would have 308 guest rooms, as well as 34 rooms reserved for employees.

To achieve a rich and peerless interior, Ginter purchased hundreds of valuable antiques in America and abroad. He imported exotic palm trees from Central and South America. And the upper lobby would not be complete,

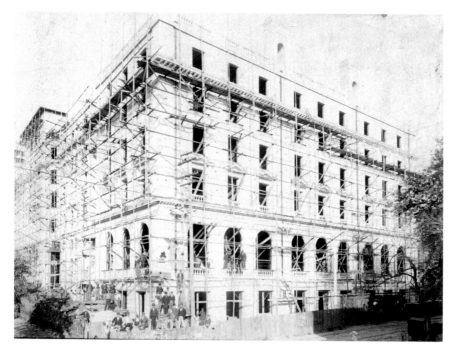

The Jefferson Hotel, circa 1894, as it went up with all speed. *Library of Virginia.*

Ginter thought, without a statue of Thomas Jefferson as a centerpiece. A *world-class* statue of Thomas Jefferson.

He commissioned Richmond sculptor Edward V. Valentine to create a life-size statue of Jefferson from pure Carrara marble. Valentine had studied in Paris, Berlin and Florence and set up his studio in Richmond right after the war. He had sculpted busts of several prominent Confederates. He had sculpted the massive *Recumbent Lee* for Lee's tomb in 1875. And he had sculpted a proud statue of Stonewall Jackson in Lexington in 1891. Ginter and Valentine were both members of the Westmoreland Club and a Masonic Lodge called the Lodge of Strict Observance.

With Valentine's international reputation, he had the rare privilege of borrowing a suit of clothing actually worn by Thomas Jefferson. He dressed his model in Jefferson's ample cloak with cape, long waistcoat, knee breeches and multifold neckcloth. It must have been the experience of a lifetime for Ginter to be able to see and touch clothing worn by his idol, the former president.

While most depictions of Jefferson had placed him in his advanced years, Ginter decided to present him at thirty-three—the age at which he signed the Declaration of Independence. To Ginter, independence was the highest of Democratic virtues. It was, after all, one of the primary themes of the Confederate rebellion.

In the statue, Jefferson would rest his left hand on a Doric column, and in his right hand he would hold the famous document that played such an important part in the nation's destiny. It would take Valentine two years to complete the masterpiece.

It's been estimated that Ginter, Pope and Arents spent nearly $2 million *in 1890s dollars* on construction— and by the time it was furnished, the grand total soared to between $5 and $10 million.

With the exterior a careful blending of cream brick, white terra cotta and gray granite, every brick used in construction was supplied by the Powhatan Clay Manufacturing Company—another enterprise owned by the three men.

Ginter's dream finally came to life in late October 1895, after twenty-seven months of construction. With its broad mix of influences, the magnificent building was a radical departure from the architecture of Richmond. But that was precisely the point. In high fashion, it lent the city the flavor of cosmopolitan Europe.

On October 30, the Jefferson Hotel opened its doors for an invitation-only preview hosted by Ginter, Pope and Arents. Word of the preview had spread, so thousands of Richmond citizens showed up eager to tour the palatial structure. They were all welcomed into the hotel's Franklin Street lobby, the marble hall.

They entered the breathtaking dining room finished in Italian Renaissance style, its magnificent archways and richly detailed coffered ceiling painted in blue and gold. They lingered in the two-and-a-half-story rotunda, with its glass roof, deep-red leather seating and floor of marble. They ascended the grand stairway, with its arched ceiling. All along the way, they marveled at magnificent paintings from the brushes of celebrated artists.

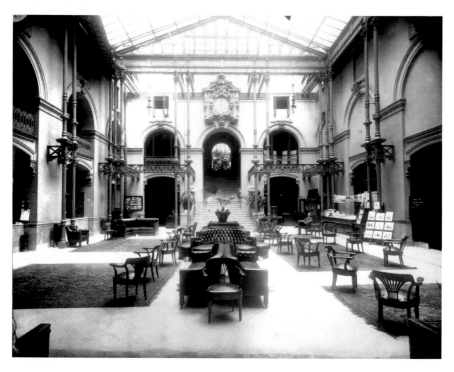

Original rotunda of the Jefferson Hotel, painted a fashionable, pale olive. *Cook Collection, Valentine Richmond History Center.*

Statue of Thomas
Jefferson, sculpted by
Edward V. Valentine.
He and Ginter were
both members of
the Lodge of Strict
Observance. *Valentine
Richmond History Center.*

And then, when the statue of Thomas Jefferson was unveiled in the Franklin Street court—amid palms and sparkling fountains—even the most sophisticated in attendance declared it a triumph. From beginning to end, "everyone agreed that it was a veritable fairyland of beauty and taste."[273]

To Richmonders, the Jefferson Hotel was as triumphant as Michelangelo's Sistine Chapel fresco, Tchaikovsky's plaintive and bombastic "1812 Overture" or Oscar Wilde's chef d'oeuvre, *The Importance of Being Earnest.* In fact, the Jefferson was enthusiastically proclaimed to be the finest hotel in the country.

On Halloween night, the day after the public preview, the hotel was the site of an engagement party for the young and beautiful Irene Langhorne and Charles Dana Gibson. Miss Langhorne had led cotillions in Philadelphia, New York, Richmond and New Orleans, and Ginter opened the hotel a day early to accommodate the elegant party.

One of the Jefferson's bridal parlors, with all the elegance of a Paris salon. *Library of Virginia.*

The next day, November 1, the hotel opened for business to the general public. The distinguished guests registered for the first night hailed from all over the country, including New York, Boston and San Francisco. And the distinguished guests just kept on coming. Just days after the grand opening, an entourage arrived in Richmond for the Langhorne-Gibson wedding, which was to take place on November 7 at St. Paul's Church on Grace Street.

That same week, the Duke of Marlborough was also planning a stay at the luxurious Jefferson. "Rooms Engaged for the Duke at Richmond's Swell Hotel," trumpeted Washington's *Morning Times*, "a suite of rooms has been engaged at the Jefferson by the Duke of Marlborough, who will shortly visit Richmond."[274]

For the first several weeks of business, Ginter added a touch of whimsy to the hotel. He brought in a tame and amusing raccoon from his Lakeside Park. It would toddle around the rotunda and climb up on the visitors. The raccoon, named Jefferson, was a favorite with staff and guests alike.[275]

Now that the hotel was in full operation, Ginter changed his morning routine. On the way to his factory by carriage, he would stop at the Jefferson and have a conference with the managers.

In every way, the style in which the hotel's affairs were conducted was commensurate with its appointments. Stationed at the doors of the Jefferson were large, handsome carriages, with drivers in regal uniforms. In the culinary department, there was an army of cooks whose continental cuisine was pronounced "inimitable." The milk and butter were supplied by Ginter's Bloomingdale Stock Farm, and the vegetables were grown just north of his Westbrook estate in the Jefferson Garden. Incredibly, Ginter had managed to create numerous interdependent enterprises.

One of the hotel's many forward-thinking features was the ladies' café. A dainty-looking room east of the Franklin Street court painted in subdued pink and other delicate hues, it was a place where ladies could socialize among themselves and without the men in their lives—a bold, new concept at the time.

The Jefferson became interwoven with the social life of Richmond. It served up a brilliant scene of cotillions. Debutante balls. Concerts. Society gathered for group dinners. Ginter would even host brilliant social functions of his own there, with hundreds of personal guests.

On the hotel's roof garden, which provided one of the best views of the James River and the surrounding country, there was a twenty-six-foot-wide

Advertisement for vaudeville acts staged on the Jefferson Roof Garden, including the "Dancing Dog." *Richmond Dispatch, August 4, 1896.*

The Jefferson.

ROOF GARDEN

VAUDEVILLE.

Sixth Week.

MISS VERA HARTE,
Prima Donna Soprano.

MATTIE AND PATSY ROONEY,
Songs and Dances.

MISS GEORGIE HOWARD,
Spanish and Eccentric French Dances.

MISS JESSIE VILLARS,
Character Change Artist.

EFFIE HUESTED and MABEL GUYER,
Comedy Sketch Artists, introducing the Dancing Dog.

THE JEFFERSON ORCHESTRA.

Reserved seats..50c.
Admission..25c.

stage with a proscenium arch in Louis XVI style. In the late 1890s, vaudeville shows were staged there, accompanied by the Jefferson's own orchestra—a real crowd pleaser among both hotel guests and native Richmonders.

Just inside the Main Street entrance was the smokers' hall. About fifty feet square and wainscoted in light oak, the magnificent room was dominated by massive columns and oak beams and had dark green leather furniture. The ceiling and walls were painted a subdued shade of terra cotta. On both sides of the room were colossal fireplaces built of Sienna marble and polished oak. The decidedly masculine features were fitting. At the time, men composed the vast majority of smokers, at least in public. The *Dispatch* called the room "a veritable El Dorado to all lovers of the fragrant weed"— and a majority of the gentlemen patrons were probably puffing on Ginter's brands of cigarettes and smoking tobacco.[276]

A century after Thomas Jefferson built the stately Capitol Building, Major Ginter had graced Richmond with another one of its grandest and most beautiful architectural ornaments. Combined with the High Victorian city hall that had recently been completed at Eleventh and Broad, Richmond was on the map again—at long, long last.

Soon after the Beaux Arts–style Jefferson was erected, some of Richmond's finest homes were built in the style in the Fan District and elsewhere. Examples included Joseph Bryan's second Laburnum, the Scott-Bocock House on the 900 block of Franklin Street and Richmond's Main Street Station—proving Ginter's influence as a style-setter.

The Jefferson also had a ripple effect on the city's economy. About ten years after Ginter built the hotel, Richmond bankers wrote in a joint statement, "The material prosperity of this community was powerfully helped by the opening of The Jefferson Hotel."[277]

Many asserted that Ginter's suburbs were every bit as beautiful as the Jefferson Hotel—despite the fact that home construction had barely begun.

With his enormous cigarette fortune—and help from John Pope, Joseph Bryan and an entire league of protégés—Ginter had turned Richmond into

a beautiful and prosperous world-class city. One of his friends and admirers, George L. Bidgood, said, "No man has done so much as he in putting Richmond and her beautiful environments in such conspicuous attractions before the world." He added that, to Major Ginter, building up this beautiful city "was the delight of his soul."[278]

But, as we'll see, he wasn't nearly finished bettering the city he loved.

Chapter 6

Departure

While Major Lewis Ginter was a bold overachiever, he had one little quirk. He avoided the spotlight like the plague. It horrified him. In the run-up to the opening of the Jefferson Hotel, some of his admirers had planned to present him with a loving cup on the occasion. He asked one of his best friends to have the undertaking stopped at once.

In 1896, Dr. Hunter McGuire was planning to recount Major Ginter's battlefield heroics at Second Manassas during a speech in Lexington. Ginter asked him as a personal favor not to do so. Then, some of Ginter's friends began a movement to have a little statue of him made and placed in one of the city's clubs. When he found out about the plan, he promptly sent a request that it not be done.[279]

As wealthy as Ginter had become, he was the most unassuming man imaginable. His friends said he rarely spoke of himself. It's one of the most amazing paradoxes of Ginter's life. While his reputation meant everything to him, and he "had a kind word for all," he "disliked flattery and abhorred gush."[280]

In spite of his vast wealth, Ginter was genuinely selfless. "He was a very humble man, modest as a woman, and retiring," said the *Times*.[281] Thomas Jefferson also had this contradictory mix of brilliance and modesty.

Major Ginter "cheerfully" gave much of his time, energy and resources to benefit his fellow citizens, making him one of the most avid philanthropists the city would ever know. Joseph Bryan called him the best citizen a city could ever have.

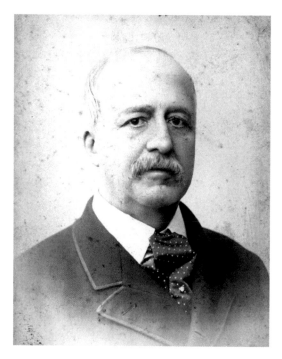

Lewis Ginter, photographed in France, circa 1895. *VCU Libraries.*

Ginter found wealth meaningless unless he could share it. Duty was calling again. He gave generously to practically every charitable organization in the city at the time, including orphanages, hospitals, the Home for Incurables and the Mechanics' Institute (the nineteenth-century version of a technical college). He helped fund the Rosemary Library, the closest thing to a public library that Richmond had ever known. He took great pleasure in "building and decorating a Baptist church for negroes in Henrico County," a plan that included "St. John's Colored Baptist Church and a considerable row of houses...for his employees."[282] He also offered discreet assistance to individuals who had suffered economic reverses or were otherwise unable to support themselves. He knew all too well how it felt to lose everything.

Almost without exception, he gave anonymously, entrusting Reverend Hoge as an intermediary. There are many stories of Ginter wrapping up money in a package and discreetly handing it to the pastor, with clear instructions to withhold the source from which it came. Hoge believed Ginter added dignity to wealth through his "discriminating and generous use of the gifts of God's providence in giving aid to the unfortunate, the friendless, and the helpless."[283]

Some guessed that Ginter had given as much as $300,000 to charity of which the public was completely unaware, while others asserted the amount was far greater. One can only imagine what that figure would translate to in today's economy.

<p style="text-align:center">———●○○●———</p>

Major Ginter had a philanthropic style all his own. Unlike most Richmond businessmen, he was willing to invest locally, even when he could have made better financial returns elsewhere. In fact, he felt so strongly about Richmond's welfare that he invested his wealth there *to the exclusion of other places.* After the Rotunda at the University of Virginia burned in October 1895, Richmonders Joseph Bryan and Wyndham R. Meredith helped collect funds to rebuild the structure. Visiting Ginter at his Franklin Street residence, they explained the project in detail and asked for a contribution. They were optimistic he would give a "snug sum," since he had given so generously to many other causes. "Gentlemen," Ginter said, "I agree with you that the destruction by fire at the University is unfortunate, and I hope the fund to replace the damage may be promptly raised. But, for my part, what I have to give will be to Richmond institutions. I am for Richmond, first and last."[284]

HELPING FOUND THE UNIVERSITY COLLEGE OF MEDICINE

No man becomes a saint in his sleep.
—*Thomas Carlyle*

In the early 1890s, Richmond was reportedly the only city of its size without a public hospital.[285] A group of the city's businessmen, including the Major, decided to do something about it.

In 1893, under the leadership of ex-Confederate Dr. Hunter McGuire, the men founded the University College of Medicine. Among the twenty-

two other co-founders were Major Ginter, John Pope, Reverend Hoge and Joseph Bryan. McGuire was elected president and Ginter vice-president.

The men's goal was to create a medical college and teaching hospital "in line with such colleges in New York and Philadelphia" and "to make Richmond a center of medical science." They also wanted to provide the city with a "hospital for the care of the suffering poor who were unable to pay for proper medical attention."[286]

For a brief time, the new venture was called the College of Physicians and Surgeons, with its home at the old Pinel Hospital on West Broad Street near Allen Avenue. Realizing that city water was unavailable at that site, the group of men purchased two historic mansions on Clay Street, between Eleventh and Twelfth Streets.

At the corner of Twelfth and Clay was the Bruce-Lancaster House—the former residence of Confederate vice president Alexander Hamilton Stephens—which was to be used for classes and administrative offices.[287] The other was the Brockenbrough-Caskie House at 1100 East Clay Street, which was to serve as the hospital.

The college's first session began on October 3, 1893, and the Virginia Hospital opened three days later. Reportedly, the University College of Medicine offered "superior instruction," and by the late 1890s, it had added two more departments: dentistry and pharmacy. Since it operated in competition with the Medical College of Virginia, it sparked a bitter rivalry. To resolve this issue, the two organizations merged in 1913.

A JOYOUS CELEBRATION FOR THE DIVINE

If the united testimonial of a whole community is cause for pride,
Rev. Dr. Hoge should be a proud man.[288]

In February 1895, the people of Richmond had a jubilee, joyfully celebrating Reverend Hoge's fiftieth anniversary at Second Presbyterian. The festivities for the beloved divine stretched on for days. Of course, there was much more to celebrate than his tenure with Second Presbyterian. He'd illuminated pulpits throughout the South and in every large capital of the English-speaking world. He'd served as minister to the Confederate Congress. He'd presided at state funerals. He'd officiated "at more public gatherings

probably than any other man in the South." The brilliant and scholarly orator had become one of the most renowned divines in the entire country, not to mention Europe.

As part of the celebration, Major Ginter hosted a delightful dinner party on February 19 in honor of his longtime friend. Held at the Franklin Street mansion, the guests included clergymen from various denominations in the city.

The *Dispatch* said, "At each plate was a very handsome souvenir badge of silk, bearing the inscription '1845—February 19—1895.' Large scarfs of silk bearing the same sentiment, and indicating the period of Dr. Hoge's pastorate here, adorned either end of the table."

Besides Reverend Hoge, the clergymen included Reverend R.P. Kerr, Reverend Hartley Carmichael, Reverend J.J. Gravatt and Right Reverend A. Van De Vyver, all of whom held a special place in Ginter's heart. With eighteen men at the banquet table, the others included Virginia governor Charles T. O'Ferrall, the infamous Dr. Hunter McGuire, publisher and industrialist Joseph Bryan and, of course, Ginter's companion, John Pope.

Major Ginter presided over the dinner and "in appropriate words proposed a toast to the gifted divine in whose honor the affair was given," said the *Dispatch*. "The Major spoke of his long friendship for Dr. Hoge. They had been friends ever since they were young men together."

This warm reception made quite an impression on Reverend Hoge. "Once in New York, and once in England I was present at a banquet, each of which was celebrated in the published accounts of it as unprecedented for elegance, good taste, and the decorum of the guests, but neither of them was comparable to one given by Major Ginter in 1895," he said.[289]

In Ginter's twilight years, while continuing his work to enhance his city, sentimentality would loom large in his life.

In March 1895 came the sudden death of Ginter's close friend John C. Shafer, the wealthy merchant tailor and fellow land speculator. An excellent financier with strong executive ability and one of the city's "most substantial citizens," he was seventy-five years old.[290]

Shafer's death was particularly poignant for Ginter. The two had journeyed to Richmond together as mere boys in 1842 seeking their fortunes. Ever since, through all the many changes in their lives, they had remained close. And, as mentioned, Ginter purchased his Franklin Street lot from Shafer, making them back-door neighbors.

Shafer was buried in Hollywood Cemetery, in an old family mausoleum along the main drive. Major Ginter didn't know it yet, but he would soon pay the mausoleum an important visit, with the most touching of overtones.

THE TIRELESS AND COMPASSIONATE JOHN POPE

Very few Richmonders really knew him, except by name and reputation.[291]

Like Lewis Ginter, John Pope was tremendously civic-minded and did everything in his power to improve Richmond. Also known for his kindness and Christian charity, he generously supported city orphanages, even chaperoning orphans on outings. During the holidays, he took them to see a Christmas program at the Richmond Theatre, complete with a "snow scene and the arrival of Santa Claus in a sleigh drawn by ponies" and presents for each child. And in the summer, he entertained orphans on the Westbrook grounds, perhaps for a bowling party and picnic.[292]

But John was more than charitable; he was an inspiration. In the early 1890s, W.P. Dabney—described as "the colored musician, so well known in Richmond"—wrote a guitar solo piece titled "Psyche" and dedicated it to John.[293]

Around 1894, John took his first steps in developing Bellevue Park on land he'd purchased, bounded by today's Westbrook Avenue, Hermitage Road, Bellevue Avenue and Crestwood Avenue. He planned a drive connecting Hermitage Road to Westbrook that could eventually serve as a street for his suburban development. In time, the street would be named after him.

As a gateway to the drive, at the intersection of Hermitage Road and Bellevue Avenue, he and Ginter planned the granite Bellevue Arch. Completed around 1894, it reflected the renewed interest in the Roman arch and was constructed of fashionable granite.[294] The stone was probably quarried right at Ginter's facility on Old Hermitage Road and transported to the site by the Barbara—at least that was his intention.[295]

Hermitage and Bellevue, circa 1894. The newly masoned Bellevue Arch stands alone at right. *Cook Collection, Valentine Richmond History Center.*

Rare photo of John Pope, circa early 1890s. Assistant manager E. Victor Williams stands in background. *Valentine Richmond History Center.*

The two men had a stone plaque fitted into the arch's summit. Carved in relief was the word BELLEVUE, signaling the entrance to a beautiful view. (*Bellevue* means "beautiful view" in French.) Reflecting the latest landscape design trends, the road that went through the arch followed the curvature of the open farmland, and traveling the country road provided a sweeping vista of Ginter's grand Westbrook country home and estate. Hence, the "beautiful view."

By early 1896, John Pope was working harder than ever—and not just as vice-president of American Tobacco and managing director of the Allen & Ginter branch. He was president of the Crystal Ice Company of Richmond, the Powhatan Clay Manufacturing Company and the James River Marl and Bone Phosphate Company. He was vice-president of the Jefferson Hotel Company and the Bloomingdale Stock Company. He was a director of the Virginia Trust Company, the Metropolitan Bank, the National Bank of Virginia and the Richmond Standard Spike and Iron Company, as well as secretary-treasurer of the Sherwood Land Company.

Many of John's associates in these enterprises were his friends, and he generously lent them his wise advice. He was stretched dangerously thin.

Then, in March 1896—ominously—one of his brand-new tobacco warehouses collapsed.[296]

POPE AND TRAGEDY

Let us go into John's room and pray.[297]

Exhausted and care-worn, John Pope was looking forward to a long vacation and rest in Europe that summer with Lewis Ginter.

But on the morning of Good Friday, April 3, he returned from a New York business trip violently ill. Also complaining of a horribly sore throat, he immediately took to his bed at the Franklin Street home.

By the next morning—Ginter's seventy-second birthday—John could barely breathe. There was panic in his eyes. Ginter rushed to summon the top surgeon in the South, Dr. Hunter McGuire, the very doctor who'd amputated Stonewall Jackson's arm during the war.

Dr. McGuire saw that an absess had formed in the wall of John's windpipe, practically cutting off his airway, so he quickly called in a specialist named Dr. Joseph A. White. Dr. White arrived at the house and

was led to the patient's bedside. Within minutes, this doctor knew that the only hope was to drain the absess. That improved John's breathing a little, but the infection had already entered his bloodstream and was spreading throughout his body. Unfortunately, this was some thirty years before the development of penicillin.

The next day, Easter Sunday, John was even worse and had a raging fever. Major Ginter stayed close to his bedside, while doctors struggled in vain to help. Even with his millions, Ginter faced the harsh truth: he was completely powerless.

By the following morning, John was already unconscious, and death appeared imminent. As gut-wrenching as it must have been, a priest from St. Peter's Cathedral was called in to perform last rites.

On Tuesday, with John's life hanging by a thread, Reverend Preston Nash arrived at the home to offer Ginter spiritual guidance and pray for divine intervention.

Lewis Ginter may have been bold and fearless in the business world, but he was also a sensitive man. The man who lay dying had been his closest friend and companion for more than twenty adventure-filled years. Faced with the gravity of the situation, he took Reverend Nash's hand and said, "Let us go into John's room and pray." There, by the bedside of his dying friend, Ginter lowered himself to his knees.

The next day, April 8—a month before John Pope's fortieth birthday—he took his last breath. Ginter was absolutely "bowed down in grief."[298] He had lost his close companion and friend, his loyal partner in a host of enterprises and philanthropic pursuits. He'd watched John take his place as one of Richmond's business leaders and one of the leading capitalists in the entire South. Together, the two of them had built an empire.

Ironically, it appears that the same work ethic that made John an exceptional businessman and public servant was largely responsible for his demise. But the ironies don't stop there. He used tobacco.

The day following John's death, the Franklin Street home was besieged by friends offering their condolences. Hundreds of telegrams poured in from all over the country. While Ginter seemed to bear up well under his great loss, he was devastated both mentally and physically.

John Pope's death came as a jolt to the entire city. Flags were flown at half-mast at the Allen & Ginter factory and the Jefferson Hotel. Even citizens who had never met him were left in grief because of his tireless civic work.

John had lifted up Richmond's business community by giving of himself and his financial support to fellow businessmen and their enterprises.

Although John had been unwilling to accept public recognition for anything he had done, that recognition came like a tidal wave at his funeral. Hundreds of citizens from all walks of life were in attendance—wealthy business associates, his many factory workers, the poor who had personally benefitted through his generosity and, last but certainly not least, Lewis Ginter. They filled the concourse at St. Peter's Cathedral on Grace, with the overflow surrounding the church.

Inside, amid a profusion of flowers, the eulogy was performed by Reverend Bishop Van de Vyver. He spoke of the great good that John had done with his wealth, adding that he had cared nothing for his money except to help others with it. It was painfully touching, and everyone's hearts poured out for the Major. Then, as the Jefferson Orchestra played Handel's "Largo," the crowd began the solemn procession to Hollywood Cemetery.

Bust of John Pope by Edward V. Valentine, 1896. *Valentine Richmond History Center.*

John was buried in a plot Ginter had reserved for himself near the prestigious President's Circle, surrounded by a grieving public and dozens of elaborate floral displays. No such funeral had ever been seen in Richmond for a man outside of public life.

Even in death, John gave generously to charities and friends throughout the city. He left his brother, George, a large portion of his wealth. Soon after John's death, George donated $5,000 to the Virginia Hospital in John's name, which enabled the completion of a wing already underway. It was named the John Pope Annex.[299]

But John had a much bigger legacy. As the *Dispatch* put it, "He was a most valuable man to this city, and a valuable lieutenant to Major Lewis Ginter in all his great undertakings for the good of the city and the community."[300] In the Lost Cause mindset, he was Richmond's martyred son—giving the Major an added dimension to his loss.

STRUGGLING TO MOVE ONWARD

We deeply sympathize with the family of our deceased friend, and more especially with that member of his household who has for so many years been his truest friend, adviser and constant companion.[301]

Lewis Ginter had always been able to rally from misfortune, whether it was the utter defeat in war, the destruction of his city or losing his entire wealth at the stroke of a pen. That rare ability to keep his wits and reach a bright conclusion would be a source of inspiration for generations of Richmonders.

But this tragedy was different. All at once, it touched every aspect of his life that really mattered. Gone was the man with whom he shared his home and life. Gone was his closest friend and confidant. Gone was his trusted partner in the Allen & Ginter works, the suburban scheme and endless other enterprises. As intertwined as they were, the Major felt strangely empty and alone. "After John Pope died, Lewis Ginter just gave up," opined Fran Purdum, an avid Ginter fan and archivist at Lewis Ginter Botanical Garden.[302]

Back in Ginter's time, it was said that he managed to muster "a philosophical resignation" to his loss. He'd learned you have to make the most of a bad situation. There are some things beyond your control. Nothing's forever. You can't turn back the clock, so you have no choice but to move forward.

Still, the truth was this: Major Lewis Ginter would never be the same.

Losing strength and vitality, his health rapidly deteriorated. At least he had the loving and loyal support of his family and many, many friends.

In June 1896 came the citywide Confederate Veterans Reunion, which the Major refused to miss. He "never forgot the old comrades who shared with him the hardships and dangers of camp and field," said friend Charles S. Stringfellow. The Major opened his home to half a dozen of his old comrades during the three-day event, and as was their custom, they regaled the "hardships endured, defeats suffered and victories won."[303]

One of the men present, Colonel T.J. Simmons, told of a touching event there:

> *After dinner, when we had retired to his library, the servant announced that a young man was at the door and wished to see him. He went to the door and found a young man from Georgia, who handed him a letter from his father. The father wrote, introducing his son, and stated that he could not come to the Reunion himself, but had sent his son, and had charged him not to leave Richmond till he had seen Major Ginter. The father was a private in the Forty-fifth Georgia.*
>
> *The Major took the boy to the dining-room, had dinner prepared for him, remained with him until he had eaten his dinner, and brought him to the library and introduced him to his guests. He made the boy feel perfectly at home.*
>
> *I saw the boy afterwards, and he said: "I now understand why papa and the other men love Major Ginter so well."* [304]

As fate would have it, this reunion was Major Ginter's last hurrah. Less than a month later, in ill health, he thought that a change of scenery might help. With his companion dead, he traveled to Europe on *Campania* with Grace and the physician Dr. Hunter McGuire. It was Ginter's thirtieth voyage across the Atlantic.

When he returned five months later in late November, Richmonders were shocked by his gaunt appearance. As it turned out, he'd been afflicted for some time with diabetes. Since the discovery of insulin treatment was about twenty-five years off, the illness had quickly triggered heart disease, kidney disease and breathing problems. He suffered severe coughing spells.

By now, Ginter had made arrangements to have his beneficent work—including his suburban development—carried on after his death. Then, in

Departure

April 1897, incapable of executive work, he resigned from the American Tobacco Company. It made news around the country.

As spring turned to summer, Ginter went to Bar Harbor, Maine, in a last-ditch effort to restore his health with the sea air. Accompanying him on a specially equipped Pullman car were Grace, Minnie and Tony. But the trip was made in vain. Ginter's kidney disease made it difficult to keep food down, so he was gradually wasting away. Soon, he was too weak to walk.

In early September, the Major made a decision: to go home to Westbrook to die.

After returning to his beloved Richmond in early September, he bravely awaited the end among his loyal loved ones and servants. There was no one more concerned and filled with grief than his devoted niece, Grace.

One day, the electric railway company sent an illuminated car so Ginter could take a ride. Dr. McGuire and his wife accompanied him. This was the first illuminated electric car to run in Richmond.[305] They made the circuit all the way to Church Hill and then returned to a point near Westbrook, where Ginter's carriage driver awaited him. Ginter was so weak that he needed assistance climbing aboard. As the carriage started on its way, Dr. McGuire bade Ginter goodbye. Though pale, thin and weak, Ginter took off his hat and laughingly waved it around his head three or four times. At peace with his fate, his usual sunny disposition shone through.

In the ensuing days, when the weather was warm and Major Ginter had enough strength, he was wheeled out onto his front porch late in the afternoon for fresh air. He basked in his home's beautiful grounds. As he sat there, he must have found a degree of satisfaction that he'd lived an extraordinarily full life. He'd had a tremendously successful career and many friends. He'd been surrounded by the finest things that the world had to offer. He'd traveled to the most glamorous capitals of the civilized world, reveling in resplendent hotels "gay and bright."[306] He had done his duty to Richmond, as well as the South.

Incredibly, even though Ginter's seventy-three-year-old body was weak and wracked with disease, his entrepreneurial brain wouldn't quit. In his confusion, he fantasized about launching a large vineyard operation and actually seemed intent on making it happen.

But by mid-September, his condition had become grave. Dr. Stuart McGuire began spending days and nights at his bedside.

Ginter hadn't taken nourishment for some time and—without the benefit of modern-day intravenous nutrition—had become emaciated to just seventy pounds. He was in and out of a coma. With death appearing close at hand, the city held its collective breath.

Then, shortly before midnight on Saturday, October 2, 1897, surrounded by devoted family and friends, Richmond's legendary entrepreneur and philanthropist Major Lewis Ginter quietly slipped away.

It was called "a public calamity."

The following Monday morning, newspapers all over the country reported that death had come to "The Cigarette King."

Richmond's deep sense of loss was measured by the sheer numbers of entire newspaper pages devoted to his obituary. Death had come to the Major, they said, the man who put his city first.

In its article "City in Deep Gloom," the *State* said the citizens of Richmond were heartsick that "her most wealthy and enterprising business man had forever closed his eyes on enterprises which he had inaugurated in her behalf and carried to completion to her credit."

In the *Dispatch* version, Reverend Hoge was quoted giving this tribute: "Few names have been so often on the lips of our Richmond people as that of Lewis Ginter; few men have so frequently been the topic of conversation, and few will be remembered longer, not only because of personal worth, but on account of the enduring monuments he has left by which he will be held in long-continued recollection."

Lastly, Joseph Bryan's *Times* said, "In the death of Major Ginter, passed away a man who has done more for the material development of Richmond and vicinity than any other citizen. He constantly bore in mind the interests of this city, and never neglected a suitable opportunity to do something for Richmond." Then, after telling the story of Major Lewis Ginter's incredible life, the article concluded: "Truly it can be said of him: 'This was a man.'"

Requiem for the Major

Will be mourned by thousands of citizens through Virginia and the South.[307]

Of course, Richmond would see that Major Ginter received a funeral truly befitting his legacy. In fact, it would compare to that of a Confederate hero.

At 2:00 p.m. on Tuesday, October 5, the long procession of carriages solemnly departed Westbrook. The hearse was driven by Major Ginter's own mulatto coachman, John Haywood, and drawn by a pair of white horses. As it slowly headed south on Hermitage Road toward the city, the streets were lined with "men, women and children, white and black, who with bowed, and sometimes uncovered heads, looked upon the flower-covered casket that held all that remained as mortal of the man who had done so much for them."[308]

As the procession slowly approached St. Paul's Episcopal Church on Grace Street—where thousands of mourners packed the streets—the old veterans of Lee Camp, in full uniform, presented arms. Then, as the casket was taken from the hearse, the low sob of the organ emanated from the church as it broke into Beethoven's Sonata, "Funeral March for the Death of a Hero."

The service was to be conducted by several ministers, including Reverend Hoge. He mourned Ginter's friendship of over a half a century, "without a ripple on its surface." He also mourned one of Richmond's "best benefactors, whose place, for the present, at least, it will be impossible for any one else to fill."[309]

Crowded into the pews were Ginter's employees from the Allen & Ginter factory, including dozens of clerks and hundreds of girls who rolled cigarettes. All the directors of the American Tobacco Company were there—even Ginter's arch nemesis, Buck Duke. Scattered throughout the crowd were men and boys wearing white ribbons with "Richmond Locomotive & Machine Works" in gold lettering. Seated together toward the back were Major Ginter's servants. Amid hymns and prayers, everyone's faces expressed deep and poignant grief.

Then came the procession to Hollywood Cemetery. It was led by members of Lee Camp, who carried a Confederate flag, rolled up and draped with crepe. As the carriages entered the cemetery grounds, "an immense throng"

was waiting in hushed silence to bid farewell to the Major. The procession strode slowly and solemnly through the crowd. Finally, it came to a gentle halt in front of John C. Shafer's mausoleum.

Since Major Ginter's family was planning a mausoleum especially for him, this would be the temporary repository of his remains. It was a poignant choice. Ginter would leave this life alongside the very same man with whom he had come to Richmond.

After a brief service conducted by Reverends Harley Carmichael and Preston Nash, Major Ginter's casket was carefully carried into Shafer's mausoleum. There, it was placed in a vault. Flowers were set inside the mausoleum to brighten the place. Then, as the iron door was closed and locked, Major Ginter's farewell was over.

As the mourners slowly ambled back home with tears in their eyes and the heaviest of hearts, they realized that Richmond would never again know such a kindhearted benefactor.

The following morning, Richmonders read in the *Dispatch*, "Never but once in the history of this city—at the reinterment of Jefferson Davis—has

Major Ginter's mausoleum.
It remains the most magnificent in Hollywood Cemetery.
Photo by author.

such a tribute been paid to the noble death as when yesterday afternoon the remains of Major Lewis Ginter were laid to rest at Hollywood Cemetery."

In the coming days, in public gatherings across the city, Richmonders struggled to find an appropriate tribute to Major Ginter. Soon, they decided on an endowment to a technical school known as the Mechanics' Institute—one of his favorite causes.

About a year later, in mid- to late 1898, the C.E. Tayntor Company of New York finally completed construction on Ginter's imposing mausoleum in Hollywood Cemetery. Located on a bank overlooking the James, it was the best that money could buy. A classic, Greek Revival–style structure composed of the finest Vermont granite. Bold pediments and soaring Corinthian columns. Doors showcasing the finest artistry in bronze. And a bell-shaped dome, finished with a decorative finial.

Even the interior was exquisite. Three lovely Tiffany windows that words and pictures can't describe. Pilasters and moldings in pink Tennessee marble. And a sarcophagus similar to that of Napoleon in Paris, with a graceful palm frond carved into the top.

Fine detailing of Ginter's mausoleum. *Photo by author.*

Yet just like the man for whom the mausoleum was created, the edifice transcends wealth. It expresses deep love and gratitude from an entire city. It's a monument, really—a monument to the selfless and generous Father of Richmond. While the modest Major Ginter would have been touched by the sentiment, he would have cringed at the elaborate show in his name.

Soon after Major Ginter's death, his executors came to realize that he'd spent most of his wealth on his beloved city for the public good. Having quietly sold off American Tobacco stock, his fortune had dwindled from $12 million to $2 million (still a tremendous sum in those days).

Ginter bequeathed his stylish Franklin Street mansion to nieces Grace and Joanna Arents and Westbrook to Minnie Arents Young. He left Bloomingdale Stock Farm to his faithful nephew, George Arents, and his seven-hundred-acre Maplewood Farm to his secretary and companion during those final months, Tony Thiermann.

Major Ginter also made monetary bequests to countless charities, friends, relatives and servants. A large portion went to his favorite and devoted niece, Grace Arents, who would faithfully carry on his philanthropic legacy.

The Jefferson Hotel—Major Ginter's pride and joy—was passed down principally to Grace Arents, Minnie Arents Young, George Arents and John Pope's brother, George Pope.[310] The majestic Jefferson—an absolute institution to the people of Richmond—would continue on for years in truly grand style. There were charity balls. Banquets. Dances on the roof garden. Just about any social function that demanded a grand, sumptuous setting.

But late at night on March 29, 1901, tragedy struck. An unimaginable tragedy.

Less than six years after the magnificent hotel had opened its doors, fire broke out in a fourth-floor blanket room and quickly spread. As fire crews fought the flames, the hotel's three hundred guests escaped to safety. "The flames leaped a hundred feet above the roof—high above the lofty towers, and swirling heavenward stood out against the darkness, writing destruction upon the bosom of the night," reported the *Times*.[311] Hundreds of Richmond citizens showed up to gaze at the fiery spectacle. Some wept.

Suddenly, the priceless statue of Thomas Jefferson was in dire jeopardy. Frantically, a rescue crew, including sculptor Edward V. Valentine himself, was summoned to help. Amid smoke and falling debris, the men pushed the statue over onto a strategically placed mattress, but in the fall the head struck and broke off. Eventually, the sculpture would be repaired by Valentine in his studio.

The morning after the tragedy, Joseph Bryan's *Times* reported that the blaze was "the most disastrous fire Richmond has experienced since the Evacuation." Most of the hotel was completely destroyed, except for the Franklin Street frontage.

The Richmond Chamber of Commerce convened on the disaster. While praising the firefighters—and grateful that no lives were lost—they officially stated they were "saddened with the fact that the magnificent testimony to the love and interest in the heart of Major Lewis Ginter, for the social and commercial advancement of Richmond, is now in ashes."[312]

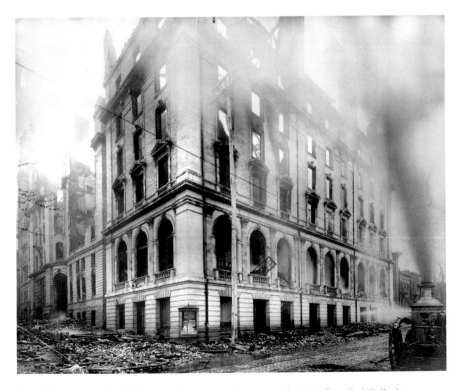

The Jefferson Hotel's Main Street side, right after the tragic 1901 fire. *Cook Collection, Valentine Richmond History Center.*

They added, "This city has suffered many discouragements, but from these she has recovered, and to no other persons does she owe more for their substantial assistance and foresight than to…Major Lewis Ginter and his associate, Mr. John Pope."[313]

In May 1902, fourteen months after the fire, one hundred guest rooms fronting Franklin Street were reopened. But major construction was needed for the portion facing Main Street. Sadly, for purely business reasons, the stockholders resisted rebuilding—that is, except for Grace. She was "exceedingly anxious" that it be restored as a monument to her beloved uncle.[314] The rest of the stockholders held their ground, so the hotel languished in its deplorable state. But then, a citywide movement mounted to rebuild the beloved Jefferson.

Finally, in March 1905—four years after the fire—a deal was struck. Five public-spirited businessmen—including newspaper editor Joseph Bryan and railroad tycoon James Dooley—bought the hotel. They announced

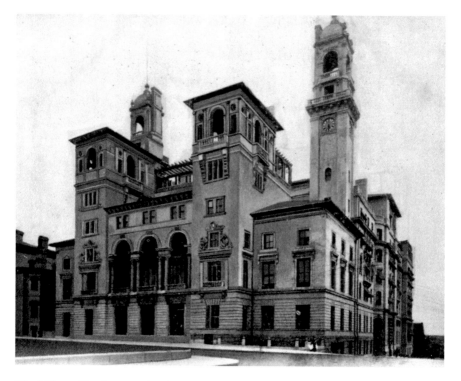

The Jefferson Hotel, restored to its former glory, thanks to Joseph Bryan and others. *VCU Libraries.*

that the Jefferson would be rebuilt at once. "No other sentence could be framed carrying such joy to the hearts of all Richmond people," said the *Times-Dispatch.*[315]

An editorial in that same issue said that "the spirit of Major Ginter will rejoice that citizens of Richmond, who in life were his friends, and who still cherish his memory, have determined to rebuild the Jefferson Hotel and restore the monument which he himself in love erected."

The restoration was designed by architect J. Kevan Peebles, who had recently—and ironically—designed the new wings of Thomas Jefferson's Capitol Building.

On May 6, 1907, the Jefferson Hotel reopened, better than ever. It was taller on the Main Street side, now seven stories high and with almost one hundred more rooms. Every single one of the guest rooms was now outside-facing, each elegantly furnished and with its own private bath.

The restoration incorporated Edwardian and Rococo touches, and massive faux marble columns were added in the rotunda. A fanciful wing was added on the east side, which included the grand ballroom. And it *was* grand.

At last, the Jefferson Hotel was back—in all its regal splendor.

To this day, the majestic Jefferson Hotel stands as a monument to Major Lewis Ginter. It embodies his ambition, leadership and enterprising spirit. His bright optimism and forward-thinking vision. His civic pride and patriotism. His creativity, good taste and glorification of beauty. And, of course, his devotion to the arts.

Should you ever wonder how so many talents and ideals can be enthusiastically embraced by any one human being, all you have to do is find your way to that one-in-a-million hotel, enter its spacious, skylit lobby and—finally—look into the resolute eyes of the Sage of Monticello.

Epilogue

In 1898, the year after Major Lewis Ginter's death, his portrait by John P. Walker was presented to Lee Camp Soldiers' Home by Charles S. Stringfellow. Speaking eloquently of his good friend's legacy, he said, "I trust that long after it has perished, the richest legacy he left us, the bright example of his true and noble life and manhood, may still be cherished and preserved to teach those who come after us, that in war and in peace, for soldier and citizen alike, 'The path of duty is the way to glory.'"[316]

The seminary to which Major Ginter had offered his generous assistance, Union Theological Seminary, formally opened its doors in October 1898. During the elaborate ceremonies, one of the speakers emphasized the need for preachers like Reverend Hoge, "staunch and unmovable as the Blue Ridge for the orthodox gospel."

The following month, already in failing health, Reverend Hoge was involved in a tragic streetcar accident a block away from the Jefferson Hotel. His buggy was struck, injuring him badly. He quickly declined, and in January 1899, Richmond's beloved divine died. His death, like Major Ginter's, was proclaimed "a public calamity." The funeral took place at Second Presbyterian, where Reverend Hoge had served for over fifty years, attended by "a great concourse of people." He was buried on President's Circle in Hollywood Cemetery, close to John Pope, with an immense crowd of devoted Richmonders in attendance.

In 1901, Richmond's Main Street Station was completed in Renaissance Revival style, composed of bricks from the company John Pope had chartered. The elaborate and handsome structure still graces the city skyline.

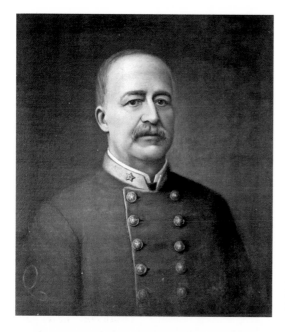

Memorial portrait of Major
Lewis Ginter, 1898, by John P.
Walker. *Virginia Historical Society.*

Reverend Hoge, painted by
William Edward Trahern, put
on display at Lee Camp. *Virginia
Historical Society.*

In early 1906, the Lewis Ginter Land and Improvement Company was formed to develop Ginter's real estate holdings. The primary stockholders were Grace Arents, Joanna Arents, Minnie Arents Young, George Arents, Joseph Bryan, Hunter McGuire and Thomas Jeffress. In honor of Lewis Ginter, they named the neighborhood east of Brook Turnpike Ginter Park, and within two years the suburb was a roaring success. It would do the Major proud, although he may have winced at the name.

Joseph Bryan's Laburnum was destroyed by fire in 1906 and was rebuilt two years later in Beaux Arts style—a style that Ginter had popularized in the city through the Jefferson Hotel. That same year, Joseph Bryan, capitalist and philanthropist, died. His wife, Isobel, purchased the old Rosewood estate on Hermitage Road, rescuing the historic property and pleasure ground from development. She donated it to the City of Richmond to be used as a public park in her husband's honor, and Joseph Bryan Park opened in 1910.

The Deep Run Hunt Club moved out of Rosedale Lodge in 1910 and farther out into the country, due to the city's rapid expansion. Later, the structure became a private home. While it still stands near I-95, the gracious, wraparound porches are long gone.

In 1911, employing the Sherman Antitrust Act of 1890, the Supreme Court forced the breakup of American Tobacco. The firm was split into three separate entities: American Tobacco Company, Liggett and Myers and the P. Lorillard Company. James "Buck" Duke, the pioneer in the application of rolling machines, continued onward with the British-American Tobacco Company. In 1925, he died an astronomically wealthy man.

The Westbrook mansion became a sanitarium in 1911. The lovely grounds provided solace for the patients. In 1975, the owners decided to modernize, demolishing Ginter's former palace. No charges were filed. The interior architectural details were sold at auction, and some were incorporated into the homes in Ginter's suburbs.

In the early 1920s, Ginter Park and Bellevue blossomed as middle-class suburbs, thanks to the arrival of the convenient automobile. Development in Sherwood Park began in 1928, with Ginter's original layout of streets altered to accommodate smaller lots. The Hill Monument remains a centerpiece of Bellevue, as does the Bellevue Arch—one of Ginter's rare few unscathed creations.

In 1924, Richmond's city government got its first free public library, fulfilling one of Lewis Ginter's long-held aspirations. Poignantly, his Franklin Street

mansion was chosen to house it. The handsome edifice still stands, serving as the home for Virginia Commonwealth University's Office of the Provost.

The Great Depression of the 1920s and '30s hit Richmond hard, including the Lakeside Country Club. When it nearly failed in 1933, the Jefferson Club lent financial support. The next year, the two organizations formally merged, creating the Jefferson-Lakeside Country Club, which is still swinging today.

In 1949, the Bryan family donated their Laburnum estate for the site of the planned Richmond Memorial Hospital. Around 2006, the hospital was converted into condominiums and named Ginter Place. The gracious Laburnum mansion still stands regally close by.

Although Lewis Ginter and John Pope were Richmond's wealthiest citizens and shared a heroic concern for the city, Pope faded into obscurity. It's partly because he had no family in the city to perpetuate his legacy. It's partly because he died in his prime. And it's partly because we can't fully comprehend his relationship with Lewis Ginter. But because signs of Ginter's brightness, generosity and eye for beauty still grace the city of Richmond, it should be remembered that—in the spotlight that he so rightfully deserves—he doesn't stand alone.

Lewis Ginter's Legacy

The strength of a city lies in the strength of its men.
—John Stewart Bryan I[317]

After Major Ginter's death, his shy niece and heiress Grace Arents carried on his philanthropic legacy. In 2009, her compassionate and important work was summarized on a highway marker in Oregon Hill that reads, in part:

Grace Evelyn Arents worked tirelessly as an urban reformer and philanthropist to improve the daily life of individuals regardless of race, gender, or class. She developed a church complex that included St. Andrew's Episcopal Church, St. Andrew's School, the Grace Arents Free Library, a teachers' house, and a medical clinic. Arents also established a night school for working children, built public baths and playgrounds, and funded numerous social programs.

As it happened, Grace was inspired by that famous journey to Australia with her uncle—establishing Richmond's first kindergarten and first sewing school. In 1913, she purchased the abandoned Lakeside Wheel Club building. (The fad of cycling had yielded to the automobile around 1901.) She remodeled the structure, added a second story and converted it into a convalescent home for children with tuberculosis and other city-borne illnesses. The accommodations included a classroom, a library and a playroom for the sick children.

With Arents's support, the Instructive Visiting Nurses Association (IVNA) was established, which provided home nursing care and instruction to the poor and sick citizens of Richmond. Since that rendered her children's convalescent home redundant, she later moved into the house with her companion, Mary Garland Smith, where they shared a passion for gardening. Arents named the house Bloemendaal after the small village in the Netherlands that was the Ginter ancestral home.

Upon Grace Arents's death in 1926 at the age of seventy-eight, she willed her companion life rights to Bloemendaal. She further stipulated that upon Smith's death, the home and eighty-five-acre farm would pass to the city and be converted into a botanical garden in honor of her uncle, Lewis Ginter. She was making sure he got the lasting recognition and praise that he had been too modest to accept for himself.

Mary Garland Smith died in 1968 at the age of one hundred. Although Bloemendaal Farm passed to the city, it languished for years. It wasn't until 1981 that a group of botanists, horticulturists and interested citizens banded together to form the Lewis Ginter Botanical Garden, Inc., to uphold the will of Grace Arents. After a legal wrangle, the Lewis Ginter Botanical Garden was chartered by court decree.

At long last, Grace Arents's wish had come to fruition, and the gardens became a poetic monument to her beloved uncle. Focused on one of their shared life passions—horticulture—the gardens are a lasting reminder of their special voyage to Australia, the voyage that made them both

synonymous with inspiration. There are exotic specimens from all over the world, like lacy Japanese maples. Madagascar palms covered with long, spiny thorns. Bird of paradise from New Guinea. A towering, one-hundred-year-old ginkgo tree, native to China. And blooms in all their many colorful and splendid forms, including her uncle's personal favorite, the rose.

But the connections to him don't end there. Located on the former site of his Lakeside Wheel Club, they promote the public good and enhance Richmond's social life—ideals he held close to his heart. They're a pleasure ground much like his Lakeside Park, and they make Richmond a beacon from distant lands much like his Jefferson Hotel. And since the gardens have evolved over time into a vast, harmonious juxtaposition of dense forest, wildflower fields, arched trellises, reflecting pools, fastidiously sculpted topiaries, shady cobbled walks and the sound of splashing water, they're reminiscent of his grand, forward-thinking vision.

And, lastly—as if Major Lewis Ginter were still working his magic—beauty is the law of the landscape.

Notes

INTRODUCTION

1. Slipek, "They Built This City," 12.

CHAPTER I

2. *Richmond Dispatch*, "Major Ginter Dead," October 3, 1897.
3. Ibid.
4. *Times*, "Lewis Ginter: Death of This Public-Spirited Citizen," October 3, 1897.
5. *Richmond Dispatch*, "Major Ginter Dead."
6. *Times*, "Lewis Ginter: Death of This Public-Spirited Citizen."
7. Thomas Nelson Page, *Social Life in Old Virginia Before the War* (Freeport, NY: Books for Library Press, 1970), 65.
8. *State*, "City's Greatest Loss," October 3, 1897.
9. Patton, *Poems of John R. Thompson*, xi–lxi.
10. Ryan, *Four Days in 1865*, 6.
11. *Times*, "Lewis Ginter: Death of This Public-Spirited Citizen."
12. Patton, *Poems of John R. Thompson*, lviii.
13. *Times*, "Lewis Ginter: Death of This Public-Spirited Citizen."
14. Mordecai, *Richmond in By-Gone Days*, 269.

15. Charles Reagan Wilson and William Ferris, *Encyclopedia of Southern Culture* (Chapel Hill: University of North Carolina Press, 1989), 871.

16. Kimball, *American City*, 115.

17. *Times*, "Lewis Ginter: Death of This Public-Spirited Citizen."

18. *Richmond Dispatch*, "Major Ginter Dead," October 3, 1897.

19. Henry Arthur Bright, "A Victorian Englishman on Tour," *Virginia Magazine of History and Biography* 84, no. 3 (1976): 349.

20. *Times*, "Lewis Ginter: Death of This Public-Spirited Citizen."

21. *Richmond Dispatch*, "Major Ginter Dead."

22. Page, *Old Dominion*, 301.

23. Little, *History of Richmond*, 207.

24. John C. Stockbridge, *The Anthony Memorial* (n.p.: Providence Press Company, 1886), 284.

25. Scott, *Houses of Old Richmond*, 230.

26. Dew, *Ironmaker to the Confederacy*, 24–26.

27. Philip Whitlock, *Recollections, 1843–1913* (Richmond: Virginia Historical Society, n.d.).

28. *Times*, "Death of J.C. Shafer." March 26, 1895.

29. *Raleigh News and Observer*, "The Pender Monument Fund." October 10, 1883.

30. *Richmond Whig and Public Advertiser*, advertisement, April 1, 1851.

31. *Richmond Dispatch*, "Major Ginter Dead."

32. *Times*, "Lewis Ginter: Death of This Public-Spirited Citizen."

33. Ibid.

34. *Richmond Dispatch*, "Major Ginter Dead."

35. Wilson, *Appleton's Cyclopaedia of American Biography*, 115.

36. *Times*, "Lewis Ginter: Death of This Public-Spirited Citizen."

37. *Richmond Dispatch*, "Major Ginter Dead."

38. Patton, *Poems of John R. Thompson*, xxxiv.

39. Page, *Social Life in Old Virginia*, 80.

40. Bill, *The Beleaguered City*, 20–21.

41. *Smith College Studies in History*, "The Westover Journal of John A. Selden, 1858–1862," vol. 6, no. 4 (1858): 281.

42. *Richmond Dispatch*, "Spirit of the Fathers," November 29, 1859.

43. Logan, "Queen City of the South," 605.

44. Memorial to the General Assembly of Virginia from "Merchants of Richmond City," Richmond City, January 11, 1860. Legislative Petitions, General Assembly, State Records, Library of Virginia.

45. *Richmond Dispatch*, "Secession Movement at the South," December 3, 1860.

46. Logan, "Queen City of the South," 605.

CHAPTER 2

47. Dabney, *Richmond*, 159.

48. *Times*, "Lewis Ginter: Death of This Public-Spirited Citizen."

49. *Richmond Enquirer*, April 13, 1861.

50. Ibid.

51. *Richmond Dispatch*, "Virginia Dare," December 3, 1860.

52. *Richmond Enquirer*, "Virginians, to Arms!" April 23, 1861.

53. *Richmond Dispatch*, "From and after This Date," April 23, 1861.

54. *Richmond Enquirer*, April 25, 1861.

55. Patton, *Poems of John R. Thompson*, 36.

56. Dew, *Ironmaker to the Confederacy*, 85.

57. *Richmond Dispatch*, "Arrival of President Davis," May 30, 1861.

58. Paul Robinson, "Sword of Honor," *World Press Review* 50, no. 10. www.worldpress.org/Europe/1485.cfm.

59. Hoge, *Moses Drury Hoge*, 146.

60. *Richmond Dispatch*, "Explosion of the Ship Gunboat *Chattahoochee*—Sixteen Persons Killed," June 8, 1863.

61. *Richmond Dispatch*, "Stolen Goods Recovered," March 24, 1863.

62. Patton, *Poems of John R. Thompson*, xxx.

63. *Richmond Dispatch*, "Major Ginter Dead."

64. *Richmond Dispatch*, "The Virginia Chemical Works," December 23, 1861.

65. Ibid., March 3, 1862.

66. Hassler, *A.P. Hill*, 2.

67. *Richmond Dispatch*, May 31, 1862.

68. Hoge, *Moses Drury Hoge*, 162.

69. Furgurson, *Ashes of Glory*, 98.

70. *Richmond Dispatch*, "Major Ginter Dead."

71. Frank Moore, ed., *The Rebellion Record: A Diary of American Events, with Documents, Narratives, Illustrative Incidents, Poetry, etc.* Vol. 9. (n.p., 1866), 382.

72. *Richmond Dispatch*, "Major Ginter Dead."

73. *Times*, "Lewis Ginter: Death of This Public-Spirited Citizen."

74. Robertson, *General A.P. Hill*, 121.

75. D.T. Carraway, letter to the editor, *Richmond Dispatch*, October 10, 1897.

76. Patton, *Poems of John R. Thompson*, 44.

77. Folsom, *Heroes and Martyrs of Georgia*, 123.

78. *Times*, "Lewis Ginter: Death of This Public-Spirited Citizen."

79. Patton, *Poems of John R. Thompson*, xxiv.

80. Speech given by Charles S. Stringfellow on the occasion of the presentation of Ginter's portrait to Lee Camp, 1898. Virginia Historical Society.

81. *War of the Rebellion: Official Records of the Union and Confederate Armies* (Washington, D.C.: Goverment Printing Office, 1885), 703.

82. Folsom, *Heroes and Martyrs of Georgia*, 118.

83. *Richmond Dispatch*, "Explosion of the Ship Gunboat *Chattahoochee*."

84. *Times*, "Lewis Ginter: Death of This Public-Spirited Citizen."

85. Recollection by James N. Boyd, *Richmond Dispatch*, "Major Ginter Dead."

86. Hoge, *Moses Drury Hoge*, 191.

87. Thomas, *Robert E. Lee*, 318.

88. William J. Kimball, *Richmond in Time of War* (Boston: Houghton Mifflin Co., 1960), 99.

89. William L. Royall, *Some Reminiscences* (New York: Neale Publishing Co., 1909), 43.

90. John Witherspoon DuBose, "The Tragedy of the Commissariat," *Gulf States Historical Magazine* 1 (1903): 30.

91. Royall, *Some Reminiscences*, 44.

92. Kimball, *Richmond in Time of War*, 141.

93. Bob Deans, *The River Where America Began* (Lanham, MD: Rowman & Littlefield Publishers, Inc., 2007), 266.

94. D.T. Carraway, letter to the editor, *Richmond Dispatch*, October 10, 1897.

95. Sallie A. Brock, *Richmond during the War*, 364.

96. Philip Van Doren, *An End to Valor* (Boston: Houghton Mifflin Co., 1958), 178.

97. Ibid., 180.

98. Letter from Susan Hoge to Moses D. Hoge, April 4, 1865. Hoge Family Papers, 1804–1938, Virginia Historical Society.

99. Ibid.

100. D.T. Carraway, letter to the editor, *Richmond Dispatch*, October 10, 1897.

101. Dabney, *Richmond*, 199.

102. D.T. Carraway, letter to the editor, *Richmond Dispatch*, October 10, 1897.

103. Logan, *Queen City of the South*, 605.

104. Patton, *Poems of John R. Thompson*, xlviii.

105. Katharine M. Jones, *Ladies of Richmond* (Indianapolis, IN: Bobbs-Merrill Co., Inc., 1962), 290.

CHAPTER 3

106. Hoge, *Moses Drury Hoge*, 235.

107. *Times*, "Lewis Ginter: Death of This Public-Spirited Citizen."

108. Furgurson, *Ashes of Glory*, 365.

109. *Richmond Whig*, April 14, 1865.

110. *Scientific American*, advertisement for sale of Franklin Paper Mills, 1866. It directs Northern capitalists "wishing any further information in regard to this truly valuable property" to refer to "Messrs. Harrison, Garth & Co, No. 18 New street, NY."

111. Harrison, Goddin & Apperson, *Descriptive Catalogue of Virginia Lands for Sale or Lease by Harrison, Goddin & Apperson* (Richmond, 1867).

112. Toast to *Virginia Dare*, "City of New York," *Daily Dispatch*, December 10, 1860.

113. Duke and Jordan, *A Richmond Reader*, 314.

114. *New York Supplement*, vol. 15 (St. Paul, MN: West Publishing Company, n.d.), 208.

115. Ibid.

116. *Times*, "Lewis Ginter: Death of This Public-Spirited Citizen."

117. Bio of Robert Alexander Lancaster Jr., in Tyler, *Men of Mark in Virginia*, 2nd series, 179.

118. *Richmond Dispatch*, "Robt. A. Lancaster" obituary, June 29, 1902.

119. *Scientific American* 15, 1866.

120. *Daily Examiner*, January 3, 1866.

121. Hoge, *Moses Drury Hoge*, 238.

122. *Richmond Dispatch*, "Major Ginter Dead."

123. *Times*, "Lewis Ginter: Death of This Public-Spirited Citizen."

124. *New York Times*, "Robert E. Lee," October 14, 1870.

125. *Times*, "Lewis Ginter: Death of This Public-Spirited Citizen."

126. *State*, "Mr. Pope's Death," April 9, 1896.

127. *Trow's New York City Directory* (New York: J.F. Trow, 1872), 43, 425 and 1168.

128. *Richmond Dispatch*, "Major Ginter Dead."

129. *What Do We Smoke* (Richmond, VA: J.F. Allen & Co., 1878(?)).

130. Patton, *Poems of John R. Thompson*, 77.

131. *Times*, "Lewis Ginter: Death of This Public-Spirited Citizen."

132. Chesson, *Richmond After the War*, 68.

133. Logan, "Queen City of the South," 605.

134. *What Do We Smoke.*

135. *State*, "Mr. Pope Still Living," April 8, 1896.

136. *Sketch of Life of Major Lewis Ginter Prepared for the Lewis Ginter Land & Improvement Company by His Niece, the Late Miss Grace Arents.* Lewis Ginter Botanical Garden Archives.

137. *Times*, "Lewis Ginter: Death of This Public-Spirited Citizen."

138. *Richmond Dispatch*, "Tributes of Respect to the Late Mr. John R. Thompson," May 3, 1873.

139. Patton, *Poems of John R. Thompson*, xxxiii.

CHAPTER 4

140. *Times*, "Lewis Ginter: Death of This Public-Spirited Citizen."

141. *Richmond Dispatch*, "Major Ginter Dead."

142. *Times*, "Lewis Ginter: Death of This Public-Spirited Citizen."

143. Kluger, *Ashes to Ashes*, 18.

144. *Times*, "Lewis Ginter: Death of This Public-Spirited Citizen."

145. John Morgan Richards, *With John Bull and Jonathan: Reminiscences of Sixty Years of an American's Life in England and in the United States* (London: T. Werner Laurie, 1905), 67.

146. *Times*, "Lewis Ginter: Death of This Public-Spirited Citizen."

147. Kluger, *Ashes to Ashes*, 19.

148. Tyler, *Men of Mark in Virginia*, 137.

149. *Richmond Dispatch*, "Major Ginter Dead."

150. *Inauguration of the Jackson Statue* (Richmond: R.F. Walker, Supt. Public Printing, 1876).

151. *Times*, "Lewis Ginter: Death of This Public-Spirited Citizen."

152. Kluger, *Ashes to Ashes*, 16.

153. Editorial from *Boston Pilot* reprinted in *Richmond Dispatch*, July 17, 1887.

154. *Richmond Dispatch*, "Major Ginter Dead."

155. *What Do We Smoke*.

156. *Richmond Dispatch*, "Local Matters," February 2, 1883.

157. *Richmond Dispatch*, "Major Ginter Dead."

158. *Richmond Dispatch*, "Allen & Ginter's Ball," February 12, 1885.

159. *History of the Town of Durham, N.C.* (Raleigh, NC: Edwards, Broughton & Co., 1884), 214.

160. *Daily Times*, advertisement, October 26, 1886.

161. *Daily Times*, "The Daily Times Chartered," October 29, 1886.

162. *Times*, "Lewis Ginter: Death of This Public-Spirited Citizen."

163. Ibid.

164. John Stewart Bryan III, interview by author, December 9, 2010.

165. *Highland Recorder* [Monterey, VA], "Virginia Notes," April 28, 1893.

166. Angus Sinclair, *Development of the Locomotive Engine* (New York: Angus Sinclair Publishing Co., 1907), 605.

167. *Times*, "Lewis Ginter: Death of This Public-Spirited Citizen."

168. *Times*, "Death of J.C. Shafer," March 26, 1895.

169. Richmond City Deeds, Hustings and Chancery Court, Book 132A, 1887, page 412.

170. Grace Arents's travel journal. Lewis Ginter Papers, 1849–1970. Virginia Historical Society, Richmond.

171. Ibid.

172. Ibid.

173. Ibid.

174. Ibid.

175. Ibid.

176. Ibid.

177. Ibid.

178. *Richmond Dispatch*, "Auction Sales Future Days," June 17, 1888.

179. Watkins Norvell, *Colonial, Revolutionary, Confederate and the Present* (Richmond, VA: Edgar K. Brown, 1896); *Richmond Dispatch*, "A Church Burnt," August 3, 1864.

180. *Times*, "The Bloomingdale Farm," May 22, 1891.

181. *Richmond Dispatch*, "Very Pretty Drive," May 10, 1896.

182. *Times*, "Tuckahoe Farmers' Club," May 22, 1891; *Times*, "Horses and Horsemen," March 15, 1896.

183. Tyler, *Men of Mark in Virginia*, 137.

184. *Richmond News Leader*, February 13, 1940.

185. *Richmond Dispatch*, "Allen & Ginter Sell," January 4, 1890.

186. *Times*, "City News," October 23, 1888.

187. *Illustrated New York: The Metropolis of To-Day* (New York: International Publishing Co., 1888), 116.

188. *Times*, "Lewis Ginter: Death of This Public-Spirited Citizen."

189. *Richmond Dispatch*, "The Cigarette Deal," January 5, 1890.

190. Ibid.

191. Ibid.

192. Logan, "Queen City of the South," 604.

Chapter 5

193. *American National Biography* 9 (1999): 78.

194. *Times*, "Lewis Ginter: Death of This Public-Spirited Citizen."

195. *Richmond Dispatch*, "Major Ginter Dead."

196. *Times*, "Mrs. Jane Arents Dead."

197. *New York Times*, "Gay Days at Hot Springs," August 12, 1894.

198. *Times*, "Lewis Ginter: Death of This Public-Spirited Citizen."

199. *Richmond Dispatch*, April 9, 1896.

200. Henrico County Deedbook, Reel 134B, 1891, page 36.

201. Tyler, *Men of Mark in Virginia*, 162.

202. *Richmond Dispatch*, "Major Ginter Dead."

203. *State*, "City's Greatest Loss," October 3, 1897.

204. Newspaper clippings concerning the career of Major Lewis Ginter, mounted in a bound volume. Virginia Historical Society, Richmond.

205. Wheary, "Ginter's 901 West Franklin Street," 4.

206. *State*, March 13, 1888.

207. Wheary, "Ginter's 901 West Franklin Street," 6.

208. Charles Brownell, PhD, VCU professor of art history, interview by author, December 3, 2010.

209. R.A. Brock, *Richmond as a Manufacturing and Trading Centre: Including a Historical Sketch of the City* (Richmond, VA: Jones & Cook, 1880), 7.

210. *Times*, "Mr. Jno. Pope's Funeral," April 10, 1896; *Washington Post*, "John Pope Seriously Ill," April 7, 1896.

211. *Richmond Dispatch*, "The Idler's Letter," January 31, 1892.

212. *State*, "City in Deep Gloom," October 3, 1897.

213. *Richmond Dispatch*, "Major Ginter Dead."

214. *Times*, "Lewis Ginter: Death of This Public-Spirited Citizen."

215. *State*, "City's Greatest Loss," October 3, 1897.

216. *Times*, "Lewis Ginter: Death of This Public-Spirited Citizen."

217. *Shenandoah Herald*, October 8, 1897.

218. *Richmond Dispatch*, "Major Ginter Dead."

219. *Richmond Times-Dispatch*, "Ginter, Pioneer of North Side, Shunned Publicity During Lifetime," August 23, 1970.

220. *New York Times*, "To Provide Good Roads," December 13, 1892.

221. Mordecai, *Richmond in By-Gone Days*, 239.

222. *Shenandoah Herald*, "Death of Major Ginter," October 8, 1897.

223. *Washington Post*, "Fashionable Bicycle Club," July 25, 1895.

224. *New York Times*, "To Provide Good Roads."

225. *Times*, letter to the editor, "General A.P. Hill," May 31, 1892.

226. *Richmond Dispatch*, "In Memory of Hill," October 15, 1890.

227. Souvenir, Hill Monument Unveiling, May 30, 1892. Hill Monument Association, Richmond, 1892. Library of Virginia.

228. *Confederate Veteran Magazine* 18, no. 6. (1910): 273.

229. *Times*, "The Fire Monster," January 18, 1893.

230. Ibid.

231. *Richmond Dispatch*, "Allen & Ginter Fire," January 18, 1893.

232. Ibid.

233. Bryan, *Joseph Bryan*, 249.

234. Henrico County Deed Book 180B, 1907, page 262; *Richmond Times-Dispatch*, "Ginter, Pioneer of North Side, Shunned Publicity During Lifetime"; *Richmond Times-Dispatch*, "When Ginter Park Was 'In the Sticks,'" November 17, 1935; *Richmond Dispatch*, "Was Blown to Pieces," November 12, 1897.

235. *Richmond Times-Dispatch*, "When Ginter Park Was 'In the Sticks.'"

236. *Times*, "Lewis Ginter: Death of This Public-Spirited Citizen."

237. Ibid.

238. *Times*, "Deep Run Hunt Club," March 5, 1896.

239. *Richmond Dispatch*, "The Week Was Gay," December 1, 1895.

240. *Richmond Dispatch*, advertisement, June 24, 1894; *Times*, "The Powhatan Picnic," July 5, 1891.

241. Frazer, *Fluvanna History*, 6.

242. *Times*, "The Deep Run Hunt Club," April 19, 1896.

243. Taylor, *Suburban Reflections*.

244. Letter from F.L. Olmsted & Co. to Lewis Ginter, dated May 16, 1892, Library of Congress, Reel 25, Frame 395.

245. Olmsted Plan of "Unnamed Parkway," at Frederick Law Olmsted National Historic Site.

246. *Richmond Dispatch*, "Run Out to Lakeside," September 22, 1895; Henrico County Deeds, Book 151A, 1896, page 56.

247. *Richmond Dispatch*, "The Seminary Plans," February 18, 1896.

248. Ibid.

249. *Farmville Herald*, "Union Theological Seminary—The Rest of the Story," May 26, 2004.

250. *Times*, "Lewis Ginter: Death of This Public-Spirited Citizen."

251. Ibid.

252. *Richmond Dispatch*, "The Seminary Plans."

253. *Richmond Dispatch*, "Grand Bicycle Races at the Exposition-Grounds Saturday," June 22, 1894.

254. Henrico County Deeds, Book 147A, 1894, page 217; Book 147B, 1894, page 83; and Book 147B, 1894, page 316.

255. *Richmond Dispatch*, "Home for Richmond Bicyclists," November 5, 1895.

256. Cutchins, *Memories of Old Richmond*, 152.

257. *Richmond Dispatch*, "Very Pretty Drive," May 10, 1896.

258. Henrico County Deed Book 138B, 189,1 page 145.

259. *Times*, "Lewis Ginter: Death of This Public-Spirited Citizen."

260. *Richmond Times-Dispatch*, "Richmond's 200 Years," December 18, 1938.

261. *Richmond Times-Dispatch*, "Major Ginter Looked Ahead," Ginter Park Supplement, May 3, 1908.

262. *Times*, "The Splendid Jefferson Hotel Burned, But All the Guests Made Their Escape," March 30, 1901.

263. Hoffman, *Race, Class and Power*, 58.

264. Charter for Virginia Hotel Company, Charter Book 7, 19. Library of Virginia.

265. *Daily Times*, "The New Hotel Boom," December 6, 1888.

266. *Richmond Dispatch*, "Joseph R. Anderson," September 8, 1892.

267. *Times*, "Lewis Ginter: Death of This Public-Spirited Citizen."

268. *Times*, "To Have a New Hotel," November 12, 1892.

269. Logan, "Queen City of the South," 605.

270. *Times*, "To Have a New Hotel."

271. Logan, "Queen City of the South," 605.

272. *Times*, "To Have a New Hotel."

273. *Times*, "They Saw the Jefferson," October 31, 1895.

274. *Morning Times* [Washington, D.C.], "Marlborough Will Go South," November 6, 1895.

275. *Times*, "Beautiful Lakeside Park," March 1, 1896.

276. *Richmond Dispatch*, "Ready for Guests," October 27, 1895.

277. *Richmond Times-Dispatch*, "Fine Hotel Be Built on Much Grander Scale," March 16, 1905.

278. *Times*, "Lewis Ginter: Death of This Public-Spirited Citizen."

CHAPTER 6

279. *Times*, "Lewis Ginter: Death of This Public-Spirited Citizen."

280. Ibid.

281. Ibid.

282. *Richmond Times-Dispatch*, "Negroes to buy Myrtle Grove," August 25, 1907.

283. *Richmond Dispatch*, "Major Ginter Dead."

284. *Times*, "Lewis Ginter: Death of This Public-Spirited Citizen."

285. *Richmond Dispatch*, "Its Objects Shown," May 26, 1893.

286. Ibid.; *Richmond Dispatch*, "Story of Virginia Hospital," December 25, 1901.

287. Ray Bonis, Jodi Koste and Curtis Lyons, *Virginia Commonwealth University* (Charleston, SC: Arcadia Publishing, 2006), 23.

288. *Times*, "The Closing Day of Dr. Hoge's Anniversary Celebration," February 28, 1895.

289. *Times*, "Lewis Ginter: Death of This Public-Spirited Citizen."

290. *Times*, "Death of J.C. Shafer," March 26, 1895.

291. "John Pope: A Most Valuable Man to This City" *Richmond Quarterly* 7, no. 2 (Fall 1984): 31–32.

292. *Times*, "Charities," December 16, 1894; *Richmond Dispatch*, "Personal Notes of Local Interest," August 21, 1892.

293. *Times*, "Personal and General," October 25, 1892.

294. National Register of Historic Places Registration Form for Hermitage Road Historic District. Section 7, page 1.

295. Letter from Ginter to Olmsted Associates, dated April 22, 1892. Library of Congress Manuscript Division. Reel 58, Frame 452.

296. *Richmond Dispatch*, "Warehouse Collapses," March 25, 1896.

297. *Richmond Dispatch*, "Major Ginter Dead."

298. *State*, "Mr. Pope's Death," April 9, 1896.

299. *Richmond Dispatch*, "Will Be the John Pope Annex," April 28, 1896.

300. *Richmond Dispatch*, "Mr. John Pope Dead," April 9, 1896.

301. "John Pope, Deceased" *Ice and Refrigeration* 10, no. 5 (May 1896), 334.

302. Fran Purdum, archivist for Lewis Ginter Botanical Garden, interview by author, September 10, 2010.

303. Speech given by Charles S. Stringfellow on the occasion of the presentation of Ginter's portrait to Lee Camp, 1898. Virginia Historical Society, Richmond.

304. *Times*, "Lewis Ginter: Death of This Public-Spirited Citizen."

305. *Richmond Times-Dispatch*, "Unique Lewis Ginter," July 20, 1952.

306. Letter from Lewis Ginter in Vichy to his personal secretary in Richmond, Tony Thiermann, dated August 26, 1896. VCU Special Collections.

307. *Times*, "Lewis Ginter: Death of This Public-Spirited Citizen."

308. *Times*, "In the Tomb," October 6, 1897.

309. *Richmond Dispatch*, "Major Ginter Dead."

310. *Times*, "Jefferson Loss Now Adjusted," May 21, 1901.

311. *Times*, "The Splendid Jefferson Hotel Burned," March 30, 1901.

312. *Times*, "Grief at Ruin of Jefferson," March 31, 1901.

313. Ibid.

314. *Times*, "Jefferson Loss Now Adjusted."

315. *Times-Dispatch*, "Fine Hotel Be Built on Much Grander Scale," March 16, 1905.

EPILOGUE

316. Speech given by Charles S. Stringfellow on the occasion of the presentation of Ginter's portrait to Lee Camp, 1898. Virginia Historical Society.

317. *News Leader* [Richmond], February 13, 1940.

Selected Bibliography

Adams, William Howard, ed. *Richmond, The Pride of Virginia*. Philadelphia: Progress Publishing Company, 1900.

Alvey, Edward, Jr. "John F. Allen and Lewis Ginter: Richmond Cigarette Pioneers." *Richmond Quarterly* 7, no. 3 (Winter 1984).

American National Biography 9 (1999).

Arnold, B.W., Jr. *History of the Tobacco Industry in Virginia from 1860 to 1894*. Baltimore, MD: Johns Hopkins Press, 1897.

Bernstein, R.B. *Thomas Jefferson*. New York: Oxford University Press, 2003.

Bill, Alfred Hoyt. *The Beleaguered City: Richmond 1861–1865*. New York: Alfred A. Knopf, 1946.

Bottorff, William K. *Thomas Jefferson*. Boston: Twayne Publishers, a division of G.K. Hall & Co., 1979.

Brock, Sallie A. *Richmond during the War: Four Years of Personal Observation*. New York: Time-Life Books, 1983.

Brown, Kent Masterson. *Retreat from Gettysburg: Lee, Logistics and the Pennsylvania Campaign.* Chapel Hill: University of North Carolina Press Books, 2005.

Bryan, John Stewart. *Joseph Bryan: His Times, His Family, His Friends, A Memoir.* Richmond, VA: Whittet & Shepperson, 1935.

Burstein, Andrew. *The Inner Jefferson.* Charlottesville: University Press of Virginia, 1995.

Chesson, Michael B. *Richmond After the War, 1865–1890.* Richmond: Virginia State Library, 1981.

Christian, William Asbury. *Richmond, Her Past and Present.* Richmond, VA: L.H. Jenkins, 1912.

Culhane, Kerri Elizabeth. "The Fifth Avenue of Richmond." Master's thesis, Virginia Commonwealth University, 1997.

Cutchins, John A. *Memories of Old Richmond.* Verona, VA: McClure Press, 1973.

Dabney, Virginius. *Richmond: The Story of a City.* Charlottesville: University Press of Virginia. Revised and Expanded Edition, 1990.

Dew, Charles B. *Ironmaker to the Confederacy: Joseph R. Anderson and the Tredegar Iron Works.* 2nd ed. Richmond: Library of Virginia, 1999.

Dictionary of American Biography. Vol. 1. Richmond: Library of Virginia, 1998.

———. Vol. 7. New York: Charles Scribner's Sons, 1946.

Dictionary of Virginia Biography. Vol. 2. Richmond: Library of Virginia, 2001.

Duke, Maurice, and Daniel P. Jordan, ed. *A Richmond Reader 1733–1983.* Chapel Hill: University of North Carolina Press, 1985.

Fishwick, Marshall W. *Gentlemen of Virginia.* New York: Dodd, Mead & Company, 1961.

Folsom, James M. *Heroes and Martyrs of Georgia*. Macon, GA: Burke, Boykin & Co., 1864.

Frazer, Susan Hume. *Fluvanna History: A Publication of the Fluvanna County Historical Society*. Palmyra, VA, 2005.

Furgurson, Ernest B. *Ashes of Glory*. New York: Alfred A. Knopf, 1997.

George, Linda. "Richardsonian Architecture in Washington, D.C., and Richmond, Virginia." Independent study report, Virginia Commonwealth University, 2004.

Ginter Family Bible Records, Virginia Historical Society, Richmond.

Ginter, Lewis. Papers, 1849–1970. Virginia Historical Society, Richmond.

Green, Bryan Clark, Calder Loth and William M.S. Rasmussen. *Lost Virginia: Vanished Architecture of the Old Dominion*. Charlottesville, VA: Howell Press, 2001.

Harper's Weekly 60, no. 1569 (1887).

Hassler, William Woods. *A.P. Hill: Lee's Forgotten General*. Richmond, VA: Garrett & Massie, Inc., 1957.

Hennessey, John J. *Return to Bull Run*. New York: Simon & Schuster, 1993.

Hoffman, Steven J. *Race, Class, and Power in the Building of Richmond, 1870–1920*. Jefferson, NC: McFarland & Company, Inc., 2004.

Hoge, Peyton Harrison. *Moses Drury Hoge: Life and Letters*. Richmond, VA: Presbyterian Committee of Publication, 1899.

Jefferson and the Arts: An Extended View. Washington, D.C.: National Gallery of Art, 1976.

Kimball, Gregg D. *American City, Southern Place*. Athens: University of Georgia Press, 2000.

Kimmel, Stanley. *Mr. Davis's Richmond*. New York: Coward-McCann, Inc., 1958.

Kluger, Richard. *Ashes to Ashes: America's Hundred-Year Cigarette War, the Public Health, and the Unabashed Triumph of Philip Morris*. New York: Random House, Inc., 1997.

Little, John P. *History of Richmond*. Richmond: Dietz Printing Company, 1933.

Logan, Charles Thomas. "Queen City of the South." *American Magazine* 41 (1896).

Malone, Dumas. *Jefferson the Virginian*. Boston: Little, Brown and Company, 1948.

McCabe, W. Gordon. "John R. Thompson, Poet and Editor: An Address Delivered at the University of Virginia, June 12, 1899." Virginia Historical Society.

McPherson, James. *For Cause and Comrades*. New York: Oxford University Press, 1997.

Millett, Wesley, and Gerald White. *The Rebel and the Rose*. Nashville: Cumberland House, 2007.

Mordecai, Samuel. *Richmond in By-Gone Days*. Republished from the Second Edition of 1860. Richmond: Dietz Press, Inc., 1946.

Newspaper clippings concerning the career of Major Lewis Ginter. Mounted in a bound volume. Virginia Historical Society, Richmond.

Norvell, Watkins. *Richmond, Virginia: Colonial, Revolutionary, Confederate and the Present, 1896*. Richmond, VA: Edgar B. Brown, 1896.

Page, Thomas Nelson. *The Old Dominion: Her Making and Her Manners*. New York: Charles Scribner's Sons, 1908.

Patton, John S., ed. *Poems of John R. Thompson.* New York: Charles Scribner's Sons, 1920.

Putnam, Sallie A. *In Richmond During the Confederacy.* New York: Robert McBride Company, 1961. (2nd ed.)

Robertson, James I., Jr. *General A.P. Hill: The Story of a Confederate Warrior.* New York: Random House, 1987.

Rubin, Louis, Jr. *Virginia, A History.* New York: W.W. Norton & Co., 1977.

Ryan, David D. *Four Days in 1865: The Fall of Richmond.* Richmond: Cadmus Communications Corporation, 1993.

Scott, Mary Wingfield. *Houses of Old Richmond.* New York: Bonanza Books, 1941.

———. *Old Richmond Neighborhoods.* Richmond: William Byrd Press, 1950.

Slipek, Edwin, Jr. "They Built This City." *Style Weekly*, November 1, 1994.

Stanard, Mary Newton. *Richmond, Its People and Its Story.* Philadelphia: J.B. Lippincott Company, 1923.

Stern, Philip Van Doren. *An End to Valor: The Last Days of the Civil War.* Boston: Houghton Mifflin Company, 1958.

Taylor, Douglas E. *Suburban Reflections.* Richmond, VA: I.N. Jones & Son, ca. 1898.

Thomas, Emory M. *The Confederate State of Richmond: A Biography of the Capital.* Austin: University of Texas Press, 1971.

———. *Robert E. Lee: A Biography.* New York: W.W. Norton & Company, 1995.

Tyler, Lyon G. *Men of Mark in Virginia.* Vol. 4. Washington, D.C.: Men of Mark Publishing Company, 1908.

————. *Men of Mark in Virginia.* 2nd ed. Richmond, VA: Men of Mark Publishing Company, 1936.

————, ed. *Encyclopedia of Virginia Biography.* Vol. 4. New York: Lewis Historical Publishing Company, 1915.

Virginia: A Guide to the Old Dominion. Compiled by workers of the Writers' Program of the Work Projects Administration in the State of Virginia. New York: Oxford University Press, 1940.

Watehall, E.T. "Fall of Richmond, April 3, 1865." *Confederate Veteran* 17 (1909).

Wheary, Dale. "Ginter's 901 West Franklin Street by Harvey L. Page." Master's thesis, Virginia Commonwealth University, December 1993.

Wilson, James Grant, ed. *Appleton's Cyclopaedia of American Biography.* New York: D. Appleton & Co., 1901.

Index

About the Author

Brian Burns started his career in the 1980s as an advertising art director in North Carolina. In 1987, he moved to Richmond, where he enjoys a simpler life in writing and horticulture. His home is in the Bellevue district, one of the neighborhoods that Lewis Ginter and John Pope pioneered.

Visit us at
www.historypress.net